NEW LIVES FOR
FORMER WIVES

Nancy C. Baker

NEW LIVES FOR FORMER WIVES
Displaced Homemakers

ANCHOR PRESS/DOUBLEDAY
GARDEN CITY, NEW YORK
1980

ISBN 0-385-14979-4
Library of Congress Catalog Card Number 79-6093

COPYRIGHT © 1980 BY NANCY C. BAKER
ALL RIGHTS RESERVED
PRINTED IN THE UNITED STATES OF AMERICA
FIRST EDITION

To my sister, Judith Ann Moll

Author's Acknowledgments

It would be impossible to thank personally the dozens of displaced homemakers who helped me research this book by telling me their stories. However, I wish to express to them my gratitude for their candor in sharing with me intimate details about their changed lives. As promised, their names have been changed to protect their privacy.

I am particularly grateful to Milo Smith of the Oakland Displaced Homemakers Center and to Cindy Marano of the Baltimore Center for Displaced Homemakers for the time and information they gave me, as well as for their aid in contacting many displaced homemakers who have been served by their centers.

I greatly appreciate the help I received from experts in psychology, personnel, and financial matters, including Dr. Frances Heussenstamm, Mary Hirschfeld, Dawne Schoenholz, Bob Ehrman, Barbara Zitelli, Dr. Barbara Pletcher, Kathy Aaronson, Phyllis Adelberg, Stan Benson, and many others.

Special thanks go as well to Loretta Barrett, my editor, who believed in this project and lent her special expertise to the planning and writing of it.

<div style="text-align: right;">N.C.B.</div>

Contents

	Introduction	xi
1	Waking from the American Dream	1
2	One Is a Lonely Number	17
3	"I Don't Like Me. Why Should You?"	49
4	The Myth of the Gay Divorcee and the Merry Widow	73
5	Growing Up Middle-Aged	103
6	Former Wife, Forever Mother	121
7	The Altered Kinships He Left Behind	155
8	Money Is the Root	171
9	"I'm Just a Housewife, I Can't Really *Do* Anything"	201
10	In Pursuit of a Paycheck	229
11	From Displaced Homemaker to Woman with Her Own Place	249
	Bibliography	255
	Index	261

Introduction

The sixties and seventies have seen sweeping social changes in America, many of which have been very good for women. They now can aspire to management and executive positions, they can handle their own money, their opinions are becoming more respected, power is more likely to be theirs, they have more control over their sexual and reproductive functions. No longer are they relegated to the one traditional path for women—that of housewife and mother.

But along with these advantageous changes have come a few that initially have been very harmful for some women, particularly those middle-aged women who have spent their adult lives on that traditional path. Rising divorce rates, the advent of no-fault divorce, the specter of younger women achieving financial self-support, double-digit inflation, the sexual revolution—all have meant at least temporary disaster for as many as seven million American women who have been full-time homemakers.

Through divorce, separation or widowhood, these women have seen their fairy-tale dreams of being loved, protected and supported homemakers shattered. And this has happened to them at a time when they find change generally unwelcome and difficult to weather. Even more discouraging is their feeling that they have very little control over this alteration of their lives.

Termed displaced homemakers—because they have been displaced from their marriages and often from their homes as well—these women have suddenly been forced to become self-supporting. When they married years ago, they believed that marriage was forever; divorce was never contemplated. But today, not only is divorce happening in one marriage of every three, often the only necessary ground for it is something like "irreconcilable differences." Because fault provisions have been removed in most divorces and because judges see younger, trained women making fairly good salaries in the work force, displaced homemakers are as a rule expected to catch up and become self-supporting in a relatively short time, something that seems to them a nearly impossible task. And at the same time, the one major family asset to which the courts consistently fail to recognize the wife's claim—the husband's career and earning capacity—is likely to be the most valuable.

Both widows and divorcees have become the victims of the last decade's accelerated inflation rates as well. Even those displaced homemakers lucky enough to have a fixed income can no longer count on its continuing to support them. Without remedial action, they can look forward to a needy old age.

While these financial realities sink in, displaced homemakers find themselves in the midst of an identity crisis. For them, most of the things in which they placed their faith have turned sour. They don't know where to turn next, in what to believe, in whom to place their trust. And they feel very alone.

Some displaced homemakers, however, have decided not to let society kick them while they are down. They

Introduction

see others demanding new treatment, so they've decided to demand some for themselves. No longer, they say, will divorcees retire in disgrace or widows in genteel poverty. Today's women left alone in midlife have organized their efforts to gain government funding for centers to help them become self-supporting adults. And they have worked to gather public support and understanding of women in their position. They have banded together to help themselves.

This book is about those displaced homemakers with the courage to help themselves. And it's *for* them as well. It's also for all the potential displaced homemakers of America, and that includes any housewife who has not prepared herself to be immediately employable if necessary.

This is not a book about hopelessness, but one about hope. It is about women who were dealt an unfair blow by life but who rallied and became stronger and happier as a result. And their example can speak to many others—those women who are also divorced, separated or widowed, those still married and in the home, and perhaps even those young women still approaching marriage.

In the final analysis, this is a book about women discovering themselves and their own self-sufficiency. It's about the journey from a husband's home to a home of one's own.

NEW LIVES FOR FORMER WIVES

1

Waking from the American Dream

Sarah worked faithfully at her job for thirty-one years but, when she lost it at the age of fifty-two, she received neither unemployment compensation nor severance pay. And she quickly learned that another job with the same economic benefits was impossible to find.

Her occupation: homemaker—until her husband left her for a younger woman.

Marian at forty-seven thought she would be able to live secure in her happy marriage for the rest of her days but, when her husband Sam died after a heart attack two

years ago, she found out differently. Since she was not yet sixty, and had no young children, she was not entitled to Social Security payments. Similarly, she had no claim to Sam's pension and his $10,000 life insurance policy was quickly eaten up by his final medical bills and repayment of a home improvement loan they had arranged.

Now Marian has one financial asset—her house—but no way to continue the payments. She, like Sarah, is a displaced homemaker.

"Displaced homemaker" is a term coined a few years ago by some California women to describe a large but generally ignored group of women like themselves. Typically between the ages of thirty-five and sixty, displaced homemakers have spent their adult lives dependent on their husbands for financial support. They have lived the American dream, comfortable in raising their children, working as volunteers in their communities, learning to budget for the good life on one salary. But then something—death, divorce or separation—takes their husband away and, along with him, their means of support. In middle age, these women are forced into the marketplace without work experience or training and are expected to earn their own living.

This book is about those women, who today number between three and seven million. We all know them, or could be one of them if we are not already. As Milo Smith, director of the Displaced Homemakers Center in Oakland, California, and a widow herself, says, "We're your mothers, your mothers-in-law and your Great Aunt Sadie. There isn't one of the people who have the money and the power in this country who doesn't know a woman in this condition."

Today's displaced homemakers were the young brides of the forties, fifties and sixties—women who believed that, if they lived their lives for their families, they would have lifelong financial security and happiness. They played by the rules that society, their parents and their husbands set out for them—only to have the rules changed when they reached the midpoint in their game of life. And the most heartrending thing is that they are left poorly equipped to cope with these changes because they have remained dependent on their husbands in so many ways. Displaced homemakers are forced to grow up in middle age, to learn to play a different game, one that didn't even exist when they were young. At the same time, their value to society has diminished. The entry-level job they could have had at twenty-two is far less available at fifty-two. The college education for which they could have had time at eighteen becomes burdensome at fifty. Their skills rusted and their egos atrophied as they tried to live their lives through their husbands and children. It's very, very hard to grow up in a society that values girls over women. Many displaced homemakers still hopefully think of themselves as girls, not women, despite their age. And they're not entirely wrong. In their minds, their emotional and intellectual maturity, they are often stuck at an adolescent level. They still need to learn who they are, how to be self-dependent, how to earn a living, how to respect their own desires, how to conquer the urge to be dependent and submissive little girls.

In midlife, this is a terrifying and pitfall-laden journey. Many displaced homemakers simply don't make it. They become addicted to pills, drown their sorrows in alcohol, sink into the mire of the welfare system, become resi-

dents of public nursing homes, commit suicide. But others use their displacement as an opportunity for growth, a chance to become full, self-sufficient adult women, women who can look in the mirror and take pride in what they see there—not just in their physical appearance but in their intelligence and accomplishments as well. Through difficult change, they are able to find out who they really are, and to like themselves.

In the mid-seventies, when the movement in support of the displaced homemaker was born in Oakland, I became interested in what was happening to these women. Housewives suddenly left alone in midlife had been around for years, of course, but no one paid much attention to them until women like Milo Smith, Tish Sommers, co-ordinator of the National Organization for Women's Task Force on Older Women, and Laurie Shields, national co-ordinator of the Alliance for Displaced Homemakers, began rabble-rousing for themselves and their peers. I realized as I became more aware of the movement that the plight of these women could easily have been mine. All the messages I received as a young girl in the Midwest said I should yearn for marriage, two to four children, a house in the suburbs and a station wagon to call my own. In my social circle, a college education was urged for girls, but only because it was easier to find an appropriate young-executive-type husband in college. Graduate school was considered overdoing it and bound to be too threatening to most potential husbands' egos. Somehow the fantasy was hazy beyond the wedding day; I was a member of the "happily ever after" generation. Nobody ever mentioned divorce.

I married at twenty, two weeks after my college gradu-

ation, and I took a job as a newspaper reporter. It was only to be a temporary job, I told myself, until my husband finished his engineering degree. Later, I moved into public relations work because it was higher paid. I wasn't in a real career, so it made sense for me to take the job where I could make the most money. That way, we'd have the down payment on that suburban house more quickly. Whether or not the job had any future or whether or not I was happy doing it were inconsequential concerns in comparison with pursuing the American dream at a faster speed. Reaching the goal would guarantee our happiness.

After we had achieved the requisite three bedrooms, two baths and a family room, I gave birth to a son and tried to be a full-time homemaker. But a year or so later, I finally had to admit that this life-style was not for me.

I decided to go back to work, this time to aim for a real career, but it was not an easy decision. I was consumed with guilt over my failure to adjust to the prescribed feminine role. In those days, it was still presumed that the one true course for all women was wife and mother. And those of us who didn't or couldn't conform were considered odd. After several months of interviewing for jobs, during which I was told numerous times by prospective employers that I shouldn't be working if I had a child at home, I got a job writing educational and industrial films. It was mundane fare, but at least I was earning a living. I wrote about integrated circuits, cathode-ray tubes and employee insurance benefits and spent a lot of time thinking about my life and the promises that had been made to the women of my generation and my mother's—promises of happiness if we played by the rules and were

good little wives and mothers. No matter what I did in those days—whether it was trying to be a full-time suburban housewife and falling short, or being a second-class citizen in the male world of work—I felt I didn't fit in. I was the clichéd square peg in the round hole.

Today, however, many of the women who were more successful than I at playing the housewife role are becoming displaced homemakers. Many are left widows with their husbands dying of heart attacks, possibly brought on by the stress of carrying an entire family on their backs. Other husbands are tiring of the unrewarding struggle and calling quits to their marriages, or are relieving the symptoms of their midlife crises with the charms of younger women. And some wives, too, are recognizing the emptiness of their lives as spouses of alcoholics, batterers or men married to their careers and are packing their own suitcases.

When my own marriage ended in separation at thirty-two, followed by divorce at thirty-four, at least I had my work skills to carry with me. These women began at forty as file clerks, restaurant hostesses, nurses' aides, department store cashiers. The ones who'd once had an education and employment credentials had allowed them to get rusty. One of my neighbors, for instance, worked in a discount store every Christmas for extra money while she let her teaching certificate lapse. A college roommate, who also held a teaching certificate she never used, spent the first couple years of her marriage working in a campus store to "put hubby through." Then she switched to homemaking and volunteer work. Fifteen years later, they're divorcing. He has a well-paid management job; she has two children to support and no recent work expe-

rience. Another of my college roommates divorced her husband, a dentist, when she discovered his dental assistant was assisting him in some overly personal ways. She was faced with raising two children on a combination of alimony and child support that would last seven years—if her former husband chose to pay her on time. The jobs she could get would leave her little income after she paid day care fees for her sons.

Many of these women saw their only salvation in finding another man to support them and their children. They spent what money they had on new hairdos and wardrobes and haunted the singles bars. In most cases, they didn't find the kind of man they wanted; they found users and hangers-on, men who would help them deplete their divorce settlements or insurance benefits and then move on to the next lonely mark.

But most of them eventually realized that it had always been an illusion—believing somebody would take care of them for life. The average age of widowhood today is only fifty-six. Two of three persons over sixteen living at or below poverty level are women. In some parts of the country, the divorce rate is now 50 per cent. And the divorce rate among couples married more than twenty years has increased 40 per cent in the past decade. Many widows do not have adequate incomes to last the rest of their lives and, contrary to popular belief, only 14 per cent of divorcees are awarded any alimony. Of those who are, only half collect it regularly. The truth is that marriage does not equal security for women and it never did. The only security we can count on is the security that comes from taking care of ourselves.

Many displaced homemakers decided their lives were,

in fact, not over; they were just beginning. Little by little, they baby-stepped their way into a healthy self-esteem and full adulthood. One woman took the equity in her house, her one divorce settlement prize, and built it into a two-million-dollar real estate empire. Another, a widow, took over the reins of her husband's meat packing business rather than take the easy sell-out route. Today, its profits have skyrocketed. A third is now earning more than $40,000 a year in technical sales and still another has built a home sewing talent into a career as a dress designer.

While not every displaced homemaker can expect to begin a spectacular career at fifty and see her success story featured on the pages of her hometown newspaper, what she can reasonably expect is to become self-supporting, self-sufficient and self-esteemed. The reality is that her standard of living will probably be greatly reduced. Perhaps she will combine forces with other women in similar circumstances. But there is a tremendous reward in making one's own way in life, one that, for many, supersedes the satisfactions of living in a big suburban house, owning two or three cars, and taking an annual trip to Europe or the Bahamas. That reward is freedom.

In researching this book, I interviewed displaced homemakers from Baltimore to Oakland, from Boston to Los Angeles and I found common experiences among women in all parts of the country. They went through difficult trials ranging from feelings of abandonment to terror at the prospect of meeting new men; from seeing their children "bought off" by their more affluent former husbands to experiencing deep suicidal depressions; from learning to subsist on a drastically reduced income to each

one's believing that she is the only woman in the world who's ever had her life crumble beneath her in this way. This book has been written from the lives of these women, women within whom I saw a core of inner strength, a delightful flowering in midlife as they discovered that they have power over their own fates.

Most of the women who shared their lives with me had grown into marvelous, vibrant people. They had worked through a life crisis situation that I doubt many men would survive as well. Of course, there were some who are making a career of bitterness and self-pity, but that is their own loss and only their own. Unfortunately for these women, they will never know the joy that can come with independence and freedom. And there were women, too, for whom it really is too late, women who were ill or elderly or who no longer had the strength to fight. They serve as a warning to the rest of us not to let the years we have slip away unrealized.

"There is hope." "You are not alone." "You can profit from the experience of being displaced." These are the messages the displaced homemakers in the book (whose names I've changed to protect their privacy) have for their sisters in crisis. These women, through recognizing that their own experience is not unique, and through banding together in mutual aid, are finding new paths and new support systems in their middle years. "Every woman who walks through this door," said Milo Smith at the Oakland Displaced Homemakers Center, "feels like the singular failure, that the great hand of God came down and did it to her alone. That's the leveling process here. The Colonel's lady and Rosie O'Grady are sisters under the skin in this particular place, because financial

need is a leveling process. And the experience of being alone and rejected is a sharing thing. The building up again and the growth are sharing things, too." The women who've been there can give a boost up the ladder to the women who must follow. Deciding not to give up is the first step, along with opting for positive change. Such a climb requires a new outlook on life, a revamping of values, but the results can be incredibly satisfying.

Milo herself is a prime example. Somewhat unusual because she had worked at paid jobs—never a career—at various times in her marriage, Milo nevertheless found her work experience unmarketable when she was widowed at forty-seven and had to have a job. But she hit every barrier that was thrown up before her head on, changed and grew in the process, and today is delighted with what she's accomplished for herself and other displaced homemakers.

"When my husband died, I hadn't worked in about ten years," she says, "but I'd worked on and off all my life. I never had a career orientation because I never thought I'd really have to work. I worked when I felt like it. If I didn't like it, I quit. If I had to write a resume of my experience at the time when consistent work experience was important, I never would have gotten in the door."

Milo, a short, silver-haired, feisty woman now in her late fifties, found roadblocks every time she turned another corner. The first was with her husband's union. "My husband had paid into a union retirement fund for thirty years—paid in; this was not a fringe benefit. When I went into his union office, they said, 'There is nothing for you because your husband died prior to being old enough for retirement.' So I didn't get a penny, not even the money

he paid into it." Legislation today has modified such retirement funds, but that didn't help Milo.

Her second stop for help was Social Security. "I wasn't the biggest dummy in the world," she says, "but I thought every widow got Social Security. I was only forty-seven and, when I found out that the minimum benefit I could get from Social Security was when I was sixty, that was a long haul."

Next stop, the Veterans Administration. "I am a veteran, my husband was a veteran. So I went to the Veteran's Bureau and they told me that, as soon as I was destitute, I could get seventy-five dollars a month."

With a little insurance money and a talent for frugal living, Milo decided to invest in a college education. She was interested in social work and in aging, so she enrolled in the University of California and earned a degree. "But I paid full tuition because there was a twenty-six-year age limit on scholarships at that time," she recalls. "There was no way except to pay it. So I got the degree and I went back to the Employment Development Department, where I'd also been before, and I was told that I was unemployable at the age of fifty. They said there was nothing for me to do but go to the welfare office, that I had wasted my money going to school, and that I couldn't get a job in social work because I had no recent work experience."

By now, Milo was raging. "I was so infuriated by this clerk," she says, pounding her fist on her desk, "that I went out the next day and got a job—a job I could have gotten without ever going to school, one that I got under my old experience." She went to work in a mortuary. "It was based on all the things I had done before. I had been

an autopsy assistant in the Army during the war, so I was used to being around dead bodies. I had a beauty shop at one time, so I could do a little painting and hairstyling. I had a good business background, so I did the bookkeeping. And, with my new social work degree, I counseled the bereaved. Now, what kind of a beautiful package did that mortuary get in me?" There were drawbacks, however. It wasn't the kind of work Milo envisioned doing for the rest of her life, "and I probably made ten cents an hour" because she had to live at the mortuary and a large part of her "salary" was room and board. But she used that job to finance experience in social work so she could improve her circumstances later. "It took me two and a half years as a volunteer to validate myself in my social work field of aging," she says. "So I worked eight hours a day at the mortuary and a good six to eight hours a day volunteering and that's how I moved out of the mortuary business."

Instead of giving up, Milo Smith decided to fight prejudice against her as a woman and as an older worker. And she has since used her seemingly endless energies to help other women who face her situation. "It was from talking to women newly widowed at the mortuary and talking to women where I was volunteering that I became so concerned with the plight of older women," she says. "I wanted to know what they did, how they managed everything alone." One of these women introduced Milo to Tish Sommers, who later became co-ordinator of NOW's Task Force on Older Women, and "we started talking about what was happening to older women over the kitchen table." In 1975, Milo's social work training and her life experience combined to qualify her for the

job of director of the nation's first Displaced Homemakers Center. Funded as a demonstration project by the California Legislature, the Center was designed to aid intensively a group of fifteen women every six months. But, by the end of the second year, more than twelve hundred women had sought help there. "We got caught in the numbers game," Milo says. "It was the pressure of the women coming. For the first fifteen women—when practically nobody knew we were here—we had a hundred applicants, every one of them needing our services. How can you keep choosing and saying, 'You are less worthy and you are more worthy?' So we took on the burden of rearranging our program so we could handle more women and get more women helping other women." The Oakland Center has existed on a budget of only $90,000 a year, a pittance in comparison with other social welfare programs. "We are the most cost-effective program in this state," Milo announces proudly. "We have that old housewife's ability to stretch a buck. There's not one stick of furniture in this place that we paid a dime for." They begged everything in the crowded rooms on the Mills College campus from closing schools, civic organizations, businesses. And they developed a volunteer program to gain unpaid staff members who, in turn, are earning experience they will later be able to market to paying employers.

In developing this prototype center, Milo Smith finds she has changed her values drastically from those of her days as a homemaker. "I've done a complete turnaround," she says. "I lived a narrow, constrained, conservative life and now nothing can shock me. I've been steeped with the pain and problems of these women and there's noth-

ing under the sun that hasn't come through these doors." Her idea of what is important in life is now tremendously different. "Before I was widowed, I was a great scrubwoman. My whole feelings of competency were in what I did in my house—cleaning and cooking and that sort of thing. Now all I can do is keep a step ahead of the Board of Health."

Today, Milo Smith likes herself much better than she did then, despite her added age and her aloneness. "I tell everyone that beneath this aging facade is really an eighteen-year-old girl," she says. "I work twelve hours a day, seven days a week. I'm going all the time and I'm exhausted ninety per cent of the time, but I'm interested and alive and I'm perfectly living the age I am. I have no need to look eighteen anymore."

She advocates for others what she has done for herself—getting on with life, not being defeated, staying frantically active. She's seen too many other displaced homemakers wallow in their loneliness and sink into the welfare system. "That's the end of them, because they're so depressed," she says. "So many women are ill because they feel sorry for themselves.

"I don't have time to feel sorry for myself. I have the worst health habits in the world. You see how I smoke, I've been fat for years and I don't pay any attention to it, I eat erratically—but I have a lot of energy and it has to do with my mind-set. I get up in the morning with my gnarled fingers and my arthritis and say, 'It's great to be half alive,' and get up and go."

Women years younger than Milo would do well to be as "half alive" as she. She's seen and experienced too much to discount the difficult road displaced homemakers

must travel to get where she is now, but she's also living proof that it can be done. The hurdles are found in every phase of life—emotions; self-esteem; social relationships; family relationships; economic survival and career planning; revamping of values; legal problems; maturing in midlife. But they can all be jumped, if with stiffer joints and painful muscles.

There's something Margaret Mead once said that Milo Smith is fond of quoting to the women at the Displaced Homemakers Center: "Anyone, woman or man, who thinks that pain can be avoided inevitably learns that growth, too, has been avoided."

"And the alternative to growth," Milo says, "is living death." With a commitment to growth at any age, the prize is vibrant, useful life, a new beginning, a second chance. That's what Milo Smith and many of the other women in this book chose for themselves. And it's what other displaced homemakers, with their help, can choose as well.

2

One Is a Lonely Number

One thing all displaced homemakers have in common, regardless of their financial status or age, is that, for the first time in years, they are without a man. They are alone. But being alone and being lonely are not the same thing. Being alone can be a freeing and valuable experience if we work to make it one. Being lonely, on the other hand, can become a disease, a debilitating sickness that feeds on itself, pulling us into the depths of self-pity and despair.

Helen let this happen to her. A heavyset, chain-smoking Southerner, she was afraid to be alone, and her resulting loneliness once nearly killed her.

Helen's emotional spiral downward to a suicide attempt began after she left her husband when he failed to support her and their two children. She was living near her in-laws in Arkansas when she decided she'd had it with her wandering, irresponsible spouse. She packed up her kids and decided she was going to make a new life back in her home city of Baltimore if it killed her. And it nearly did.

"I came here with two kids, twenty dollars in my pocket and the clothes on my back," she told me. She had a long, hard struggle ahead of her to achieve the kind of life she dreamed about. When she arrived in Maryland, Helen formed a close relationship with her mother, one that helped give her emotional, if not financial, support. She found she needed it, as over the next few years she would be constantly broke and overburdened with the problems of being a single, working mother. Helen was realistic about the demise of her marriage. She knew her leaving him was not going to change her husband and that, in the end, she would be solely responsible for supporting herself and her youngsters. She took a series of unskilled jobs—housecleaning and waiting tables—and tried to make do the best she could.

But Helen dreamed of a better life. She didn't want to do physical work forever. She wanted a money-making white collar job—and she wanted a man to keep her company. So Helen found a boyfriend she thought she could count on and went on welfare long enough to enroll in a community college and train to become a court reporter. When she was graduated, however, she found she couldn't get a job because she didn't have a car. And she couldn't afford a car without a job. Catch-22. She tried to

get back child support from her husband to finance such a purchase, but even today she says, "I have had my husband through eight courts in eight different states and I have yet to receive one dime from him."

Next, Helen's mother died. Shortly after that, her children, then thirteen and fourteen, decided they wanted to go back to Arkansas and live with their father. "That was the lowest blow I could ever receive," Helen says. "He'd never even supported them." And the capper came two days after her children left home, when her boyfriend announced "he didn't want to see me anymore—after two and a half years."

This time, Helen was really alone, and she no longer wanted to carry the burdens by herself. She hit bottom with a crash. By this time, her feelings of depression and anxiety had lasted for five years, years in which she ate herself up to 210 pounds and several times came close to a nervous breakdown. When her lover left her that day, Helen says, she "emptied a bottle of tranquilizers." But she was lucky. A friend telephoned to chat shortly after she'd taken the pills. "She said I sounded funny and asked if I'd been drinking," Helen recalls. "I said, 'You know better than that. I don't drink.' She asked if I'd taken a tranquilizer and I laughed and said, 'Yeah.'" Helen's friend got her to confess having swallowed the bottleful of pills, drove to Helen's apartment, forced her into the car and headed for a hospital. "We got to the hospital," Helen says, "and by that time I was like a little child, skipping and hopping into the emergency room. They asked me what kind of pills I'd taken, how many, and when. I answered those three questions and fell right over on the floor. It was very touch and go for a while.

They gave me the last rites and they had to pump my stomach and pound my heart to start it a couple times."

Although Helen very much wanted to die when she took those pills, she's come far past that point in the subsequent four years. She's lost weight, is now engaged to be married, has a good job and has begun to like herself. And one of her children has come back home. "The suicide attempt was my bottoming-out point," she says. "It's all been uphill since then." She puts the reasons for her attempt to kill herself only partially down to the unfortunate circumstances of her life, circumstances that would threaten to overwhelm almost anyone. A larger reason, she says, is that "I've always had an inferiority complex, all my life." Helen felt everything that had happened to her was her own fault and, when she could no longer stand the guilt feelings that attitude produced, she sought the ultimate escape. "Now I've got that under control," she says. "I'm very proud of some of the things I've done." Among Helen's accomplishments is helping other displaced homemakers with their depressions and adjustment problems through her job as a counselor in a women's center. She serves as a source of support for these women, much as the friend who saved her life did for her.

And today, Helen's no longer afraid to be alone. She's discovered that, when she's alone, she's in pretty good company.

Divorce, separation and widowhood are all major losses. For a woman like Helen, who's been a housewife most of her adult life, becoming a displaced homemaker means a loss not only of her husband, her marriage, but

of her actual identity. Most lifelong homemakers don't see themselves as individuals. They are Fred's wife, Tommy and Susie's mother, and, without these attachments, they feel like nonentities.

Who is Helen? Unfortunately, it took a suicide attempt and near death to help her find out and then learn to be alone and satisfied with her own company. As she rebuilt her life, Helen learned to appreciate herself as an individual and not just as an appendage of her husband, her children, her mother, her boyfriend. And, predictably, in becoming a self-respecting and self-loving woman, Helen found a man who could appreciate her individuality and was willing to share her life as an equal partner.

The journey to finding out who we are is a painful one at any stage of life and perhaps becomes more so the older we get. We usually think of it as an adolescent project, but many women in our society have stopped growing in adolescence—at the time of their marriage. When the cocoon of the marriage dissolves around them, they find themselves with that unfinished business of discovering their own identity. It is a painful process, but the women I've interviewed who have accepted growth and worked toward independence in midlife have told me it's worth every bruise along the way. "I'll never be that dependent little girl I was again," one told me. "I really like myself now," another said. "I could never say that before, when my husband was putting me down all the time. I even believed all the terrible things he said about me. But I'd never put up with that abuse again." Still another proudly showed me an efficiency apartment she'd rented and decorated herself. "It's sure not the house I had

once," she said, "but this time it's all mine. I did this myself and nobody can take that away from me."

These women, like Helen, struggled to accept the loss of their marriages and went on to establish their own identities as adult women. Luckily, many displaced homemakers are able to make the journey far faster and with fewer tribulations than Helen, but most experience very similar emotional highs and lows.

Mental health experts delineate four steps in moving through a great loss such as divorce or death of a spouse—disbelief; depression; anger; and acceptance. Struggling through each in its turn is absolutely necessary and can result in our becoming emotionally stronger, much as a broken bone heals to be stronger at the site of the break. The danger is in becoming stuck at any of the first three stages.

When a husband asks for a divorce or dies, or we are forced to look at the quality of our lives and make a decision for separation, our first predictable reaction is, "This can't be happening to me." I've talked with women who spent years waiting for their husbands to come to their senses and call off a divorce. They begged, pleaded, cajoled, threatened, all to no avail. Others convinced themselves their $20,000 life insurance policy would support them in the style to which they'd become accustomed forever. Six or eight months later, it was gone, they were broke, and they'd done nothing to prepare for earning their own living. Still others lived on child support for years until their youngest child reached eighteen and it ended abruptly. Then they were surprised to realize there was no more free lunch. This stage of disbelief

is normal if it lasts a month or two, but not if it becomes a lifelong preoccupation.

According to Milo Smith, "The idea that this didn't happen to me, and it isn't going to happen to me, goes on a lot longer with middle-class women (than with the more reality-oriented working-class women). So they keep living in an unrealistic fashion, living in the same life-style they had when they were married, living in great big houses without thinking of changing. Some of them come into the Center and they don't have the tax money for next year. But they're still sitting there not wanting to let go of those houses."

When they were housewives, their physical surroundings symbolized their worth in society, Milo says. "They think once the house is gone, their total status is gone. We've talked to them about sharing their houses—some of them have four bedrooms and are alone—but they don't want to learn to live with other people. I've had women sit across my desk and say they're too afraid someone will scratch their furniture. They're so beset by materialism that they lose sight of the total desperation that's facing them." That desperation includes both financial devastation and abject loneliness for those who refuse to recognize reality.

Milo Smith has had plenty of experience in trying to deal with this lack of reality orientation, this failure to believe the facts that sometimes goes on for years—often until the displaced homemaker is destitute. Many women squander their inheritances, their divorce settlements, their child support, getting their faces lifted, taking cruises peopled mainly by other lonely women, buying new wardrobes they hope will attract another sugar

daddy. But Milo is extremely reality-oriented herself and she doesn't mince words in trying to shock displaced homemakers out of their fantasy worlds. "They have to disengage themselves from that materialism," she warns. "When their lives were contained within the walls of those homes, those material things became precious commodities for them. But I tell them, 'Look, you're only one step behind that poor old thing in the nursing home. And they're only going to allow you one suitcase when you go in. So you might as well open up and enjoy life right now, while you've still got a chance.'"

Milo admits she's "not the sweetest thing in the world when I tell them these things, but I'm a realist. The nursing home is not that far down the line for these women. There are women living there who are younger than some of the women here at the Center—women who have lost every bit of their zest for living and who have gone down in the spiral of abject poverty and isolation and depression." Milo sees her job as helping women accept reality, accept the fact that another man is not going to come along and save them from having to learn self-reliance. "They think the knight in shining armor is going to rescue them, and that they don't really have to go through what we're putting them through. But I remind them that they'd just have to shovel up after the horse."

Many of the women who told me their stories spoke of a sort of "bottoming-out" period, a time when they felt they'd gone as low as they could go, either emotionally or financially or both. For some, it was at this point that they recognized reality, accepted that their life had changed whether or not they liked it, and realized that

they could either go along for the ride or insist on planning the route themselves.

Typical was Betty, a dark, thin forty-four-year-old who was culminating a five-year, $10,000 divorce. Betty had worked outside her home off and on as a teacher and substitute teacher and as a result saw herself as quite an independent woman. The mother of three children, she had been at home since she was pregnant with her youngest, who had been two years old when her husband Don walked out. "It was the third separation for us," she told me. "They seemed to happen every time one of the children was two. It was my husband's decision to separate. I was pretty unhappy, too, but kept thinking we could straighten it out."

But this time was different. Not only was Don not back home asking for a fresh start within a couple weeks, but Betty seemed to have more trouble holding herself together. In truth, she had had some economic independence at times during her marriage, but she was totally dependent on Don for her identity and self-esteem. "I could hold myself together the first six months, when I was trying to see it as just a temporary separation," she said, "but I wouldn't tell anyone I was separated. I just wouldn't acknowledge it, or the fact that it might go into a divorce." Betty's family lived three thousand miles away and she pretended to them that Don was still living at home, that their family was happy and intact; part of her almost believed it.

But eventually reality broke through. "I remember it was on a Mother's Day," she says. "My husband had his own apartment and he had a girl friend. On Mother's

Day, I called his place and she answered. I finally had to face the fact that he had another woman there and she was staying with him. That was my lowest point." Betty slammed down the phone, then called her best friend. "I'd been afraid to cry up to that point, because I felt if I started crying I'd never stop. I'd just dissolve away." But her tears broke through that Mother's Day. "I called my friend and I was just sobbing. She stayed on the phone with me for five hours. In the end, it felt like I'd come through a tunnel. It was like a rebirthing; I really did feel I'd been born again."

Once she had faced the reality of her husband's leaving and the likelihood he wasn't coming back, Betty found the strength to become self-dependent. She went on to the other stages in her journey through grief, her mourning process, and today is both independent and emotionally healthy. She also found the strength to push for what she wanted and needed for herself and her children in her divorce settlement despite Don's jockeying of funds and hiding of assets. The woman Betty is today would not take Don back. She's much too strong to need a man with his manipulatory nature and need to dominate others.

When Betty finally faced reality, she felt relieved, but she was also in for some bouts with depression. It's at this stage in the process of dealing with loss that Helen attempted suicide. Psychiatrists point out that depression involves feelings of worthlessness and self-criticism. When a woman feels depressed, she has a tendency to compare herself with others and find herself inadequate. Betty compared herself with her husband's new, younger

girl friend; Helen, with happily married women, those with high-salaried jobs, anyone slimmer than she. When a woman is depressed, she is afraid to be angry with those around her, so she turns this anger inward, against herself. Helen went to the extreme of trying suicide, the ultimate act of self-hatred.

Midlife is a time when many women experience depression. As their children grow up, they suffer the empty nest syndrome. If they have accepted society's traditional valuing of them as only either sex objects or baby makers, they feel useless as their bodies age. Add to that widowhood or divorce and their depression becomes even heavier. Depression, experts say, causes half to two thirds of all suicides and Nancy Allen of the UCLA Suicidology Department points out that the highest rate of suicide for women is between the ages of fifty and sixty-four. "This age bracket encompasses menopause and some of the mood swings which accompany it," she says. "Many women feel abandoned at this time. They feel the loss of their children and they have difficulty coping without an appropriate support system." So some attempt, or succeed at, suicide. Interestingly, the period of separation is the highest risk period for suicide, Allen says. Evidently, once the divorce is final, the depression begins to lift for many displaced homemakers—perhaps because they have, by this time, found a new support system to replace the one lost when the marriage died.

Some depression is entirely natural and normal in the process of working through grief, but if it is too prolonged, it can be very dangerous. And becoming a displaced homemaker can certainly trigger such a dangerous depression, as Helen's case illustrates. Dr. Frederick

Goodwin, a psychiatrist on the staff of the National Institute of Mental Health and an expert in depression and its treatment, says he sees two recurrent traits among people who become chronically depressed—unrealistic expectations and dependency. And Freud described people prone to bouts of depression as marked by "excess dependency, early childhood deprivation, excessive guilt and a tendency to turn hostility against themselves." In truth, nearly all of these traits are applicable to a majority of American women. We live in a society that fosters dependency and guilt in women, one that teaches us illogically to expect happiness by living through our husbands and children, and one that tells us to turn our anger inward. Among the things that are not socially acceptable for women to show are too much independence and open expression of anger. So we learn to be passive and dependent and to turn our anger against ourselves, where it becomes depression.

Included in the symptoms of serious depression, when they are prolonged or severe, are an increase or decrease in appetite; loss of energy; sleep disturbances; decreased ability to concentrate or remember; loss of interest in usually pleasurable pastimes; self-blame and inappropriate guilt; irritability; recurrent thoughts of death or suicide; and such physical symptoms as headaches, backaches, neck aches, nausea, stomachache, constipation, diarrhea and skin ailments. Some of these problems, of course, may have other origins, but depression must be a prime suspect among displaced homemakers.

Many, many displaced homemakers say they reached the lowest point of their entire life during the depression phase of their reaction to the loss of their marriage. For

some, it meant spending weeks barely able to get out of bed, for others, experiencing crying jags at unpredictable times, and for far too many, a severe depression leading to a suicide attempt. Depression following a major loss can make a woman feel there's no reason to go on living, but most survive that feeling—some despite disastrous circumstances—and come out of their depression to live a newly rewarding life. One such woman I vividly remember is Lucille, who found a strength she never knew she possessed and used it to climb out of a truly tragic situation to a different but very full life. Lucille and her husband, Tom, had two children, a boy, Gary, and a girl, Lori, who was mentally retarded. They weathered the disappointment of Lori's handicap and decided to keep her at home. "I couldn't put her in an institution," Lucille says. "She was my baby, I gave birth to her, and I just couldn't shut her away and forget her." Lori was six years old when she fell into a neighbor's swimming pool and drowned.

"As I look back, that was when the family really started to fall apart," Lucille says, "almost like there was a curse on us." She was consumed with guilt over Lori's death, berating herself with questions and doubts—"Why did I let her wander off?" "If I hadn't been so stubborn about keeping her at home, she might still be alive in the institution." "I felt everybody blamed me and I blamed myself most of all." It took a full year before Lucille could look at Lori's photograph without crying. The family, now numbering three, was almost back to normal—until Gary was sixteen. Lucille and Tom bought him a motor scooter he'd coveted for his birthday, a gift that would allow him to travel to and from school without

depending on the school bus or his mother. The rules covering the use of the scooter were strict; Gary was a conscientious boy and a careful driver. But when Gary was on his way home from school a few months later, a driver ran a red light and hit him broadside. He lived five days.

Lucille's eyes still fill with tears when she talks of her son's wasted life. "He had so much ahead of him . . . I'll still never understand why it had to happen." After Gary died, she and Tom fell apart. After Lori's death, Gary's was simply too much. They blamed each other and they blamed themselves. With a second tragedy to weather, the marriage ran out of steam. "We were too caught up in our own grief to give anything to each other," Lucille now realizes. "I couldn't help Tom and he couldn't help me. We were at each other's throats all the time."

Lucille and Tom decided to separate. Each time they looked at each other, they were reminded of their children; it was too painful. Tom began drinking heavily, he lost his job, he wasn't emerging from his deep depression. He refused therapy and shunned his family and friends. One gray winter morning as he gazed outside at the dirty snow, an empty Bourbon bottle beside him, he shot himself to death.

"I don't know how I made it through that third funeral," Lucille says. "I was in a stupor. I don't think I even knew what was going on around me." But she survived somehow. "My sister was a godsend. She took me home with her after the funeral and put me to bed for a week. She forced me to eat and she talked to me for hours and hours. Most of the time I didn't even hear what she was saying to me, but I knew she was there. I

knew she cared about me and that there was someone left after all." It may have been that little bit of human contact that helped Lucille weather the devastation of her entire family. She had almost nothing left—no husband, no children and no money. Their months of separation and Tom's unemployment had depleted their savings; Lucille's only financial asset now was her house. "I knew there wasn't any farther down I could ever go," she says. "I figured I had three choices—I could go crazy, and I think I was halfway there already; I could kill myself; or I could fight back." Some spark in Lucille's mind wanted to live, and to live in a rational world. "One day, I got out of bed and I just plain got mad," she recalls. "I thought, God damn it, why me? What had I ever done to bring this thing on myself? I cursed fate and I cursed Tom, too. I was furious that he had brought me more grief. It was so damned selfish of him. I started screaming and throwing things and pounding my fists on the wall and crying. My poor sister thought I'd gone beserk, and I suppose I had in a way. But, when I calmed down, I felt a lot better. I knew I was going to survive."

Lucille did survive. She sold her house, moved into an apartment and used the proceeds from the house to buy a small card shop. It was a long, incredibly painful struggle with the aid of a psychiatrist, but she finally has been able to accept the tragedy of her family's short life. "I still feel life has been very unfair to me," she says, "but I know there's nothing I can do about it. It wasn't my fault. And the only thing over which I have any control at all is what I do with the rest of my life. Long ago, I decided that wasting it wouldn't help anybody, least of all me."

Today, seven years later, Lucille's business is doing

well, providing her an income on which she can live comfortably. The photos of Lori, Gary and Tom have been put away in an album. She looks at them occasionally, but she doesn't dwell on her loss. "I have good friends, I have my shop and I have a lot of interests," she says. "I have my health and a clear mind. I travel. Sure, I've had it rougher than most people—but I also have things to be grateful for. My life is pretty damned good these days. And I'm determined to make it better every day."

If a woman with Lucille's history can make the climb out of depression to a full life, nearly any woman can. There are a variety of things that can help a woman work through her depression before it reaches the possibly irreversible extreme of mental illness or an attempt on her own life. Perhaps the most common is one Lucille used, therapy—available either privately or at public mental health centers in most cities throughout the country. The public centers generally provide services on a sliding fee scale depending on income. According to Mary Hirschfeld, who is both an attorney and a therapist in the Los Angeles area and who specializes in divorce counseling, "It has been shown statistically that people who were in counseling, whether it was individual counseling or a short-term group, made the adjustment [to single life] more quickly. One of the things that happens when you are unbonded from a spouse is that you unearth feelings you didn't even realize you could have. We're talking about the bottom dropping out, feelings of hopelessness and despair. People think, 'My God, I've changed. Will I always be like this?' They need some reassurance that it's a normal process that they're going through, that it

doesn't mean they've lost everything. They're not going to be this strange person with these strange responses forever." One way to find this reassurance is through counseling or support groups of others who've weathered similar experiences.

One fifty-five-year-old divorcee, for example, reports finding the support she needed to get through her depression at a divorce therapy workshop. "We met once a week," she said. "There were fifteen of us, men and women, and it grew to be a very sharing and very warm group. We all shared similar feelings. Before the workshop, I was having trouble moving on with my life. But talking with the other people, particularly the men, helped me understand my former husband much better. I had never been able to express my anger at him before. When I reached the point where I could, it was like a weight lifting. For me, that workshop was the most important thing in getting over my pain. I feel great today."

Some very severe depressions respond well to drugs or a combination of drugs and counseling. But such medication must be administered and monitored only by a psychiatrist and for short periods of time. Unfortunately, many women try to self-treat their depression with drugs and/or alcohol, with disastrous results. And many physicians, too, are guilty of passing out powerful mood-altering drugs like candy to women who complain of feeling nervous, depressed, unhappy with their lives. Dr. Joseph Pursch, who heads the Alcohol Rehabilitation Service at the Navy's Long Beach Regional Medical Center in California, says that alcohol and the overuse of tranquilizers represent the nation's number one health problem. "Clas-

sically, today, if a woman walks into her doctor's office and says, 'I'm nervous; my husband drinks too much,' the doctor will automatically give her a tranquilizer."

Milo Smith echoes Dr. Pursch's accusation that pills are given to emotionally overwrought women with much too great a frequency. "We have more Valium junkies than you would believe," she says. "Immediately when these women get into the crisis situation, the first person they go to is their doctor. The doctors indiscriminately look at this Menopause Minnie and out comes the Valium—so we get them in here half goofy. The doctors give it to them and they turn into legalized addicts."

When used with proper supervision and in only necessary cases, medication can do wonders in helping a woman pull through a crisis. The problem is in keeping its use within those boundaries. According to a National Institute of Mental Health study, 70 per cent of all patients receiving mood-altering drugs are women. One has to wonder whether women really have 70 per cent of the depressions, neuroses and psychoses that respond well to medication—or if handing her a prescription isn't just an easy way for a doctor to terminate a visit with a woman who threatens to take too much of his time or whose emotional problems he's ill-equipped to handle. Unfortunately, too, displaced homemakers are even more susceptible to addiction to such drugs than most people because addiction—to drugs, alcohol, overeating, smoking or whatever—serves as a replacement for love. And the death of a marriage—no matter how bad a marriage it was—is seen at some level as a loss of love.

So drugs for depression or other emotional problems related to becoming a displaced homemaker should be used

as a last resort, under expert supervision, and only for short periods of time. As Dr. Pursch, whose patients have included Betty Ford and Billy Carter, says, "None of these drugs solve our problems. They make people feel better because they make them feel dull and insensitive. But they don't solve anything."

One less drastic method of helping to lift lesser depressions is physical exercise. Many woman have told me that they are amazed at how much better they feel when they ride a bicycle for a mile or two a day or even just take a brisk walk around the neighborhood. When they work up to a full program of vigorous exercise, they often find that not only has their depression lifted markedly, but they feel physically better and have more energy as well.

Another hint useful to many is not to live alone. Dr. Paula Clayton, professor of psychiatry at Washington University School of Medicine in St. Louis has done internationally recognized studies on widows and widowers and has found that those widows who recover from their bereavements most quickly are those who live with someone else—possibly a child or a sister. And many divorcees relate the same experience. One woman, a tall, forty-year-old redhead, told me, "My kids got me through those first terrible months after my husband left. I didn't want to get out of bed. Honestly, I think I just would have pulled those covers over my head and stayed there until I starved to death. I felt that low. But I couldn't do that, because my kids needed me. Once I was up and moving, I began to feel better, little by little. I think they may have saved my life." For women who live alone, finding a roommate or renting a room to a college student can help in more than financial ways. Having another

person around can help relieve a depression before it turns severe.

Since depression is basically anger turned inward, the best way of getting rid of it entirely is to recognize it for what it is and then find a socially acceptable way to release the anger. Perhaps that's why exercise works so well for many women—it provides a way to release tension physically without hurting themselves or anyone else.

When we reach this third step in the process of mourning the loss of a marriage—anger—most of the battle is finished. And the emotion of anger is present and appropriate whether a displaced homemaker is a widow or a divorcee.

As Lynn Caine described in her book *Widow*, about her experiences after her husband died, sheer rage is one of the primary emotions one feels when a spouse dies— rage both at fate and at the spouse for leaving. Los Angeles psychologist Dr. Frances Heussenstamm, a widow herself, remembers that emotion well. When she was forty-seven and had been married twenty-seven years, her husband was killed in an automobile accident. "I was in a rage for two years," she recalls. "How *dare* he leave me like that?" She began several new relationships with men during that period, "but I was still so angry that I wasn't able to make a new relationship work. Until I went to a workshop with Elisabeth Kubler-Ross and pounded for five days and five nights, I didn't really get rid of the anger."

Mary Hirschfeld, who is a divorcee, agrees that "anger is obligatory. If you haven't expressed anger, you haven't really finished your marriage or divorce." She began see-

ing the anger of divorcing couples when she worked as a divorce attorney. "I would see this incredible anger running the case," she says, which is terribly destructive. She became involved in counseling her legal clients, found she enjoyed the emotional aspects of the cases more than the legal ones, and went back to school for a master's degree in counseling. Since that time, she's been counseling divorcing and divorced couples. In that capacity, she urges both men and women to get rid of their anger outside the judicial system. "The clear thinking process is what should run your divorce," she says, "and clear thinking and anger don't go together." Hirschfeld recommends "the recognition that you are angry, first of all; then, the recognition that the other person hasn't necessarily been a bad guy. It just looks that way because you're seeing life through an angry filter." Ways of getting out the anger, she says, include "pounding on the bed, yelling in the shower, running. Say, 'I'm angry!' and yell and scream in some place where it's not going to be injurious to yourself or anyone else."

Unfortunately, this is not always easy for women to do, because of our conditioning not to feel—never mind express—anger. Therapy of some kind may be needed for many of us to release these feelings. If it's not released, internalized anger is likely to result in physical symptoms —headaches, hives, rashes, stomach pains, backaches. Women do have a right to be angry at someone other than themselves and they have a right to be furious with fate. We've always been angry, if the truth be known; we've just denied it to ourselves and the world. As with getting rid of depression, many women told me they were helped by joining together with and getting support from

other women who've been through the process. There's something about being told it's all right to be angry, having other women encourage and support that anger, and hearing how these other women dealt with the same feelings, that is invaluable. Other widows and divorcees, too, are more likely to validate our right to be angry than are our still married friends, who often have a vested interest in believing we did something to bring this on ourselves—something they'll be able to avoid in their own lives.

As with the earlier stages, there is a danger of becoming bogged down in anger, however. I talked with several women who seemed to be making careers of being angry and bitter, women who had become hostile, lonely complainers. Mary Hirschfeld points out that an abnormally prolonged anger that never seems to be resolved nearly always dates back to a similar experience in childhood. Susan, for example, was an attractive, petite woman of forty-eight—or she would have been attractive except for the perpetually hard line of her mouth. She never missed an opportunity to berate "that bastard I was married to" and wasted her energy feeling sorry for herself—energy that could have been used in starting a profitable career and establishing new relationships with men. But she seemed to get almost a sense of pleasure over feeding her anger, watching it grow, never missing an opportunity to tell a new acquaintance her tale of woe. Her rage seemed endless. When Susan was a child, I learned, her father had abandoned her mother. "That's exactly the pattern I'm talking about," Hirschfeld said when I told her Susan's story. "Abandonment in childhood really resonates in abandonment in a divorce." As a child, Susan had felt rage over her father's leaving her and her mother, but she

had had no power to deal with the situation or to express her anger. It had remained buried for nearly forty years. When her husband filed for divorce after a marriage that had been a disaster for both of them, Susan's childhood terrors and rages surfaced and were directed at her husband. She again became the helpless little girl, deserted by her daddy. And her continuing refusal to recognize that her anger has become pathological is effectively limiting the rest of her life.

"If anger persists for a terribly long time," Hirschfeld explains, "it generally has a basis that preceded these problems. There are two things going on—the event and how you react to it. If you continue to react to the event even though it's no longer happening, you'd better ask what's really going on with you." One way to find that answer is to ask yourself when you've felt this way in the past, she says. Often we'll find that the emotions are much like the ones we felt during some childhood event—at a time when we were actually helpless to express our feelings or to change anything. Often simply recognizing the meaning of such childhood experiences and realizing that some of the emotions we're feeling properly belong to those events and not the ones at hand will help us overcome being caught in irrational anger.

To help determine which anger is appropriate and how to deal with it, Mary Hirschfeld recommends doing what she calls a "psychological autopsy" of the marriage, particularly in the case of divorce. "It's vital to determine what was going on, what went wrong," she says, so we can move past the fruitless feeling that someone was at fault. "If you feel there was a failure in the relationship, you'll need to blame someone." To oversimplify a bit, the

blame will either be placed on ourselves, resulting in depression, or on our former spouses, resulting in anger. With an honest psychological autopsy, however, it's likely that the marriage can be viewed, not as a failure, but as a system that simply doesn't work anymore. "Then you don't need to blame anyone else and you don't need to feel guilty, either."

One typical reason why marriages no longer work, Hirschfeld says, is that, at the age when most of us marry for the first time, we may not have fully determined who we are or what we want in life and in a marriage partner. "Unconsciously you're modeling all you know, imitating mother or father or the relationship between them. When you enter marriage, the old tapes begin to play and you think, 'That's how husband and wife relate.' It's familiar, but it may not be for you. You may be playing out a pattern that doesn't belong to you, but to your parents. And, after a number of years, you may see that this pattern is not bringing satisfaction to you (or your husband may see it's not bringing it to him) because there's another whole part of you that doesn't fit into the role you've been playing." If we recognize this, a marriage that ends in divorce can be viewed as one where the people involved simply outgrew it. No one need be at fault and there's no reason to continue holding onto inappropriate anger.

Frances Heussenstamm, too, has thoughts about any displaced homemaker who refuses to give up her anger and bitterness: "The function this behavior serves for her is that she gets to stay attached to the man. She stays bitter and holds onto her hate and, as a result, doesn't let go of her man. At the same time, though, she's not available to another man and she may be missing an opportu-

nity to start a new relationship. It could be a much better relationship than the one she had, because it would come to her in a more awakened state of mind." Dr. Heussenstamm also expresses concern that such a woman will suffer a variety of psychologically caused physical symptoms, and that she has a high likelihood of becoming addicted to drugs, alcohol, food or tobacco as a substitute for the love she refuses to let into her life. "As long as she stays bitter, no man is going to approach her and she's not going to have the second half of her life. I predict a sort of steady downhill path as she becomes a hostile shrew."

Surely no woman really wishes to live the rest of her life as "a hostile shrew." After all, such a stance harms no one but her. The former husband simply feels more and more justified in his decision to leave her. Friends and family desert her. And it hardly feels good to be unhappy all the time. Anger is a healthy emotion and one that is appropriate when one becomes a displaced homemaker—but only in logical amounts. Like the stages of disbelief and depression, anger should be passed through with all reasonable speed. It should not become a life's work.

The experts I spoke with estimated that a normal recovery time—from the point of separation to final acceptance of being alone—takes from six months to two years. The displaced homemakers I interviewed confirmed those estimates, though some felt full recovery to a point of learning to love themselves and being satisfied with their new life-styles took somewhat longer. There seemed to be a major difference in the time spent in recovery based on how much control the woman felt she had over her situation and how expected the end of the marriage was. With

displaced homemakers who chose to leave their husbands, the recovery time seemed shortest, although one told me, "I went through years of depression and anger before I ever got the courage to leave him. Now I still get angry when I see him sitting there in that big house with two cars, a boat and his own airplane and I'm trying to put three kids through college on $948 a month. But I'm much better off without him." Terribly dependent homemakers whose husbands walked out on them generally spent a longer time floundering after the split. Even when they knew their marriages had been getting increasingly untenable for years, they expressed surprise when their husbands actually left. Women like Susan were the extreme. Subconsciously, she felt that her father had deserted her in childhood because she wasn't a "good enough" little girl to hold him. So she remained emotionally a little girl in her marriage, trying to hold onto her husband through her extreme dependence. When it didn't work, Susan felt history was repeating itself. And she was called upon to do an incredible amount of maturing before she could become self-sufficient. She still hasn't made it. Widows, as opposed to divorcees, were more likely to experience true shock at the abrupt end of their marriages. Dr. Heussenstamm remembers that this was her first emotion when her own husband died. A divorcee can claim to be shocked that her husband would walk out on her, but "she's really exhibiting a defense mechanism called denial. She's been denying what he's been telling her or showing her for years," Dr. Heussenstamm says. A part of her mind has been prepared for the inevitable break and, at some level, there is a feeling of relief that the suspense is over when the break finally

comes. With the death of a husband, however, often the wife has had no prior mental preparation at all.

All these circumstantial factors, coupled with our individual personalities, combine to determine how long we can expect our unique journey from separation to acceptance of our aloneness to take.

Accepting that we are alone, however, does not mean reconciliation to loneliness. With positive attitudes, we can come to cherish being alone and the inherent freedom it entails, along with the right to choose when we wish to be with others. Being alone can be far better, many displaced homemakers have told me, than the terrible loneliness of a bad marriage. And, for women who moved from their parents' home to their husband's, it can provide the first time in their lives that they've been free to do what they wanted to do when they wanted to do it.

Dorothy comes to mind when I think of a displaced homemaker who survived a harrowing divorce and bitter degredation to appreciate fully being alone. She had been married thirty-four years to an officer in the merchant marine who, right before one Christmas, called "one of our sons and told him he was going to divorce me." Dorothy thought it was a joke at first, but she soon learned he was deadly serious. "When I think about it, our marriage probably had twenty-five good years," she says today, but then adds, "I guess a lot of that really wasn't good either, when you stop and analyze it. The signs were all there. I just didn't read them too well . . . and I really didn't want to know." Because her husband had been away at sea for several months out of each year, Dorothy was used to making her own decisions, doing her own home repairs and attending social events by her-

self. But she had been entirely dependent on her husband for income. "Financially, it was horrendous," she says of the split. "I was used to a good allotment and I went from that to zero." Her husband divorced her in Texas, even though they'd been living in Florida. "His ship came in and out of Texas, so he just established residence in Texas. He knew exactly what he was doing." Dorothy was awarded no alimony, no cash settlement, nothing. She was fifty-six years old and unemployed.

The most difficult part of the change, Dorothy says, was being left so abruptly without either income or health insurance. She has "a rotten health history. I have a heart defect and I had cancer at one time. The first thing that happened to me after I was divorced was that I fell off my son's bike and cracked my hip. I couldn't even pay the hospital bill. The people at the hospital kept saying to me, 'You've been here before and you had coverage then. Are you sure your husband divorced you and you don't have insurance?' They acted like I was crazy." That hospital stay taxed all of Dorothy's survival powers. "That was the lowest part of my life," she says. "I've gone through some rotten things in my life—I had a daughter who had a heart operation when she was little, my kids have had rheumatic fever, I had a cancer operation, some really grim things. I could weather all of those but, when I was in traction in the hospital and I couldn't walk and I had no money and no insurance, there wasn't much lower I could go."

Those days in the hospital, though, gave Dorothy time to think about her life and where she would take it. She figured there were two choices—she could give up or she could fight for survival. She found out she was a fighter.

"By the time I was out of the hospital and learned to walk again, I knew I had to do it myself," she says. She couldn't lean on her children any longer and her husband had neither any intention nor any legal obligation to support her. "I knew I had to leave Florida," she says. "Jobs are low-paying there and I didn't think I could continue under my changed circumstances in a place where I'd lived with my husband for the past seventeen years." So she headed North "with two suitcases, a dollar in my pocket, a carton of cigarettes and a plane ticket purchased by my daughter."

In the subsequent three years, Dorothy has found a part-time job helping other women set up their own small businesses. Her income is only about $5,000 a year, but she's earning it herself and she's deservedly proud of her accomplishments. She likes being self-supporting and has learned to appreciate single life. "If I ever thought about getting married again," she says, "it would be for the emotional part, not the money. I love what I'm doing. I like going to work. I think it's great. I earn my own money and I can do what I like with it . . . and with my life. My only responsibility now is to me.

"I also feel I don't need a man in my life all the time to be a complete woman. I like myself and the new things I'm exploring. I like the fact that my children say to me, 'We haven't seen you for a while. When are you going to come and visit?' and I say, 'I'm really too busy, but I'll try to fit it in.' My life is very full and I really don't want to get married again."

Loneliness is not a problem, Dorothy says. She keeps her hours crowded, she has good friends, many of whom are men, and she carries a book to keep her company at

all times. Her one continuing regret is that she hasn't a higher income, but the value of the money she's earned herself is infinitely higher to her than that of the money her husband once earned for her. After emerging from a mire of misfortune, Dorothy at fifty-nine is savoring the freedom of finally living her own life her own way.

Joanna is another displaced homemaker who has learned to value her freedom. The end of Joanna's marriage was a mutual decision between her and her husband. Divorced when she was in her early fifties, Joanna looked upon living alone as an adventure—one that was frightening, but exciting, too. "I had a couple recurrent dreams in those early years [following her divorce]. One was that I was driving the wrong way on a one-way street. And the other was that I was shopping at a market where there were names on every parking slot. One day I went back and all the names were gone; nobody cared where I parked." In the first dream, she says, she felt frightened and worried about her failure to conform to society's rules. In the dream, she was breaking the driving laws; in her life, she was breaking society's rule that said she should stayed married. The second dream, about the parking lot, "to me was a realization that we are all condemned to freedom. For women, it's so true that we define ourselves by others' expectations of us. When those expectations—in my dream the names on the parking slots—are removed so nobody really cares, nobody's depending on us, we really feel terror. It's like being in a free fall."

But a free fall is also very exciting. Part of Joanna was terrified of freedom, part exhilarated, and part intel-

lectually "interested to see what I would put into my life" when the choice was hers alone. The divorce marked the first time in Joanna's life that she'd ever lived alone—she'd married at eighteen—but not her first taste of loneliness. The final days of her marriage had been extremely lonely for her as she and her husband grew farther and farther apart, neither meeting the other's needs. She felt being alone could hardly be worse. So she moved from her affluent suburb to a city apartment, far from her former friends who were still married and living a well-defined suburban life-style. Joanna was determined to make a new life for herself. "I knew that my loneliness at that time was something I had chosen," she says. "And I knew the things I would choose to do and the people I would choose to see would be extremely significant to me," not just the empty time-fillers with which her previous life had been crowded.

Today, Joanna is satisfied with a life that she has created from her own desires. She no longer lives through her husband and children, although she sees all of them on occasion. And she has had several "significant relationships" with men, at least one of whom wants to marry her, but she's not willing to give up her freedom just yet. "Now I know what I want and I'm not willing to put up with anything I don't want," she says, thinking of the compromises marriage requires. And she knows now that marriage would not mean security for her. "There's an assumption that being married is a secure position and it's hard to get into focus how crazy that is. You can't see it all if you're married but, the minute you're not, you can see that all those things were just creations in your head. Marriage isn't secure anymore than anything else is

secure. As soon as you're not married, you realize you've always been in a tenuous situation and you just didn't know it." Marriage, Joanna has learned, is not even a guarantee against loneliness.

Many women like Dorothy and Joanna have learned to be alone and have found that they like their lives better that way. But that level of satisfaction is achieved only after the exciting and sometimes painful process of finding out who they are. One widow, whose children had just moved out, leaving her alone for the first time in her life, told me, "I love being able to make dinner at midnight if I want to, or going away for the weekend on the spur of the moment. The only one I have to please now is me. But," she added, "I don't have the kids around to distract me from me anymore either. Now there's no one here to keep me from finding out what I'm really like. I just hope I like what I find."

These courageous women were willing to risk finding out. They decided that, rather than frantically trying to find another relationship through which to define themselves, they would get to know who they really were. They would use their displacement from homemaking as an opportunity to seek full adulthood.

3

"I Don't Like Me. Why Should You?"

She was like many women who have come to the Oakland Displaced Homemakers Center in the past few years. After a thirty-four-year marriage, she was being divorced—her husband had left her for his secretary—and she felt worthless. Alone, she was nothing. She was frightened and depressed, and she had attempted suicide three times. "She came in here and I never saw her face the whole time we were talking," Milo Smith remembers. "She kept her hand over her mouth and her eyes on my desk and she sat here saying, 'I don't know how to do

anything.'" This woman was suffering from an extreme form of what seems to me the core problem of displaced homemakers—a crucial lack of self-esteem. And often this dislike of one's self is as real a problem for women of great accomplishment as it is for those whose eyes seldom leave the television screen during their married lives. "While we were talking," Milo went on, "she told me how she'd bought old houses, learned to fix them up herself and sold them to make money. Each time, she'd moved her family herself . . . and she had four children. She'd done her husband's research and typed all his papers as he pursued his doctorate and got a high professional position. But this was a woman who felt she had no value and could do nothing. I said to her, 'I like all those things you say you can't do; come here and do them with us.'" She did, becoming the Center's first office manager. Her first job there was to procure enough furniture to furnish the Center's offices—without spending any money. Using her housewife's ability to stretch a buck, she did it. Today, this woman has learned that she does have worth. She has redefined her value as a person, and it no longer depends on being her ex-husband's wife.

When a woman defines herself through her connection to others, she feels less important than they. Her own abilities are left untested and her personal goals unrealized. Betty Friedan described this process of ego-deterioration among housewives in *The Feminine Mystique:* ". . . no matter how often she tries to tell herself that this giving up of personal identity is a necessary sacrifice for her children and husband, it serves no real purpose. So the aggressive energy she should be using in the real world becomes instead the terrible anger that she dares

not turn against her husband, is ashamed of turning against her children, and finally turns against herself, until she feels she does not exist."

If the housewife eventually feels she does not exist as a person, what happens to her when her children leave the nest and her husband deserts her through death or divorce? Obviously, her reason for being, her whole identity, goes with them. And, if she doesn't think she's worth anything, how is she going to convince a potential employer, friend or lover that she is? She's caught in a completely no-win situation.

Counselor Mary Hirschfeld says that everyone, when a marriage dissolves, experiences a feeling of helplessness. For homemakers, this is often stronger than for anyone else. "There's a feeling that, 'Without him, I'm nothing,'" she says. It won't last forever, but "for the first few months after the separation, it really feels like, if he's gone, she'll have, and be, nothing." Traditionally, she says, we have been taught that a man's life is his career, a woman's her relationship. "She is defined by her man and her marriage, he by what he does for a living." So, if her marriage is no longer, it's entirely understandable that she would feel she, too, no longer exists—or has any right to exist.

These feelings of low self-esteem, however, can be overcome. I've talked with women who endured incredible degradation from their husbands—beatings, rapes, vicious verbal attacks—because at some level they felt they deserved such punishment. And today, months or years down the road, they have learned to feel good about themselves. They grown to the point where never again would they allow themselves to be abused in that way.

They've learned that to command respect and love from others, they must first respect and love themselves.

Julia comes to mind, a woman who hung on for thirty-five years to a marriage that had begun to fall apart in its third year. Now in her late fifties, she is an extremely soft-spoken woman with a gentle demeanor—a true southern belle. But what she says today has bite. She has progressed a great distance in the past year—from a point where her self-esteem was almost nonexistent to a place where she says, "I've come out of it and I'm proud of myself. I've come over a lot of humps and I'm going to make it."

Before her husband walked out for the fourth and final time, Julia had accepted his insultingly negative attitude toward her as justified. He'd been unfaithful to her for years and had left her for another woman as far back as when she was pregnant with her first child. "As I look back over all those years," she says, "I don't think the man ever really loved me. He just . . . maybe he just wanted his freedom. I don't know." But, during those years, she allowed this man who didn't love her to define her self-worth. And the results were close to disastrous. For the last ten years of her marriage, she stopped taking care of herself, even to the point of not going to a doctor or dentist. "I hadn't bothered, I thought so little of myself. I was just a thing running around taking care of the house. The house was my security." And she began to be afraid to leave that security. "I wouldn't drive a car. I got so I was even afraid to go to the supermarket. I had no confidence in myself. Once I left that house, I became extremely nervous. If I did go to the market, I'd have to

"I Don't Like Me. Why Should You?"

walk around the house and talk myself into it before I could go out. Some people call it agoraphobia."

In some respects, Julia's husband's departure may have saved her sanity. "When he left," she says, "all of a sudden the realization came that I was alone. Of course, at first I couldn't sleep at night. I walked the floors and cried. I didn't know what was going to happen to me. Then I began to realize that I'm the only one who's going to take care of me. So I began making appointments at the doctor. I began going to the dentist. I began taking care of myself. And I began to drive. Then I noticed I wasn't nervous about it, because it was just me [that I had to please]. I wasn't depending on him any longer. I realized that he wasn't going to take care of me—he didn't care whether I was alive or dead—so I began to care about myself."

Julia still has many financial problems and her divorce is not yet final. She has had to leave her house because she can no longer afford the mortgage payments. She worries about getting a fair financial settlement and spousal support. At the age of fifty-six, she started her first paid job, a temporary CETA position. She still feels unrooted, but she's now making progress toward a full life of her own. Her regrets mainly revolve around having allowed herself to be so thoroughly dominated by a man who didn't really care for her. "I don't feel the thirty-five years were totally wasted, because I have three marvelous children. That, to me, is worth the thirty-five years. But it wasn't worth putting up with the things I did. And I reacted to those things very emotionally and very badly. It makes me feel very wasted, in a way. I loved him very much. I don't think I would have stuck it out if I hadn't,

but I think he lost respect for me and I lost respect for myself by hanging on the way I did. I don't think I should have done it, but I was just too afraid to be out on my own."

In her mind, Julia had mixed up love for her husband with her fear of life without him. Perhaps both figured in her decision to cling to him for years after whatever positive relationship they had once had was dead. And the major victim of her fearful clinging was herself—her self-esteem. By the time they separated, Julia felt worthless, not even entitled to medical care, and afraid to venture beyond the walls of her home. But, just a year later, a step at a time, she is truly learning to esteem herself.

Unfortunately, a major message of the feminine mystique to which so many women have subscribed in the past few decades is the idea that women, unlike men, have no real need for self-esteem. Among the needs of human beings are those of survival that we share with animals—food, shelter, sex, physical safety. What distinguishes men from animals, however, are our higher needs —for knowledge and self-realization. But, Betty Friedan pointed out in 1963, "In our culture, the development of women has been blocked at the physiological level with, in many cases, no need recognized higher than the need for love or sexual satisfaction. Even the need for self-respect, for self-esteem and the esteem of others . . . is not clearly recognized for women." Women do, however, need a strong self-image just as men do. We cannot find happiness in defining ourselves by others' accomplishments. And, Friedan says, self-esteem "can only be based on a real capacity, competence, and achievement;

on deserved respect from others rather than unwarranted adulation. Despite the glorification of 'Occupation: housewife,' if that occupation does not demand, or permit, realization of woman's full abilities, it cannot provide adequate self-esteem, much less pave the way to a higher level of self-realization."

It is certainly true that, as we grow up, females are taught that it's not really important for them to achieve anything by themselves—beyond finding the right man to marry and providing him and their children with selfless support. We are supposed to feel good about ourselves by subjugating ourselves to our families—by definition, an impossible feat. I do think, however, that there are times in most of our lives when our egos have been strengthened by our own accomplishments. In our girlhoods, many of us had strong self-images and ambitions beyond marriage and motherhood—all of which we promptly buried when we recited our wedding vows. Then many of us, myself included, spent our subsequent years feeling guilty when marriage, by itself, could not make us happy. In truth, we placed far too great a burden on matrimony; it could never measure up to our expectations. And, because marriage alone is not enough to fulfill us, we feel inadequate. Surely, if there were not something terribly wrong with us, we'd be satisfied with our obviously rewarding lives, wouldn't we? The more unhappy we become with burying our personal identities and ambitions, the more inadequate we feel . . . and the more we begin to dislike ourselves. And the more deflated our egos become, the harder it is to do anything constructive to change our lives.

Executive wives are a prime example of this phenome-

non. Washington state psychotherapist Maryanne Vandervelde, who has studied corporate wives, says that they comprise a significant portion of this country's psychiatric patients, being particularly plagued with feelings of worthlessness, depression, and drug and alcohol addiction. A major reason for this seems to be the conflict between their enforced submissiveness and dependency on one hand and their own personal needs on the other. Vandervelde recently surveyed corporate executive officers of *Fortune* 500 companies and their wives, asking them to rank twenty-two personality characteristics according to their level of desirability in corporate wives. Ranked at the top by the respondents were adaptability, unselfishness and ability to entertain well. Independence was ranked near the bottom and dead last was a wife's concern about her own identity.

Vandervelde, herself an executive wife, says this group of women have particular trouble gaining sympathy for their problems from outsiders, because others tend to say, "Why are you bellyaching? You have everything." And, indeed, in terms of material possessions, they often do have everything—expensive homes, a high family income, costly clothes, vacations in exotic places. But "affluence doesn't make it easier if it comes at the price of personhood," Vandervelde says. And, ironically, the executive wife is often far more terrified of doing the wrong thing—anything that could cost her her marriage—than are other, less affluent wives. After all, she has so much more to lose. Her greatest fear, Vandervelde says, is that, if she rocks the boat by asserting her independence, she'll lose the marriage. So she buries her ego and, year by year, despises her "sell-out" position—and herself—more

and more. Vandervelde encourages her own executive wife clients to become more independent regardless of the possible risk to their marriages, telling them something that displaced homemakers have learned the hard way: "Every wife should know she is one second from being alone anyway. A sudden heart attack could make her a widow tomorrow. A relationship with another woman or simply a dissatisfied, re-evaluating husband could make her a divorcee overnight." And, with society's changing mores, a divorce no longer is the kiss of death for an executive's career. His life's rules have changed. But, unfortunately, Vandervelde's work has shown, the rules of the executive wife's life have not. As a result, she is left poorly prepared for life on her own if she is widowed or divorced. And the part of her that needs the most attention when that happens is what Vandervelde calls her "personhood."

It seems clear that women have been sold a lie, one that costs them their self-esteem, but I often have seen a sense of self-love that's been buried since adolescence re-emerge after a marriage ends. Once displaced homemakers move beyond their initial grief reaction, many begin to rediscover the girls they were in their teens—at the time their growth process was cut off by marriage and conformity. When I was a teen-ager, I remember, I had a great passion for creative things—the theater, acting, playwriting, literature, dramatic journalism. But when I married, I put away my dreams of accomplishment in that milieu because I had been taught they were "childish." The true calling of any "mature woman" was to be a wife and mother; submitting to my true destiny would provide me real fulfillment. When I divorced,

however, I found those old dreams resurfacing. I began again to attend plays and movies. I wrote two novels and collaborated on a play and a screenplay. I turned my nonfiction writing skills away from commercial work to a more creative bent. In many ways, I picked up again where I'd left off at nineteen. And many other women have related the same experience.

For some, it's not so much a process of rediscovering long-buried career goals as it is finding again a feeling of worth as an individual, a feeling of accomplishment. That's how Rachel felt after she ended a twenty-one-year marriage she'd entered at eighteen. During those twenty-one years, she had descended from a high school leader to a woman who escaped her marriage with little more than the remnants of her sanity. After a history of physical and verbal abuse at the hands of her extremely authoritarian husband, she left her home and her three children behind.

"This was the second time I'd left him," she told me. "Four years earlier, I took my kids and stayed away three months. I was terrified. I worked at a very low-paying job. I had no money. My mother was dying at the time. And my older son had problems. I just didn't think I was going to make it on my own. So I panicked and went home, but right away I knew it was a mistake to go back." So Rachel, a classically pretty brunette, began preparing for a second departure. It took her four years. "I kept thinking, if I could just hold on a little longer, my children would get older. I also knew that, if I left a second time, I'd have to leave them behind. They weren't being mistreated and that way they could be with their

friends and stay in the same schools, so it wouldn't be disrupting their lives so much. I knew my husband would never leave the house under any conditions. I was the one who would have to do the leaving."

Rachel's husband, she says, "had to have control over everything and everybody. For seventeen years, I had been very passive. I would give in, make peace—until there came a time when I had to take a stand on certain issues, big issues. And that was the beginning of the end of our marriage, because he could not cope with that. As long as I was a doormat, things were fine but, as soon as I started standing up for what I believed in, that was it." He started becoming physically abusive, a situation which spurred her first flight with the children. She says the evidence of her beatings was never strong enough for her to trust police intervention. She had bruises, but no broken bones or cuts. "I was and still am afraid of him," she says. But she was more afraid of being alone and poverty-stricken with three children. So she returned after her three-month hiatus. "When I came back, there were threats of more physical abuse. I was trying to decide what in God's name I was going to do. I hoped it wouldn't happen again and I was very careful so there wasn't any antagonism. It's a tightrope I walked on." Rachel's marriage was sick in many ways. She and her husband stopped sleeping together several months before she left for the second time. "If I tried to get into the bed," she says, "I was literally kicked out, physically kicked out. Now, where do you take this into court? What do you prove? There are no witnesses. There were times I thought I should fight, should cry out, let the kids

be aware of this. But I fought back that urge. I don't want my kids to know. To this day, I haven't told them, because I don't know how it will affect them."

While her marriage deteriorated further, Rachel saw her self-esteem shrivel. "It's incredible what I allowed myself to become," she says now. "At the time, I saw being a doormat as being the perfect wife and mother. I also recognize that my mother lived exactly the same kind of life. She was unhappy and never did anything about it. One day I woke up and said to myself, 'You are not going to go the rest of your life like your mother did.' That, I think, got me on the way to making a decision to leave the second time."

Rachel found moral support almost nowhere. She went to her father and told him she'd been abused. He told her to stay home and put up with it. "My so-called friends from over twenty-one years of marriage disappeared and only one couple remained supporting me," she says. "I didn't really have any women friends of my own, only as a couple, because I went right from high school into this marriage. Marriage, motherhood, mutual friends, togetherness, that was my life."

The final indignity was when Rachel's husband forcibly raped her. "It's something nobody talks about," she says with understandable bitterness. "It was a horrifying experience and what could I do? Nothing. It's legal." Her state is not one in which spousal rape has been outlawed. "This was something that made me think, 'I've got to get out of here no matter what the consequences. I'm ill.'" So she packed her bags again and left her children, her house and twenty-one years' accumulation of material possessions behind her. And, legally in her state, she's

guilty of desertion, so "there's been no alimony, nothing. I sold my one piece of jewelry, my diamond engagement ring. And my mother left me some jewelry when she died, so I sold that, too. And I took whatever wedding gifts that were salable—like my sterling silver—and sold them, and that got me through."

Once on her own, Rachel began to rediscover the person she once had been. "In high school, I was president of my class for four years. I had been a leader and I'd accomplished a lot. I'd been geared toward college, but I thought it didn't matter because, if you met a man and he was a professional, you could just marry him. You didn't need a college education. But at least I had some history of accomplishment to fall back on."

Little by little, she has rebuilt her battered self-image. Her first problem, of course, was economic. She took a department store sales job, which she hated. She did this for a year and a half—solely because it was work she could get. And she tried various inexpensive living arrangements—sharing an apartment with another woman, then living in an efficiency apartment by herself. When one of her sons came to live with her, she found a larger apartment in a different section of town. Then she quit her selling job to work part time in a job with professional potential. It's a gamble. Because of her limited hours, she has seen her income shrink again, but she's willing to take the risk for a profession with a future. She's moving toward being a leader again.

"It's as though, across the span of the years," Rachel says, "I took the hand of the girl I was then and reached out and grabbed her. That other period of my life—my marriage—it's almost as though it happened to someone

else. I am the girl-woman of then now. I just feel terrific about it all."

Before any woman's self-esteem can really be raised significantly, she needs some personal achievements to list on her mental scorecard. And accomplishing something means taking a risk, changing things. This may sound easy, but for women who have stayed in the protective atmosphere of their homes for years, it can be terrifyingly difficult. Julia, for example, got to the point where she was afraid to risk leaving her house. And Rachel wanted the security of her marriage so badly that being beaten, raped and verbally abused was, for a time, better than the risk of being alone.

The problem with being dependent on others, of course—whether it's for identity or financial support or anything else—is that the prospect of losing that protection is so terrifying one hesitates to risk changing anything. Because so many long-term housewives are afraid of losing the security they have in their homes, they don't want to threaten it in any way and, for many, that means never taking any risks, always taking the sure route, following their husbands' and children's desires and directions at the expense of their own. Some women feel this is a small price to pay for security; they feel they really have nothing to lose through such passivity. But they do. They lose their self-love, because the less anyone accomplishes on her own, the less she likes and respects herself. And the less she likes herself, the less she believes she has the ability to succeed at anything new, so she becomes even less likely to try. This vicious circle ends with the woman afraid to make any move by herself, in a frighten-

ing state of inertia, and, at the same time, disliking herself for her childish dependence and fear.

One answer to raising self-esteem seems to be to relearn how to take risks. We all did it as children. Rachel ran for class office—and won—four times. She put herself on the line then. But fifteen years later, she was afraid to risk stating her opinion for fear of raising her husband's masculine ire. Julia, as a young woman, had traveled throughout the world. But as a middle-aged wife, she was afraid to drive to the supermarket. Risk taking is not something foreign to women. We've all done it at some time. We simply need to dredge up those skills, start slowly, and begin taking small risks again. With each one, we will feel stronger, more able to take on the next challenge. And, even if not all the chances we take work out, at least we will feel better about ourselves. We will know, once and for all, that we have courage. How much better to be able to say, "At least I tried; next time I'll make it," than to have to admit we prefer the misery at hand to the unknown.

I think another major roadblock for many of us is that we have learned to define our worth by others' opinions of us, and we have far too great a need for approval. We grew up under a what-will-the-neighbors-think set of rules and most of us have never quite thrown off that mentality and replaced it with a mature respect for our own values and opinions. We have lived our lives trying to please others and make them happy, which means trying to live up to *their* images of us, not our own. It started with our parents and progressed to our husbands and children, with a good dose of neighbors and friends thrown in. This is a pervasive, hard-to-fight problem.

Many displaced homemakers told me they could beat it only by moving away from their old friends and neighbors. They couldn't live their new lives in their old environments. That's one solution. I think another is simply to realize that, no matter what we do, somebody is going to be displeased with us. In the end, does it really matter which people we pick to be unhappy with what we do? A pretty blond matron I met in a college class told me, for example, "It's really hard for me to start school over again. In the neighborhood where I live, the other wives spend their time playing tennis and watching soap operas and some of them have been pretty hostile to me." She was going against the norm of her social group, trying something new. And the other women resented her example. But she decided her goal of a degree before she turned forty was more important than the opinions of people who wanted to keep her down to their level. In the process of taking the risk of going to school, she found her feeling of self-worth grew remarkably. And she made new, more supportive friends, too.

A key element for this woman, of course, was that she had a clear goal. She had examined her life and decided on a destination and a time frame for accomplishing it. For many long-term homemakers, however, they've had so little control over their lives for so many years that they have seen no point in setting personal goals. I know military wives, for example, who have been unable to achieve anything on their own because their husbands are always being transferred. "I had a job once," one told me. "It lasted three weeks before we got our orders again. After that, I figured, 'Why bother?'" Others are so dependent on their families' needs that their usual practice

is to wait for their husbands and children to define their goals and then follow along behind. Learning to set goals, we can see, is another priority on the way to achieving full humanity.

Maureen, a chunky but energetic displaced homemaker who has become a successful real estate saleswoman, told me about an excellent exercise in goal setting that she learned in a women's support group: "We were told to imagine ourselves as we would ideally like to be—looks, occupation, relationships. For a long time, I was even afraid to fantasize; everything seemed so far out of reach. But, after I forced myself to do it, I began to like what I imagined. In my ideal life, I chose to have a good job, to be able to afford a nice house and nice things around me. I wanted to have the body I had at eighteen again. And I wanted my hair to be the nice auburn shade it once was, not graying brown. I wanted to have a love affair with a wonderful man—maybe not a marriage, because that seemed too much like jumping back into the fire, but a warm, loving partnership of some kind. And I wanted to get to know my kids better and to become a friend to them." Maureen eliminated from her list her unrealistic desires—having the body of an eighteen-year-old, for example. And she refined other goals—she went to the beauty shop and had her hair tinted a flattering compromise color that covered her gray. Then she set out to achieve the possible. She chose an occupational field—residential real estate sales—where she could make a good income if she worked hard and one where her enthusiastic personality would be an asset. She has worked very hard to be successful. She has bought a town house, which is more practical for her than a house would be,

and she's furnishing it with good pieces as her income permits. She has made a concerted effort to re-establish ties with her adult children, something which is just beginning to pay off. And she has met several men. She has no permanent relationship with any of them yet, but is presently finding a great deal of satisfaction in a variety of friendships. "Now I look back to where I was four years ago, when my husband and I split up, and I can hardly believe I'm the same person," she says with pride. "My only regret is that I didn't do all this a hell of a lot sooner."

If we truly want to change our lives through relearning how to take risks and pursue goals, it's essential that we not stack the deck against ourselves by subconsciously expecting to fail. We must believe we can win, that we deserve to win, before we can become winners. And there are a variety of psychological techniques we can use to boost our self-images and learn to think of ourselves as worthy, according to mental health experts.

"Self-esteem, or the lack of it, is not a given quantity you're born with and stuck with the rest of your life," says counselor Mary Hirschfeld. "It can be raised and it's important to know that you can really esteem yourself. If you start with that premise, you can look back and see what in your life has worked for you to raise your self-esteem. More often than not you'll find it's an achievement —whether it be making a new friend or developing a new skill or overcoming a problem with your child. Start to go along that same track because what's worked for you before is going to work for you again."

That technique worked well for me. The times I re-

called feeling best about myself were when I saw an article I'd written in print, each time I got a good grade in school, and when I'd had the lead role in the play *Anastasia* in high school. So I took those events and modified them for my life in my early thirties. I began to free-lance articles, determined to see them in print. I went back to school to work on a master's degree, and found my grades were better than they had been when I was an undergraduate. Now, it seemed, I had much more reason to be dedicated to my studies. And I renewed my affection for the theater, establishing a still unrealized goal of having a play I've written professionally produced.

These efforts, I found, began to pay off, little by little. Each time I saw my by-line in print, my self-esteem rose another notch—even if my name was on an article for which I'd been paid only a few dollars. And each test or paper that drew an "A" grade from a professor had the same effect. I still had what it takes, I began to think; I wasn't a loser after all.

Hirschfeld points out that it's vitally important to break large goals into smaller, achievable ones. In my own case, my first publishing goal as a free-lancer was simply to have my work published anywhere that would pay me. If I'd started with the goal of selling a book to a major publisher or an article to the *New Yorker* on my first try, I would have set myself up for failure. "Break your goals into really small steps," Hirschfeld advises. "For example, say, 'This week I will make one phone call a day to a strange new place to gather job information.' Determine to make that one phone call a day, even if you do nothing more and spend the rest of the day back in bed feeling depressed." Sooner or later, a phone call will

pay off, or the goal will grow to two phone calls, then to a job interview, and ultimately a job interview will result in employment. By baby steps, we can accomplish a goal on our own and, when it's accomplished, our self-image will take on a definite shine.

A second step Hirschfeld recommends for shoring up our egos is to redefine failure. "If you want to go from Los Angeles to New York and you find yourself in Podunk on a dead-end street," she says, "you're not going to say you failed. New York is still there and the roads are still there. You just haven't found the correct route yet. It's no different if you make that phone call and reach a dead end. Say to yourself, 'Okay, I found another way not to get to my goal,' not, 'I've failed.' Every day, you move a little bit closer to your goal." This is particularly important because, if we feel we are repeatedly failing, most of us will simply stop trying. And, if that happens, our efforts will simply have cemented an image of ourselves as failures instead of helping build a new, healthier self-respect.

Hirschfeld's third suggestion is particularly helpful for women like Julia and Rachel who have allowed an abusive husband to berate them for years. They felt that, if a man who purported to love them held them in such low regard, they must deserve it, and they incorporated that abuse into their self-images. "Women who've been told how rotten they are and who have allowed it don't know how to keep out of their lives that which is abusive," Hirschfeld points out. "I don't have to allow you to be abusive to me. I don't need to allow you to talk to me in an angry tone of voice. I am permitted to say, 'I will talk to you when you speak to me with respect in your

voice.'" These are lessons women like Julia and Rachel, and many of the rest of us, need to learn. Hirschfeld recommends shoring up our boundaries: "This is where I live, my private space, and I am entitled to have it free of dirt. If I allow you to tell me I'm rotten and I take in that insult and keep looking at it, I am allowing you to defile my private space." Usually, permitting oneself to be demeaned is a practice that has a long history, she says. "Generally you'll find a woman who lives with a highly critical husband has lived with a highly critical parent. So once the husband leaves and he's not there to criticize her, she will replace that with her own internal [mental] parent, the critical parent that says, 'You're rotten, you're terrible, you're a failure.' She needs to replace gradually that mental tape, beginning, 'I may not feel good about myself, but I feel good about the one thing I did today.' Just slowly read new language into that new tape."

It's tremendously helpful, too, if women can replace those critical people around them with supportive, understanding people. And often people who best fit those criteria are other women who've experienced widowhood or divorce themselves. Psychologist Dr. Frances Heussenstamm strongly advocates establishing a support group for the displaced homemaker. "She needs a network of support," she says. "She needs friends and a place where she is able to say, 'I feel needy. I need help now. Next year, I'll feel better, but right now I need help.' It's absolutely crucial to be able to get those words out instead of sitting at home becoming an alcoholic." It's also important, Dr. Heussenstamm says, that the people in that support system merely listen and provide support, never telling the displaced homemaker what to do with her life.

"She needs to be able to talk about her feelings in a safe, supportive place. That's what women have done spontaneously throughout history—they've gotten together and helped each other." Having such a network of people to sympathize with her and tell her they understand her feelings and care what happens to her will provide an invaluable ego boost to a displaced homemaker.

Both Julia and Rachel found support through an organization for displaced homemakers and both feel it made a crucial difference in their lives and their opinions of themselves. Julia expressed her feelings well: "Finding these women and making new friends has given me back my confidence. These people care. If I make a mistake, it's not like I'm stupid, the way I felt with my husband. They're nice to me and they make me want to do better next time. They understand what I've been through because they've done it, too." Julia feels so good about herself now that she's taking back her maiden name. She is creating the woman she wants to be for the rest of her life—a dynamic, confident, successful woman—and that woman, she feels, should carry her own name, not her ex-husband's. "I figure I've been Mrs. K long enough," she says.

Milo Smith has long advocated women helping women at the Oakland Displaced Homemakers Center. "I see women coming in here," she says, "so down and so depressed, the ones on the verge of suicide, and a week later you can see such changes. They have friends and they're sharing their lives. They're not going to be a bunch of old ladies stuck off somewhere alone and dissolute."

Displaced homemakers don't have to settle for lives as

bitter old women full of hatred for themselves and those around them. Like all women, they can learn to love themselves . . . and they deserve to love themselves. After all, if we don't think of ourselves as worthy, how can we expect our families, friends, lovers, employers to do so? Using the techniques other women have used before us, we can all raise our self-esteem and achieve the goals we define as important in our lives.

The first step on the road to a new, happy, fulfilling life is simply to believe we truly deserve to have it.

4

The Myth of the Gay Divorcee and the Merry Widow

Being one half of a couple has many social advantages for women: we can make his friends our friends; we always have an escort at dinner parties; we have a set of rules by which to conduct a regular sex life; and we have an acceptable place in a Noah's ark society. When we become single again in midlife, the safe haven of the couple is shattered for us and we have to learn to revamp com-

pletely our social lives. The gay divorcee and the merry widow are, at least at first, truly myths.

Many displaced homemakers have told me they felt as if they changed from Mrs. Executive to Ms. Nobody when their marriages ended. And, for a while, they did—until they found their own identities and became Ms. Somebody. That is not an easy process. They had to learn to deal with the negative, threatened reactions of friends they had when they were part of a married couple. They had to learn to make new friends who would better understand their changed lives and be supportive of them as individual women. And they had to learn to meet and relate to men again on a romantic and sexual level.

Usually, the first social hurdle a displaced homemaker faces is that of current friendships—and it can be a very painful one. Particularly poignant is what happened to Dorothy, the woman who, one Christmas, was shocked to learn that her merchant marine husband was divorcing her. During the thirty-four years of their marriage, he was often at sea for eleven months out of twelve, so Dorothy was used to seeing their mutual friends alone. She'd never been made to feel like a fifth wheel during her married life. But when her husband divorced her, things changed drastically and rapidly. "It was very embarrassing for my friends, what was happening to me," she says. "For a homemaker suddenly to be divorced is a big threat to her friends. Whether it's because it causes them to look more closely at their own marriages, or whether you're the fifth person invited to a dinner party, you're an embarrassment. Soon I found I was not being invited to the parties, and you've got to understand I always had gone to the parties alone. So now I was invited

to coffee, not the parties. Pretty soon, I found it was a strained relationship."

Being excluded from social events was bad enough, but it got worse. A bigger problem was what happened with her friends' husbands. "They all began to feel they could do something for me. Sooner or later they got around to putting their arms around me and saying they could help me out. It all boils down to: 'I can take care of all your sex problems.' And I was used to living alone a lot of my life without sex." Now that she was being divorced, these men acted as though she were suddenly sex starved and that they'd be doing her a favor to offer their services. Dorothy still feels betrayed. "In all my friendships there were only three husbands who never made a pass at me. Only three," she says. "It's pretty grim because it's very disillusioning. In the first place, I really didn't want their husbands. And what makes these men think a woman's going to jump into a relationship with her best friend's husband? It's very belittling. I'd thought they cared for me as a person and then, when they turned around and made passes . . . I couldn't believe that the man who one day I thought was a friend, somebody I could talk to about problems with my children or something, turned out to be interested only in jumping into bed. What kind of a friendship is that? And my women friends had no idea that their husbands, every one of them, had been at my door.

"You say to yourself, 'Oh, boy, I'd like to tell them they'd better examine their marriages. They don't have it going for them at all.' But you don't do that, because you wouldn't do to somebody else what's been done to you."

Unfortunately, I think that a primary premise of the

kinds of friendships most long-term homemakers had as couples was secrecy. They were not to tell others of their marriage problems—at least not serious ones like impending divorce—in return for not being told about theirs. That way, everyone could pretend such problems didn't exist, that they were all happy, that a traditional marriage truly was utopia and happily-ever-after did exist. And, when these women most needed friends, when divorce or widowhood struck, they often found out that their friends were of the fair-weather variety. If a displaced homemaker's friends look at what happened to her too closely, they'll have to realize it could happen to them, too, and that would burst their bubble of false security. So, when a displaced homemaker calls on her friends in her time of need, she's likely to find they're really not there . . . and she's dealt a double blow.

Ginger, a displaced homemaker in her mid-thirties who is raising three children alone, recalls what happened to her when she and her husband split up. "At first, we divided the friends—who was heavier on my husband's side, who was heavier on mine. I went around to my side and told them we were splitting up. At first, they all behaved as if things were fine, but I always had a sense they were a little uneasy around me. It's not that I didn't want to tell them what was going on with us; I tend to blab. I really wanted to talk to someone, but people really didn't seem to get it." Or they didn't want to.

Ginger, an attractive woman whose nickname is derived from the color of her abundant hair, was particularly hurt by an incident with a woman she'd considered her best friend. "She didn't want me around when her husband was there," she recalls. The friend's husband and

Ginger's were co-workers, so "I was always watching my words around him. My friend tossed a party, a big open house, and did not invite me. It was a major incident." The friendship began to curdle and Ginger was hurt, but she hid her feelings. "I didn't discuss it with her then and I never have. Since then, she's been divorced and she tells me, 'Oh, I'm so isolated.'" But, by that time, it was really too late to rekindle the closeness the two women once felt with each other. "I don't really think other women think we'll steal their husbands," Ginger says today. "I think they're afraid to have to look at their own marriages. And they don't realize that we still feel human inside, that we still need human contact."

Widows, too, find that, while their friends are initially consoling, their attention sometimes sours quickly. "At first, I was invited to dinner and the theater," said Bonnie, a forty-seven-year-old woman whose husband had died of cancer three years earlier. "I would ask our friends to my house for dinner, too. But then things began to change. I'd find out about parties where I wasn't invited. And, when I got a job—and I needed one to live—things got even cooler. My girl friends would ask me how I was, but they'd never really wait for me to answer. They'd chatter at me about the bridge club or their husband's promotions. They truthfully didn't want to know what I was doing. Then later I'd run into them in the market and they'd say to me, 'We'll have to get together one of these days, but I know how busy you are.' It became clear to me that we had nothing in common anymore and that they didn't want to bother with me, so I began to make new friends."

The sad truth is that the majority of friendships are

based on mutual experiences and similar lives. When one person's life changes dramatically, the basis of the friendship may no longer be there and it terminates—either gradually or suddenly. A change in a marriage is not the only time this happens. For example, I remember being part of a group of friends, all of us hopeful writers. When I sold my first book, several of them no longer had time for me. My success, I later realized, made those who merely talked about writing instead of actually doing it uncomfortable. Each time they saw me, they were reminded of what they could have done. And we no longer shared the common status of being unpublished book authors.

And, when I was divorced, a friend I'd had since I was fifteen years old suddenly cut me off without a word. In our adult years, I'd spent hours listening to her complain about her marriage to a man who constantly berated her and occasionally became physically violent. But she wanted the security of marriage more than she wanted her self-esteem. So, when I was divorced and no longer shared her position of unhappily married woman, the basis of our friendship was altered and she became too uncomfortable with it.

One reason losing a friendship is so difficult is that we expected it to be invulnerable and most friendships simply are not. We thought we could count on someone and we end up feeling betrayed when we cannot. And we have to admit our grasp on reality has been poor when these facts come as a surprise. For some displaced homemakers, the retreat of a friend is more unexpected and thus almost more devastating than the loss of the husband. "You'd have thought I had contracted the plague,

not a divorce," one woman said of her closest friend's cutting her off. "The minute I told her Bill and I were divorcing, she was unavailable. She had hair appointments, her kids needed her, her husband insisted on her doing only business entertaining that month, every flimsy excuse in the book not to see me. I really needed a friend then, too. I never asked her to take sides against Bill. Truth is, I never got a chance to." Her bitterness is evident and, she thinks, wholly justified. "I thought we were like sisters. We'd shared the birth of our kids, the time she found a lump in her breast, my husband's losing his job, everything. But this was too much, I guess. The time I needed her most was when she checked out of my life. All I can say is I sure hope her marriage doesn't fall apart, because, if it does, she'll need a friend and I sure as hell won't be around." As angry as she is at her friend, this woman is angrier at herself—for having gotten the rules wrong, for having been vulnerable to someone whose concern turned out to be superficial, for having been a fool.

Not all friends retreat into the shadows when a woman becomes a displaced homemaker, however. Such an event in her life simply separates the wheat from the chaff. The friends who stick, who really help, will likely be the ones who last the rest of our lives. And finding out which are which can be a really valuable experience in the long run.

To be fair, the fault when a friendship dies does not always lie with the friend. Some displaced homemakers have been known to impose on their friends to the point where the relationship crumbles under the strain. Dr. Frances Heussenstamm warns against becoming a professional complainer. "Part of keeping friends has to do with

the way a woman presents herself," she says. "For example, there is nothing so incredibly boring as to be around a victim who, at the drop of a hat, will bring out her hands and show you where the nails were driven in, as she drags her cross into every encounter. For a while, you're willing to wipe the blood off her palms. Even if it gets on your clothes, you don't mind it, because you get an opportunity to be loving. But eventually, you get awfully tired of martyrdom and victims."

All the more reason to begin to get our lives together without counting too heavily on our old friends. Either we cannot count on our couple friends in the first place, or we risk ruining all but the closest and most secure relationships by failing to emerge from self-pity quickly enough. "Eventually," Dr. Heussenstamm says, "the displaced homemaker can be an inspiration to her friends because she's now pursuing her independence." And, if her old friends don't want to be inspired in that direction, she can be well on her way to creating new friendships with people who like women to be independent.

Creating new friendships. That seems to be the bottom line for most displaced homemakers. Even when they retain a few relationships from their married lives, most a few years down the road seem to be new ones. Many such women go so far as to move away from their old neighborhoods to foster a new social life and get away from the pressures inherent in trying to live a new lifestyle in old surroundings.

Pamela, a former Marin County housewife, did that. After a divorce that was a mutual decision, she moved into an apartment in San Francisco. "I didn't want to stay in the suburbs, where everybody was married," she ex-

plains. "I was a known person in the community and I didn't want to cope with explanations and a lot of curiosity. I very much felt that I would be starting a new life and I wanted to be as free as I could be to do that. I told my close friends about my decision, but I didn't ever really discuss it with them. I got a flat and moved to the city and, little by little, created a new life for myself."

Her decision to keep her new life apart from her old one worked well for Pamela, particularly when her onetime best friend "just couldn't hack it. She became very disturbed about my divorce and, rather than handle it by talking to me directly, she talked a lot about me behind my back. She became very hostile." This woman, Pamela feels, was hurt because she "wasn't the first to know. It was important to her to have control over knowing everything that was going on and I think she was very put out because I hadn't told her early on." They are no longer friends, but the hurt that fact could have caused Pamela has been lessened because she's made many new friends among single San Francisco people whose values and experiences are closer to the ones she's developed for herself.

Yvonne moved away, too, but only after she felt her ego had been smashed by her husband, friends and neighbors in her affluent midwestern neighborhood. Her divorce had been spurred by her husband's love affair with Yvonne's best friend, an affair that went on for three full years before she gathered the courage to end her marriage. Yvonne lost everything—marriage, friends, home, economic security—all at once. "I got into therapy," she says. "It was a three-year stint—and this was after I was forty—during which my husband would move

out of the house and then he'd move back in. All this time he couldn't or wouldn't break off with my friend." When they finally did divorce, the settlement provided that Yvonne would stay in the house with the children for a year, then it would be sold and the equity divided between her and her husband, a doctor. "My friendships universally dropped off," she recalls of that year. "My husband was invited to every party, every hostess picked him up as a desirable bachelor. He still fit into the referral system. I had become a nonentity. Partly it was because I was so embarrassed. I would see someone in the grocery store and walk the other way. I dropped out of clubs where I'd belonged for years." It was not only the circumstances of Yvonne's divorce that embarrassed her, but the fact that she was divorced at all. "It was twelve years ago and it was not stylish to be divorced. It was like having leprosy."

When the year was up and the house sold, Yvonne and her children moved to a cheaper neighborhood. "I moved into a tract neighborhood. It meant moving from an upper-class, fancy neighborhood to a middle-class neighborhood and it was hard on the kids. They had to change schools." But it got her away from what she felt was the constant gossip of her neighbors and forced her to make new alliances. And, after her children left home, Yvonne moved to an apartment away from the family-oriented suburbs. She has made new friends and now says, "That was a good thing. I would advise women to do that. Don't try to hang on to those couple friendships, because it doesn't work."

Yvonne, like Dorothy, Ginger, Bonnie and most of the rest of the women in this book, found women who'd had

similar experiences of their own—widows, divorcees, single women, more independent married women—with whom to form new friendships. And, with this new support system, they were better able to give birth to their own new identities as self-sufficient adult women. One of the most gratifying results of the displaced homemakers movement, it seems to me, is that it has changed the character of many women's friendships. No longer do we see other women mainly as potential rivals for the available men. No longer do we prefer spending our time with anything in pants to being with a close woman friend. And no longer do we see most other women as empty-headed and uninteresting. Women can be interesting, loyal, intelligent, all the qualities we've attributed to men. And they can be nurturing, understanding and loving, too. "I think women are learning to relate to women more, which is an important thing," says Milo Smith. "I could never stand showers and all those women-gathering kinds of things when I was married," she adds, but her attitude toward other women has been altered since she joined the Displaced Homemakers Center. "I love these women. I love their courage. I love their strength. And I love seeing the growth that comes from nothing." The relationships these women now are forming with each other are no longer the coffee-klatch, Tupperware-party liaisons of their former lives; now, they're of the honest, substantial variety. And they are forming the kind of supportive groups of friends Dr. Heussenstamm says women need to help them through the grief process.

With such a base of friendships with sympathetic women, friendships based on more trust and honesty than those of the old couple relationships, many of these

women are finding the strength and confidence to pursue more difficult new alliances—those with men.

From my discussions with displaced homemakers about establishing new relationships with men, I have formed one general conclusion: women's actions soon after their marriages end are likely to be immoderate. Some women told me they became sexually promiscuous for a time, bedding down with practically any man who would have them. At the other extreme were women who vowed they'd be forever celibate; they wouldn't risk being hurt a second time. Some displaced homemakers wanted instant remarriage, largely to avoid the hard work of becoming self-sufficient, adult women. And others claimed they would never remarry, that marriage, or living with a man, was, by definition, stifling for a woman. Again, they refused to risk another injury by becoming involved with a new man. After the first couple years, however, these radical positions tended to moderate and most women found themselves somewhere on middle ground, perhaps having several continuing relationships with men ranging from friendships to love affairs. By the end of that period of time, most had completely redefined what they wanted from a relationship with a man. They now wanted men who would treat them as equals, who would recognize and satisfy their emotional and physical needs, and who would allow them to live as independent adults within the relationship. No longer were they willing to subjugate their own needs and desires to men in exchange for having the bills paid. And most had also recognized and accepted the hard fact that finding such a man and es-

tablishing a permanent bond with him was not likely to happen for them.

That process of self-realization and change was often painfully won, and it was usually the result of many months of over-reaction to men in general, to the men they dated, and to their own sexuality. Confusion, fear, anxiety, anger, frustration—such emotions were not the exception but the rule for displaced homemakers taking their first few steps toward new romantic attachments.

Ginger, for example, found herself over-reacting in many ways in her attitudes toward men and sex. Right after she was divorced, she says, she "attached myself to anything that walked by, frankly . . . or tried to, anyway." She refers to her first year as a displaced homemaker as "that crazy period. The whole year, I was entertaining the strangest fringe element, people who hung out in hip places, anywhere. I'd strike up conversations with any weirdo on the street. It was silly." Why? In retrospect, Ginger has been able to see that she was very insecure being on her own. She felt desperate to attach herself to another man, no matter how inappropriate he was. And, "the sexual thing, in my mind, was my only ticket. That was all I thought I had. I knew other women had brains and all that to attract men, but I thought all I had was sex."

After that year, Ginger went through a second period in which she wanted nothing to do with men, at least not on a permanent basis. "I felt rage, just total, snarling rage at all men," she says. "I hated them all."

Now, though, she has mellowed. "It's come full circle, so that I can entertain the thought of having an exclusive relationship." She's still baby-stepping her way there,

though. She has a boyfriend, a man who means a great deal to her, but she's not yet ready to marry him. They spend many nights together and he's practically living with her—but the key word here is practically. Ginger insists he maintain a separate apartment so "we both are sure we have a way to get out of the relationship without condemning the other one." If her boyfriend wants to get away alone or to spend a night away from her, he simply goes to his own place—no explanations necessary. Or, if Ginger wants time to herself or to be with other friends, she just tells him and, again, he stays away—no questions asked. Perhaps the next step will be back to square one—marriage—but it will be a stronger, more equal liaison than her first.

Ginger found she had no trouble meeting men to date, and most of the women with whom I talked reported the same thing. The major problem they had was in finding men with whom to form a more permanent bond. Displaced homemakers reported they met men at singles groups, through computer dating, at social and athletic clubs, through their friends, at their workplaces, through their churches. Some told me they dated men who were involved in some way with their children. One, for example, had an affair with her son's soccer coach, another with her children's pediatrician, and still another became involved with her daughter's high school French teacher. They used a variety of social clubs for singles—ranging from the bar scene to organizations such as the Advanced Degrees in Southern California, a group for unmarried people who have master's, law or medical degrees.

For those women who simply want to find someone to make them once again feel feminine, attractive and sex-

ual—even if the feelings wear thin the next morning—it's really not too difficult. The larger problem seems to be in handling these kinds of relationships well emotionally, in recognizing them for what they are and not feeling guilty about them.

Like Ginger, Polly had a series of brief sexual encounters after she divorced, and she now realizes she used them as a way to boost her flagging ego. With this new introspection, she no longer feels guilty about her actions—and she's found she has less need for sex with a variety of men as well. Married for twenty-five years to a man who not only was unfaithful to her but did it under her nose and then told both his parents and hers how great he felt about having a new sex life after forty-five, Polly felt like a sexual failure by the time her marriage ended. "Toward the end of our marriage, I had craved a lot of lovemaking. I wanted to mend things between us, I guess," she recalls. "But my husband wouldn't give it to me. I was devastated. I was wiped out. I had no ego. After my divorce, I went through the community with all kinds of wild and woolly affairs, usually fairly short-lasting."

In retrospect, Polly has no apologies and feels she learned a great deal both about herself and about sex from her behavior. "Some of my affairs were very important and deep relationships that made me feel I was valuable," she explains. "I learned that the sex life I'd had in my marriage was active, but it was not satisfying. I didn't know enough about sex to know it wasn't everything it could have been." Many other women, in fact, have made the same discovery, particularly if they were young, inexperienced brides and then were faithful to their husbands during long marriages. In their midlife years as single

women, many of the sexual inhibitions they have carried from their restrictive girlhoods disappear and they discover a new, freer pleasure in their sexuality.

Polly's sexual re-education as a divorcee came with her first affair, one she had with a married fisherman who was a graduate of a major university. "We'd go off on Thursday afternoons after I was through working and we'd stay at a motel half the day and just live in bed," she recalls. "He was a very physical person and he loved me because I was warm and intelligent." He was also a most unusual man who taught Polly that "there were a whole bunch of people out there in the world that I didn't know." She enjoyed the sex and his friendship for what they were to her, but, unfortunately, the fisherman wanted more. "He was important to me for quite a while, until he left his wife, which I had never intended. I was furious.

"Then I became involved with a doctor I'd known for years. I thought about marrying him, but it didn't work out. It's really a good thing it didn't, because I needed to decide who I was first. But he was very useful to me. He was a very deep person who appreciated me for things no one had ever seen in me before.

"Then I got involved briefly with a German writer. That was lovely. It was very short, but a wonderful connection. We'd talk half the night and then go to bed." The German writer had come to America with very negative views about American women, intending to write about them when he returned to Germany. But he later wrote Polly and told her he'd changed his mind about American women after meeting her.

There followed another writer, a Jewish man from New

York, she says, with whom she lived briefly. Unfortunately, the living together arrangement spelled a quick end to the relationship. "He seemed to change overnight," she says. "I know that I changed as well. It was a total disaster and things just didn't fit between us."

Today, like Ginger, Polly has mellowed. She no longer needs a man constantly in her bed to prove to herself that she's feminine and valuable. She has several male friends and lovers in her life, but she lives alone. Sometimes she thinks about remarriage, but she's not terribly anxious for it now. "If I married again, I would marry for such a different reason," she says. It would not be for security and status, like her first marriage. "I get lonely and I want someone to hold me. I miss a bed partner. But he would have to be able to take me as I am and accept me. He'd have to share the other parts of life with me. I think of a good marriage as two redwood trees that have a connection in the roots and in the lower part of the trunk and then they spread out and each has its own branches and does its own thing—but it's all very connected." Polly, however, now in her late fifties, has a suspicion that such a man doesn't exist for her. And, on a permanent basis, she's not willing to settle for less.

Many American women define themselves largely in terms of their sexuality. We're taught, after all, that our major mission in life is to attract a man to take care of us. So we have to be sexually attractive to men—but not too much so. We're not to look "cheap" or "like a tramp." We're told that, to find fulfillment for ourselves, we should have an active and satisfying sex life—but, to be moral, it should be only with our husbands. So, if we don't enjoy sex or we have an unsatisfactory sex life with

our husband, we feel there's something wrong with *us*—not with the relationship or with the man involved. Many husbands, too, as a marriage is disintegrating, use the weapon of the wife's sexuality against her, particularly accusing her of being frigid. So, when the marriage breaks up, many wives feel that it was partly because they weren't "enough of a woman to hold a man." They feel like unfeminine failures. Rachel, the woman whose husband beat and raped her before she left him, remembers feeling this way. Her husband had continually told her she was frigid and she believed him. "Before I left, I really thought I was frigid, because I could not stand to have him touch me," she says. "There came a time when I could not have him touch me without my literally getting sick."

After they split, Rachel says, "I think I had to prove something to myself. I was angry at my husband and I went bananas for the first three months." She saw many different men, found out she was not, after all, frigid, and "got it all out of my system. I think it was a combination of anger and sexual repression that made me do that then, but I know now that's not for me." Rachel has had a steady boyfriend for about two years now. Marriage may be a possibility, "but it doesn't really matter to me anymore," she says. They have a satisfying, exclusive relationship, which is exactly what she needs at this stage in her life.

The experiences of Ginger, Polly and Rachel are not unusual among displaced homemakers. Many newly divorced or widowed women use a variety of sexual liaisons as a way to bolster their egos, to feel valuable again, and

to express anger at their fomer mates. Mary Hirschfeld explains, "Being unbonded from a mate is an unsettling experience. It's like a boat that's been cut loose in a storm and the anchor is gone. With a marriage, the relationship was the anchor and, when the seas were rough, you had the anchor to stabilize you. When the mate is gone, unless you are a particularly stable sort of person, you find yourself in a pattern of mood swings up and down. There are a lot of people—both men and women—who, during such a time, become sexually very active. It doesn't even matter who they're with; they just need a body. Sexual relations during this period are not really designed to promote closeness. If anything, I think they ward off intimacy, because it's done so mechanically and hysterically. A friendship is not allowed to deepen before there is physical intimacy."

Dr. Frances Heussenstamm states, too, that promiscuity is a way "to deal with the anxiety [of dating]. The reason that happens is that the woman says, 'I cannot stand the tremendous anxiety of the courting period. I may as well just get into bed with these men and relieve my anxiety.' She just wants to get it over with so she doesn't have to deal with those incredible negotiations. Many women, too, feel sex is all men want anyway, so they'll give it to them so they don't have to worry about it any longer."

One problem, however, for women who were raised in times that were not so sexually permissive as today is that they end up feeling very guilty about their conduct. And the guilt can be far more destructive to them than is the promiscuity. "I think it's very important to get some clarity of thinking, possibly through counseling," says Hirsch-

feld, "so you can give yourself permission to do some things you haven't done before. I'm not against doing things differently at all, but they shouldn't be done destructively. And, if you do new things in spite of feeling guilty about them, it often becomes destructive."

Ginger, Polly and Rachel have become philosophical about their numerous relationships with men. They have all analyzed why this period in their lives happened and have come to a new position on what sexual behavior is comfortable for them. They are no longer locked into the good-girls-don't rulebook of their childhoods. But, on the other hand, they have seen that prolonged promiscuity is not productive for them, either. They have found their middle ground, and they have worked through their feelings of guilt.

At the other extreme is the displaced homemaker who becomes a hermit, avoiding relationships with men with a fervor. Nina, a stunning redhead, did that for nearly two years after she was divorced at thirty-nine. "I was angry," she says, "and scared, too. So I just repressed all my sexual feelings. If I saw a man eyeing me across the room, I'd leave. I felt all men were looking through my clothes, treating me like a piece of meat." And she became very defensive with men, instantly rebuking them for as innocent a remark as, "You look very pretty today."

"I wore baggy clothes and kept my hair pulled back in a bun and really made myself look as unattractive as I felt," Nina says. "I truthfully wasn't aware of missing anything in my life. Once in a while, I'd have a sexy dream, but most of the time I felt fine without sex and without men. The thought of them repulsed me." Nina's distaste for men stemmed from a combination of a re-

strictive religious upbringing; a lengthy, unhappy marriage to a man who was sexually rejecting and treated her as an inferior; and her feeling rebuffed by the job market, where she thought her intellectual talents were being overlooked by male employers. "I wanted men to respect me as an equal, but I really didn't think they ever would. So I made sure that, if they didn't respect my mind, they wouldn't have a chance to relate to me on any other level."

There can be a variety of reasons for such a posture, Dr. Heussenstamm says. One is Nina's—"They do nothing because they're afraid of not being valued, of just being used." Another, she says, is that sex with a new man is "so terrifyingly unfamiliar after years of sex with your husband." Many women feel embarrassed and inadequate. "It takes an incredible effort to get your clothes off with a new man when your body's older and you've been doing it with the same old guy all those years. Sex is not always rewarding at the beginning, either, when two people are just getting to know each other, so a woman may be embarrassed or confused or disappointed or afraid." Even the preparation for having sex can be traumatizing. "For example," Dr. Heussenstamm says, "if your husband had a vasectomy, to go to your gynecologist who's known you for the past twenty years and ask to be fitted for a diaphragm so you can have sex with another man can be very, very hard for a woman between forty and sixty."

After a time, though, if a displaced homemaker is determined to grow, her anger will dissipate and she will find the strength to overcome her fear. For Nina, that time came when she became friendly with Todd, a man she met through a new job. "We would spend our lunch

hours together and, at first, there was nothing sexual or romantic about it," she recalls. "We simply liked talking with each other. He treated me with the respect I wanted and after a while I began to loosen up." Without realizing what had changed, Nina began to take more pains with her appearance, and she began to feel like a sexual woman again. Nina and Todd started to spend time together outside work, still on a platonic basis, but one day they realized their friendship had grown into something more. "I was afraid of sex, even with him," Nina says. "I've had a couple kids and my body's not what it was when I was eighteen. I'm really pretty inexperienced and I wasn't at all certain I could please him. I was truly scared to death that he'd find me repulsive in bed. Somewhere, I got the courage to tell him I was afraid he'd be disappointed in me—before we ever made love. It was easier for me to talk it out than to risk being rejected later in bed. He was great about it. And a few months later he told me he'd been just as afraid that I'd find him inadequate."

Nina was lucky in many ways, particularly that her first venture into renewed sexuality was with a man she truly cared about and who cared about her. And she was fortunate that her previously rigid position had softened enough by the time she met Todd so she was open to a relationship with him. "We both feel lucky to have found each other," she says today. "I don't know if we'll ever get married, but I think we'll always be friends. And I can't see myself ever turning into a piece of stone again, like I did after my divorce. Todd's given me confidence in my sexuality and he's shown me that a man can respect

me and make love to me at the same time. This love affair has been worth it just to learn that."

Neither a series of casual sexual encounters nor complete withdrawal is healthy as a lifelong position. "I've heard women say, 'What would I do to get a man into my bed? Anything!' There's a desperation in that stance," says Dr. Heussenstamm. "But there's a desperation in the other one, too, an incredible desperation in accepting loneliness and an empty bed for the rest of your life." These are stages that many displaced homemakers experience and they should not be a source of guilt, but, if they persist too long, most experts recommend counseling to help the woman toward a more moderate realization of herself as a valuable and sexual person who has the right to insist on quality, meaningful relationships with men.

Another stance in which I see a great deal of desperation is that of the displaced homemaker who will do anything just to get married again. Rapid remarriage after being divorced or widowed is not psychologically recommended, because it robs a woman of her chance to become self-sufficient and to find her own identity, and, in addition, she's not likely to make a mature and lasting choice of a mate while she is in the midst of emotional turmoil. Also, instant remarriage is an exceedingly impractical goal for which to aim.

Very few of the displaced homemakers I interviewed had remarried. Part of the reason may be that the remarried women are less visible, less actively identifying themselves as former displaced homemakers. But I think even more significant is that a great number of middle-aged women who are widowed or divorced simply do not

remarry. At least not quickly. That's one reason the women who spend their insurance money or their divorce settlements buying new wardrobes and getting their faces lifted in hopes of snaring another man to take care of them seem so pitiful. How much better if they spent an equal amount of time and money preparing to be self-supporting and finding their own identities as adult women.

The truth is that the pool of available single middle-aged men is just too small. When you add in the fact that many of these men are pursuing younger women, the chance of remarriage shrinks even further. "I don't think women over forty-five realize they're probably not going to marry again," says Cindy Marano, director of the Center for Displaced Homemakers in Baltimore. "I wish I were seeing more women who could face the reality that it's very unlikely they will again have a permanent relationship with a man at that stage in their lives. It's a very difficult reality to accept, I think, but we then see that the option is there to find a meaningful way of life in which women can enrich each other and basically provide the nurturing and friendship that can make that period in their lives interesting and exciting." Cindy urges particularly that middle-aged women not "believe somehow they are inadequate because it is not happening to them, that they, alone, are not able to attract a man to marry."

A man's life-span, of course, is statistically an average of eight years shorter than a woman's and most men have traditionally married somewhat younger women. When they are single in midlife, the age difference between a man and the woman he would like to marry may become

even greater. Nowadays, it's true that there is some evidence of older women making liaisons with younger men, but whether or not that will make the pool of available men larger for displaced homemakers remains to be seen. Most of society has not really changed its views. As Mary Hirschfeld says, "There are some raised eyebrows, perhaps, if a forty-five-year-old man brings a thirty-year-old woman into his social group of middle-aged people. But, if a forty-five-year-old woman brings a thirty-year-old man, the eyebrows are on top of the heads."

The biggest caution for a new widow or divorcee is not to look for quick remarriage as a way of avoiding becoming her own person. In fact, avoiding the growth process is the best way *not* to attract the kind of new man with whom she'd want to form a permanent relationship. Dr. Heussenstamm has learned from her own experience as a widow and from that of her clients: "You have to be awfully interesting and awfully loving to get another man to come to you at midlife, when there are so many attractive younger women with whom you're competing."

Eventually, whether they're craving remarriage or a renewed sex life or just companionship, most displaced homemakers do want to attract men—not the kind they meet in bars, but stable, loving men. "Whenever a client tells me she's bought new, lacy underwear, I know the mourning period is over and she's ready to meet men again," says Dr. Heussenstamm. "There's a look a woman has that says, 'I'm available,'" and men recognize it. She suggests as places to meet men many of the traditional spots—singles events, churches, temples.

Another excellent method is enrolling in courses interesting to men. "I once took a course in metalwork at

the local high school," she says, "because I wanted to make a fireplace screen. I was the only woman. I ended up making a dynamite fireplace screen and all the guys in the class helped. It was wonderful."

A tall, handsome woman in her early fifties, Dr. Heussenstamm wears her dark hair in bangs and dresses in a comfortable but elegant style. She has no trouble meeting eligible men. When she felt ready to begin dating again, she called her friends and relatives and told them she wanted to meet someone. "My cousin introduced me to the first man I dated," she says. Since then, "I've met men everywhere. The escrow officer at my bank introduced me to the man who was standing in line behind me one day. He turned out to be a professor of sociology. I've met men standing at a counter in a theater, sharing a table in a nightclub, traveling. I met one absolutely gorgeous man at a tourist bureau in the middle of Iran. Singles meetings are good, too. I spoke at one of them last night and met four interesting men. I've already made dates with two of them."

While she is interested in forming friendships and love relationships with men, one of the reasons for Dr. Heussenstamm's success is that meeting Mr. Right is not the primary motivation of her life. She has her career and her private life, her women friends and her own interests. When men fit into that structure, it's marvelous. When they don't, it's not the end of her world. And because she doesn't give off vibrations of desperation, her attraction for men is very high.

The question most often asked of Marie Edwards, a California psychologist who has conducted courses for more than four thousand singles both under the auspices

of the University of Southern California and privately, is, "Where can I meet someone?" She says that displays the wrong emphasis entirely, that the problem isn't so much *where* to meet someone as *how* to do it. And she advises singles of all ages (those who have attended her workshops ranged in age from eighteen to seventy-two) to stop thinking of singlehood as a waiting ground for marriage. It can be a full life in itself, she says. And, if singles would stop feeling something is wrong with them because they aren't married and go out into the world to pursue their own interests, they would likely radiate a joy in life, self-confidence and personal warmth that would attract people to them.

The displaced homemakers I interviewed who were most satisfied with their social lives generally had followed Edwards' advice. "I used to go out and try to meet men," said Gloria, forty-three and separated five years. "I finally got it into my head that I'd better go do something that I wanted to do for enjoyment. If I met somebody there, great. If I didn't, at least I'd had a good time doing something I liked." One thing Gloria learned to do, painfully at first, was not to wait for a date to take her to a social event she wanted to attend. "If I don't have somebody, I've learned to go by myself, but it took a lot of work." And she's learned not to be disappointed when a man she's met turns out not to be the one for her. "I used to complain after I'd gone through one man," she says. "A friend of mine would tell me, 'You have to go through the pawns, honey, before you get to the bishops.' And she's really right." Until Gloria finds the bishop—if she ever does—she's living a full life of her own, developing her own interests, becoming independent and never missing a

concert or play she wants to attend. She's found she can have a full social life without being a wife.

Self-confidence, as in every other area of life, is important in seeking relationships with men. A woman who is secure in her self-image and content with being single can withstand rejection and she can afford to take risks. And she needn't be afraid to initiate a relationship with a man who interests her, to be the first to speak. The reason most people hold back and don't want to make the first move, Marie Edwards says, "is that they think the other person is going to reject them. If you go ahead and do the risk taking, you're not rejecting him. If nothing more, you're having a nice conversation. But sometimes you can have more."

When she meets a man with whom she might like to establish a firm and perhaps sexual relationship, Dr. Heussenstamm advises a displaced homemaker to "go slow. That doesn't mean she gives up her spontaneity and never does giddy things, but she should proceed slowly in a new relationship and allow it to develop. She should get acquainted with the man over time and negotiate to get her needs met all the time." That means not having sex immediately if she doesn't want it. And this is often the most frightening concern for women re-entering the dating game. "The last time I dated," one woman said, "I was worried about whether to kiss on the first date. Now I'm expected to hop into bed on the first date." Most experts, however, say that each woman should set her own standards regarding her sexual behavior, not let society's changes force her into a style that doesn't feel comfortable. "I have a friend whose husband died," Dr. Heussenstamm says. "She was a virgin when she married. She

says she didn't have sex before her first marriage and she's not going to have sex before her second. She's dating and she's about to get a marriage proposal. That's her personal strategy." Other displaced homemakers feel free to take advantage of changing social mores and enjoy a varied sex life without guilt or apologies.

"Deal with your sexuality in any way you want to deal with it," says Chicago psychotherapist and sex counselor Marion Holtzer. "How you choose to lead your sex life is not the business of your family or your friends. As an adult, you do not have to ask permission of anyone to have sex; the responsibility is yours." And, on the other hand, she says, "Don't feel that you have to submit to a male's advances simply because he calls you a 'frigid' woman if you don't. If you feel uncomfortable with casual sexual encounters, don't engage in them."

Each woman must reassess her own values, deciding which of the ones she inherited from her parents she wants to retain and which she wants to modify for her new single life-style. She must realize that she is entitled to conduct her sex life, as all other aspects of her life, in a way that seems best to her. As a self-sufficient woman, she owes a man nothing she does not wish to give . . . and she's entitled to ask for everything she needs and wants. The true test of a lasting relationship, after all, is whether or not the resulting compromise is acceptable to both parties.

Many, perhaps most, displaced homemakers will never return to their former life-style as a married woman keeping house for a husband. Their social lives, as a result, will probably never again revolve around the same kind

of couple life—his friends, the bridge club, business entertaining. Thus every displaced homemaker has an opportunity to create a social climate for herself that is much more to her own liking. If she likes the ballet, she can go to the ballet—alone, or with a woman friend, or with a male friend or lover who enjoys it. Never again will she have to stay home because her husband is not a dance fan. If she wants a close, supportive friendship with a woman, she can form one. Never again will she be confined to superficial comradeship with the wives of her husband's friends. And, if she chooses, she can take advantage of the fact that sexual mores have, indeed, changed, and that today she can have an active and possibly even more satisfying sex life without marriage. A fulfilling social life need not be dependent on her having a husband.

She has an opportunity to find out who she is, to establish a new life around that identity, and to offer her true self to her friends and lovers. She may feel like Ms. Nobody for a time, it's true, but with introspection, courage and hard work, Ms. Somebody will soon be standing in her shoes. She may never call herself a merry widow or a gay divorcee, but a displaced homemaker can certainly become a satisfied single.

5

Growing Up Middle-Aged

Growing into an independent adult is not an easy task at any age, but when a woman has spent thirty, forty or fifty years being totally dependent on someone else, it's even harder. Dr. Frances Heussenstamm illustrates the initial process: "The breast at which these women have been feeding for so many years is suddenly withdrawn and it's like a forced weaning. You can imagine a baby falling into a temper tantrum when the mother suddenly jerks the breast away. It's quite similar. So such a woman has a great range of possible behaviors. At one end is regressing into infancy, thumb-sucking, in effect. That's what the heavy smoking, compulsive overeating, Valium abuse

or alcoholism represent. Or, on the other hand, she can begin to look, to search in the community for a place that will help her deal with what it's like to become independent."

Lorna is an extreme example of the kind of dependent woman who never quite made the transition to independence. She chose never to grow up, becoming a sort of female Peter Pan. She remained dependent on her parents—living at home, playing bridge in the afternoons and dating eligible young men in the evenings—until she was twenty-eight. Then Lorna married George, one of the more eligible of her suitors, and transferred her dependency to him. Twenty-five years later, when Lorna was fifty-three, George divorced her. She went back home to Mom and Dad, where she's stayed for the past fifteen years. Today, with both Lorna's parents over ninety, her thirty-six-year-old daughter Micki is afraid she'll soon be forced to take on responsibility for the elderly child who is her mother.

Most women Lorna's age, of course, don't really have the option of returning home to their parents, but they often become dependent on their adult children, on their friends or on another man if they can find one. They rob themselves of adulthood as Lorna did.

"My mother is still a spoiled little girl," Micki says. "She never worked when she was young, although she had a college degree and was an accomplished pianist and artist when she married my father. She's not a stupid woman. But she never thought she'd have to take care of herself."

In the early years, Lorna and George both thought they were happy in their marriage, a relationship that in

many ways was more like parent and child than two adults. Lorna married expecting to be treated like a princess. She wanted money, social status and a handsome man on her arm. George, for his part, wanted to be adored, and he wanted to be the boss. For a while, both were satisfied, but then George's business began to decline and he could no longer afford to keep Lorna in the southern aristocratic style to which she'd become accustomed. She began to nag, and she began to drown her growing dissatisfaction in drink. He began to look for validation elsewhere—mainly in his secretary's bed.

Lorna's drinking grew into a major family problem, but George didn't really want her to stop. "I think my father wanted to be a martyr," Micki says. "He wanted to blame my mother for all his shortcomings. His stance was: 'I'd do much better but, you see, my wife's a drunk.' I don't think he really wanted her to dry out, because that would take away his excuse. He'd send her to country-club-type hospitals and she'd sneak the booze in. Then he could say he'd tried to help, he'd done everything he could. One doctor told us the best thing would be for my mother to get a job—but Dad wouldn't go for that. It was too threatening to his ego. I think he was afraid she might be more successful than he was." So Lorna continued to be a problem drinker and George continued to use her as an excuse and sleep with his secretary.

When Micki was twenty-one, her father lost his job. He headed East from their St. Louis home, ostensibly to find employment, leaving his daughter in charge of Lorna. A few months later, on the eve of Lorna and George's twenty-fifth wedding anniversary, a sheriff visited Lorna and informed her that George had divorced her the pre-

vious day in Mexico. At that moment, he was in Las Vegas marrying his faithful secretary. "He figured I was an adult now," Micki says, "so he could just dump Mother on me, I think." But she didn't want to be saddled with her mother for the rest of her life, so she escaped in the only way good southern girls knew fifteen years ago. She got married. With a husband of her own to follow, Micki couldn't be expected to take care of her mother. So Lorna reverted even further into childhood. She went home to her parents.

Lorna now holds a job in a department store, but it's one far beneath her abilities, and she's still sleeping in the frilly pink room she had as a child. Her ninety-two-year-old mother does all the housework and cooking. Her ninety-three-year-old father pays all the bills. And Lorna's still a spoiled little girl.

I think the kind of dependency that pervades every area of a woman's life—from which Lorna suffers in the extreme—begins with a core economic dependency and radiates outward. I know wealthy homemakers, for example, who feel they're not entitled to buy themselves a new dress without asking their husbands first. "He earns the money," one explained to me, "so he's entitled to decide how to spend it." How demeaning to be fifty years old and not feel entitled to spend forty dollars on oneself without permission. These same women have accepted their husbands' value systems without question, have followed their husbands' careers blindly (sometimes crisscrossing the country in job transfers), and have even voted the way their husbands decide they should. They never mention what *they* think about important issues. It's always what "we" think —and "we" translates "he."

Hidden in the shelter of their homes, such women have little chance to find out who they are and what they think, to question and test the set of rules dictated to them by their parents and reinforced by their husbands. During the years when most of today's displaced homemakers married, a third of women were wedded by the time they were twenty years old—well before they were emotionally mature. And many, like Micki, married at least in part to escape their parents. I remember feeling, when I finished college, that I had a choice between remaining under my parents' jurisdiction and getting married. It never really occurred to me that I might live alone, make my own decisions and be solely responsible for myself. My attitude was common then. Looking back today, it seems bizarre that most of us bought the ideas that someone would always take care of us and that it was good to remain a child-wife forever. Because we did buy it then, many of us today are faced with growing up in middle age—an infinitely harder thing to do than growing up in our twenties would have been. But, unlike Lorna, most of us manage to do it. It's up to us whether we want to accept the fact that we must mature and plunge forward, or fight it every step of the way, making it more difficult than is necessary.

There are many ways a woman can resist growing up and can manage to stay dependent, even as a displaced homemaker. Lorna chose one. My friend Rosie chose another. When she'd been married for twelve years, Rosie could no longer live with her suspicious, accusing husband Tony. She put her arm around her two young sons and filed for divorce. Somehow, she vowed, she'd manage to live alone with her boys, away from the combination

of financial support and abuse Tony had provided her. The divorce was granted on grounds of mental cruelty and Tony was ordered to pay Rosie $400 a month for the support of his sons. Unlike the majority of divorced fathers, however, Tony not only paid the full amount of child support, he usually paid much more. As a result, although Rosie is divorced, Tony continues to dominate her life and manipulate her decisions and actions.

"I know what I'm doing and I hate myself for it," Rosie once told me, "but it's too hard to stop. I had a job right after we separated, a rotten receptionist's job. I spent all day feeling guilty because I wasn't home with the boys. This way, I can be with them. But I'm paying for it." She's paying for it by failing to develop her job skills and by continuing to accept her former husband's abuse. She's literally selling him the right to berate her by accepting the extra money and the strings attached to it. And those strings may as well be steel cables for the strength with which they're keeping Rosie down.

She started graduate school once, feeling she could spend fewer hours a day there than she would at a job, and it would help her support herself someday. But she quit long before her program was finished because Tony accused her of sleeping with her professors. "He made my life so miserable it just wasn't worth it," she said. In truth, his implied withdrawal of the extra money if she didn't quit school forced Rosie's decision. She doesn't date for the same reason; she doesn't dare antagonize Tony. The only difference in Rosie's life as a divorcee is that Tony now sleeps a couple blocks away. Otherwise, she may as well be married to him. He still degrades her, he still makes the decisions in her life, he still runs things.

And Rosie allows it. She's still a dependent child dominated by daddy—because it's easier than being an independent adult.

One of Rosie's basic problems is that she feels guilty about being a divorced mother, particularly since she is the one who initiated the divorce. She tries to make up for that action by being a self-sacrificing, overprotective mother to her sons. And, each time her former husband steps on her fragile ego, she feels justly punished for her failure to make her marriage work. The extra money is her excuse, but perhaps the real motivation for her to remain dependent is that she is afraid to grow up and become self-sufficient; she is frightened to find out who she is; and she is terrified of having to form her own values.

In ten more years, Rosie will be like Trudy, a woman I met at a women's center a couple years ago. Fifty pounds overweight and seething with hatred for all men, Trudy had spent the previous decade living on child support. The amount never increased for inflation, so her standard of living, and her children's, declined each year until her youngest child turned eighteen. Then Trudy was forty-eight and her income ceased entirely. She had done exactly nothing to prepare herself for paid employment, and, when I met her, she was about to apply for public relief. One of the most negative women I've ever met, Trudy is an example to the rest of us to become self-dependent before we reach either her depth of bitterness or her financial devastation.

Rosie can still make it, if she dares try. But first she will have to form her own value system, and that means giving up her guilt. Guilt, it seems to me, is an emotion far too often used to keep women in line with somebody

else's desires. If our children aren't happy, we feel guilty; it must be our fault. If our house isn't spotless, we feel guilty; obviously, we aren't good housekeepers. If we haven't enough money for lavish Christmas presents, we feel guilty; we must have managed our finances poorly. But according to whose values should we feel guilty about these things? Maybe, in our heart, we really think our kids ought to manufacture their own happiness. Or we don't believe in an immaculate home; we may feel more comfortable with lived-in clutter. Or we may simply not have an income high enough to buy those gifts and still pay the rent on a place where we'd like to live. Perhaps we value a better apartment more than a once-a-year show of generosity. Feeling guilty for failing to meet someone else's standards is self-destructive. But most of us have been conditioned to think automatically that everything's our fault, that we have failed, as illogical as this usually is.

This syndrome goes so far, I've found, as to produce guilt in us when we so much as question the values we've been told to accept. I remember the difficult time when my marriage was ending and I was giving a great deal of thought to what I really believed in. At that time, I actually felt guilty because I preferred living in the city to living in the suburbs, and living on the West Coast to living in the Midwest. The values my parents and husband held said that the suburban Midwest was the best possible place to live. Who was I to think differently? And I felt guilty because I wasn't satisfied with being primarily a homemaker with perhaps a non-threatening job on the side. The values of my family said that was the correct life-style for me. A career was definitely out of line. Since

I was ambitious, I felt guilty. The point is that none of these things corresponded with *my* values, once I realized I had some of my own. But I felt guilty for holding any opinions that differed from what I'd been taught was right.

For women who don't voluntarily keep themselves in line by feeling guilty when they fail to conform to others' rules, an almost sure cure is to tell them they're being selfish. Most of us were raised to fear being accused of being selfish above all else. It seems to me, however, that everyone is better off when women learn the value of a little well-considered self-interest. Being aware of one's own needs, and acting upon them, is not really being selfish, because no one can really give to others until she has a sense of her own needs. Such self-interest also puts an end to martyrdom, and martyrdom is destructive to everyone it touches. Martyrs expect others to feel obligated because they're making such vast sacrifices. The truth is, however, that nobody wants to pay that kind of price. What's supposed to bring the martyr gratitude and love instead brings her only resentment.

Monique was a true martyr while she was married. When she was forty-five, her husband died and she took a secretarial job to supplement her insurance money. "I was amazed," she said, "that, once I didn't have time to do so much for my kids, we all seemed to be happier. I used to be first in line to bake for the school cake sale, or sew them a costume for a class play or haul them all over town for piano or dancing lessons." But Monique did those things largely because she thought she should do them, not because she wanted to. "When I had to work— and I really like my job a lot—I couldn't do all that for

my kids anymore. I felt guilty about it for a long time. But then my oldest daughter told me, 'Mom, I used to hate dancing lessons anyway. It wasn't worth it, the way you never let us forget all the things you did for us.' She was tired of having to act grateful to me. And I was so busy playing the role of what I thought was a model Mom that I paid no attention to what my kids really wanted from me."

Now Monique takes time to do what she wants to do—for herself—and she finds the time she spends with her children much more enjoyable for everyone. Her kids now thoroughly enjoy her company. "I'm not nearly so uptight—as my son would say—as I used to be. I guess I was pretty much of a sourpuss when I was so busy sacrificing for everybody else and resenting them for things they never even asked me to do. Now I can understand their wanting to do things for themselves that don't include me, too. There's room for all of us to be individuals in this family."

Being self-interested can have its advantages. Monique has allowed herself to grow up and become an independent adult, and her entire family has benefited from her metamorphosis. She is doing a job she likes and is being rewarded with periodic salary increases and added responsibility and, as a result of her involvement in the business world, her children are freer to grow up, too. She isn't around to hover over them constantly, gratifying their every desire—or what she perceives as their every desire. They, too, are becoming independent, likable people.

Monique has discovered what many other women have still to learn—that true independence can bring happiness

and that self-sufficiency can benefit everyone. Unfortunately, too many of us have bought the idea that dependency is feminine and independence unfeminine. We feel we must appear helpless or we will be unattractive to men.

Santa Monica therapist Dawne Schoenholz has found this syndrome among many of her middle-aged women clients who are either displaced homemakers or married housewives. Schoenholz, who is in private practice as a marriage and family counselor and clinical sociologist while earning a doctorate in sociology at the University of Southern California, recently completed her dissertation study on middle- and upper-middle-class middle-aged women. Her study included approximately one-third divorced women, half of whom had initiated their divorces and half of whom were left by their husbands. All had originally been homemakers, but some were now working. She excluded widows.

Among both married women and displaced homemakers were women who had remained dependent, and Schoenholz theorizes: "Truthfully, I think that economic security is what those women don't want to give up, the ones who are not changing anything about their lives. I think they feel they'll only attract the kind of man who'll want to take care of them if they come from a traditional position that says, 'Daddy, take care of me.'" And they can't see a man's being useful for anything other than taking care of them.

Such women either feel they must hold their husbands through making them feel fatherly and responsible or they hope to find a new husband by using the same little-girl tactics. Today, however, fewer men are finding that

kind of clinging woman desirable, and, as we've seen, it's basically a foolish idea for a woman to put all her energy into hoping a new man will rescue her from having to take care of herself. Chances are, it's not going to happen and, even if it does, she has no guarantee that this man will stick around as long as she will need him.

For most displaced homemakers, a job is an imminent necessity. They must achieve financial independence if they expect to survive. With only 7 per cent of divorcees regularly collecting alimony payments and double-digit inflation gnawing away at settlements and inheritances, the woman who doesn't prepare to earn her own living is a fool. Once she's achieved economic independence, she will usually find herself being self-sufficient in other areas of her life as well. This generally means, however, that she will have to revamp her value system and redefine what she sees as feminine and valuable in herself.

Unfortunately, many of us were raised to see the qualities of successful wage earners as basically masculine. Women often fear that, if they are successful in the business world, they will no longer be considered feminine, a concept originally articulated by Dr. Matina Horner's classic 1964 study of women's fear of success. The research for Dr. Horner's doctoral dissertation was done at a large midwestern university and included a comparison of male and female attitudes about professional success. Her analysis of the results held that women feared not only failure but any success that would either interfere with their feminine goals of home and family or threaten the men they would meet on a personal or professional level.

Due in part to such fears, women often experience a

difficult adjustment to the working world when they've been away from it for years, Dr. Kathleen Mogul recently told an American Psychiatric Association meeting in Atlanta. "The more her sense of self was grounded in her identity as wife and mother, the greater the readjustment in the sense of self when she re-enters the occupational world," she said. "The sense of femaleness, and with it attractiveness and lovability, is often connected with being dependent and less competent than men. To be aggressive and actively self-promoting are characteristics this generation of middle-aged women have not identified with in their development."

It's interesting to see how far some women will carry these outdated and restrictive ideas of masculine and feminine. Dawne Schoenholz, for instance, has a client who has taken an office job in which she's been doing quite well. "However, she had to move a typewriter the other day," Schoenholz said, "and she asked a young man in her office to do it for her even though he was half her size. She said, 'I could have lifted it, but I didn't want to do that.'" This woman saw moving equipment as unfeminine, so, without seeing the lack of logic in her request, she asked a smaller male to do it for her—and she made herself appear less competent than he in the process.

A thirty-seven-year-old displaced homemaker illustrated for me a rather amusing extreme of her dependency on her husband: "I was used to having this nice big pillow next to me who did everything for me. I felt very helpless after I was divorced. When I was married, for example, if a pipe burst in the house, I'd call my husband and say, 'A pipe burst!' He would tell me to call the

plumber and I'd call the plumber. Usually, my husband would add some nastiness to his instructions, like, 'Why did you call me at the office with this?' but it made me feel secure that he'd tell me what I should do.

"Once I was divorced, I finally learned that I could just call the plumber myself and not call my husband first. I could skip that little middle step and get the same results, in fact, better ones. The plumber wanted only my money; he didn't need a slice of my ego. So, eventually, it became a lot easier. At first, I thought, 'Oh, my God, who is there to tell?' But, if you stop and think about it, you don't have to tell anybody."

It's amazing, too, how accomplishing a minor task for which we've always depended on our husbands can boost our egos. I remember my first Christmas alone, when I managed—unaided—to install a speedometer on my son's bicycle. It was a very small achievement, but it was also something that, during my married life, I would never have attempted. Now I had a choice—do it myself or have my child go without a speedometer. And, surprise! It wasn't that hard. I found that, if I could follow directions for making a chocolate torte or roasting a turkey, I could follow the directions for installing such a piece of mechanical equipment. Other women have told me they felt the same sense of accomplishment when they learned to change the oil in their cars or got their first mortgage in their own name or traveled across country alone.

The biggest problem with believing in such arbitrary definitions of what's masculine and what's feminine is that limiting ourselves to what's feminine means limiting ourselves to dependency and childishness. If we can't earn our own livings—or if we limit ourselves to the low-

paying, so-called female occupations—and we can't do our own mechanical repairs, and we can't make major purchases, and so on, then we can't really grow up to full adulthood. We'll always be scared little girls waiting to hear the bogeyman's step on the stairs and praying for a big daddy to protect us from life.

If this kind of life-style ever made any sense, that day is gone. Today, young women are aiming for good, solid careers, ones with which they'll be able to support themselves. And they are finding themselves in a position where, if they want to be married, it will be only because they want to be with their husbands. They have a viable option to be alone and free. They don't need a man to pay their bills or to take care of them, so men and women are able to relate to each other on a much more important level. And, while they're admittedly starting from a catch-up position, their older sisters, too, can have the same options if they want to work hard for them.

When we have the courage to reassess our lives, decide what is truly important to us and not just to those who've dominated us in the past, we experience a heady sense of freedom. When we become independent adults, life is not nearly so frightening anymore, because we achieve control over it. We finally have a sense of security with the one person who can never leave us—ourself.

The women in Dawne Schoenholz's study who became strong and self-sufficient reported that, after about two years alone, they felt a gratifying sense of freedom. "All of a sudden, they can eat whatever they want to, they like earning their own money, they don't have to split it with anybody, and they can buy a dress if they want to," she said. "Many of them found they were forced into

something that later turned out to make them experience life as being fuller."

Counselor Mary Hirschfeld sees a definite trend today in women avoiding diving into another dependent relationship right after a marriage ends. "With the women's movement and all the publicity about women doing things," she says, "we feel more supported in being women. It's a great development. I see a lot of them who will dig in their heels and say, 'I'm going to make it somehow. I don't know exactly how, but I don't want to get into another relationship yet.'" They're using the end of their marriages as a time for adult development.

In the process of "making it," these women will test their abilities in the marketplace and in the home, they will examine their own ideas and for once in their lives respect them more than the ideas of those around them, and they will mature in the process. They will be frightened and they will make mistakes, but they will learn and grow and emerge full adults.

The only woman who really loses in this process is the one who refuses to remove her head from the sand, a woman like Lorna. "My mother was a spoiled southern woman," her daughter Micki says. "She thought she could get anything she wanted by batting her eyelashes." At sixty-eight and with a thirty-year history of alcoholism, it may be too late for Lorna. She will probably die an elderly child, dependent on her reluctant daughter. But others can benefit from her example. Micki is one who has. "One thing I learned," she says, "is that I was never going to let anyone destroy me the way my father destroyed my mother. I made sure I could always go out and earn a living. It's like probing an open sore whenever

I see any woman who gets her entire identity from a man or from anyone else and I won't let that be me." Micki is still married and she has three children and a career. She works very hard on her marriage, taking nothing for granted. "I'd say I do eighty per cent of the work on my marriage," she says. "It's important to me and I want it to work. But I won't become dependent like my mother was. Nobody's going to do that to me."

Micki has seen from her mother's example what other women have also learned—that nobody gets a free ride forever. We can't expect to be taken care of, regardless of what we were told when we were girls. That myth was never true. And it wouldn't have been good for women if it were. An adult, self-sufficient woman never need be afraid the way a child-wife constantly is, because she's put her life and her future into the hands of the only person she can trust never to leave her—herself. And acceptance of the fact that we are responsible for ourselves is true maturity.

6

Former Wife
Forever Mother

"Housewife and mother" is the phrase most displaced homemakers use to describe how they've spent the majority of their adult years. When their marriages end, the first half of that phrase no longer applies. But the second stays with them forever. We remain mothers, but our children's lives and our relationship with them are drastically altered by this loss—theirs of a father and ours of a husband—no matter how old they are.

It is generally the mother's task to help her children through their emotional transitionary period following

their parents' divorce or their father's death, and this can be one of the most difficult, yet most rewarding, jobs a displaced homemaker will face. If our children are young, we as mothers must help them deal with the fact that Daddy won't be around so much anymore, if at all. And, if they are teen-agers or adults, we must learn not to load our troubles onto their shoulders, risking alienating them as Micki's parents did her. In fact, we must realize they have their own problems stemming from their loss and help them as best we can. Unfortunately, many displaced homemakers find this a hard lesson to learn.

Recently, I researched and wrote an article, from the point of view of young adults, about their feelings and experiences when their parents divorce. I was amazed at the burdens I found being dumped on the children of divorce by their supposedly loving parents. When the children are adults themselves, their parents' split often seems to become a contest over which parent can pull them away from the other more quickly—and the result can be alienation from both.

Twenty-two-year-old Sandy, for instance, was used as an arbiter in her parents' divorce proceedings, a role she foolishly took on with ultimately unfortunate results. "I'm trying hard not to favor either my mother or my father," she told me, "but it's almost impossible. They keep asking me to carry messages back and forth because they aren't speaking to each other." She was caught in a no-win situation, relaying information and having both her parents constantly venting their anger on her.

The situation that Charles, twenty-eight, found himself in was similar, although he was actively siding with his mother. His father had walked out on her after a thirty-

three-year marriage and shortly afterward began living with a young woman only six years older than his son. Charles voluntarily took on the arbiter's role in the hope of aiding his mother, whom he saw as the wronged party. "What else could I do?" he asked me. "My mother has nothing. She's fifty-eight years old, she's never worked before and she's been forced out of her home. What right does my father have to throw her on the scrap heap?"

Charles helped his mother move into an apartment, lent her some money and helped her find a lawyer, all of which aided her through a difficult time. But he didn't stop there. He also called his father several times to berate him on his mother's behalf. "Maybe someday Dad and I will be father and son again," he said, "but it will never happen unless he starts taking care of Mom the way I think he should."

When children get into the middle of their parents' divorce disputes, everybody loses. Sandy ended up with a nervous stomach from trying to pacify her mother and father and ease the friction between them. When the pressure became unbearable on her, she withdrew and refused to mediate any longer. As a result, her parents became hypercritical of her and she has since severed communication with both of them.

Charles has, at least temporarily, lost his father through his intervention in his parents' business. And, ironically, he has done his mother a disservice, too. He effectively prevented her from becoming an independent woman who fights her own battles.

Libby, a young mother, felt very guilty when her parents divorced. Her father remarried shortly after the divorce was final and her mother, a woman who put far

more energy into complaining than into working toward a new life for herself, was vocally bitter. Because Libby wanted to maintain a good relationship with both her parents, she and her baby visited her father and his new wife often. "But every time I went to see Mama," she recalls, "she'd start crying and saying to me, 'How can you do that to me? I can't bear to think of that woman's hands touching my grandbaby.' I felt just awful, but what could I do? I didn't want to stop seeing my father just because Mama was mad at him."

In the end, Libby began to avoid seeing her mother because she was tired of being chastised. Predictably, it was her mother who lost in this tug-of-war. She sought to use Libby and her grandchild to punish her ex-husband for leaving her. But she ended up punishing only herself.

Sadly, divorced parents often try to use their children to punish each other. Sheila, for example, a divorcee in her early forties, had been married to a wealthy physician who saw every penny of child support he paid as going to Sheila's benefit. As a result, he was exceedingly stingy, to his children's detriment. "At one point," Sheila said, "I felt it was important for our son Jimmy to see more of his father, so I talked him into having Jimmy stay at his father's place [with him] every weekend. You know what that jerk did? He reduced my child support payment because he said he was feeding Jimmy half the time. It wasn't legal, but I don't have the money for lawyers to press it. Since the checks got smaller, I had a choice between keeping Jimmy home on weekends or cutting down our standard of living. It's not that his father doesn't have the money, it's that he doesn't want to give it to me."

Former Wife, Forever Mother

The extent to which battling divorced parents will use their children as ammunition against each other is practically unbelievable. Sally's story, among the saddest I've heard, illustrates this point dramatically.

Divorced after a rocky marriage to her high school sweetheart, Sally was left with two young sons to raise. The marriage was never particularly good and Sally's husband, Russ, seemed to have trouble accepting his status as a father. Inevitably, they went their separate ways. Sally, who'd always been a homemaker, sharpened up her secretarial skills, got a baby-sitter and a job, and centered her life around her sons, Greg and Brent. Russ had visitation rights on alternate weekends.

On a warm September night in 1977, however, Sally waited in her Los Angeles town house for Russ to bring the boys, then ages six and two, home from one of their weekend outings. She's still waiting.

When Greg and Brent didn't return, Sally tried to call their father and found out his phone had been disconnected. Confused and fearful, she called the police and was told, "Sorry, there's nothing we can do. It's a domestic matter."

Frantic, Sally drove to Russ's house. She found it empty and abandoned; a letter addressed to her was in the mailbox. Russ had taken the children away, it said; she'd never see them again.

Bizarre as Sally's experience may seem, it's unfortunately not uncommon today. She became a victim of child snatching—a term coined to describe one parent's stealing custody of his own children from the other parent—and the practice is happening as many as 100,000 times a year, experts say. Children in these tragic cases

become pawns in their parents' hate campaigns against each other, suffering predictable psychological damage as a result.

In Greg's case, Sally insists, there is a great danger of physical damage as well. Her older son suffers from epileptic-type seizures and needs daily medication, something his father has been known to ignore. Greg also needs immediate emergency treatment following a seizure, another thing Russ has overlooked in the past.

Why does a parent like Russ resort to stealing his children away from their mother? Does he "love" them enough to become a fugitive from justice so he can have them with him all the time? Sally says no and psychology experts agree with her. She sees Russ's drastic action as his way of punishing her. "Russ doesn't even like children," she says. The first time her husband left her was eight days before Brent was born, and she thinks a major reason was his fear of taking responsibility for a second child.

Ironically, Russ always wanted to be the boss, and he wanted Sally to remain dependent on him, but he didn't really want the responsibility of a family on his shoulders—an ambivalence that eventually resulted in heartache for Sally and his sons. After Russ and Sally were divorced and she grew independent, he began to resent her more and more. "I think he just couldn't stand it that I could make it on my own," she says. "I'd never had a job before. I'd never lived alone. He couldn't stand it that I was all right without him."

And Sally was fine without Russ. She managed to rent an attractive two-bedroom town house and furnish it well, and her sons were well cared for by a good baby-sit-

ter while she was at work. She was happy, and so were Greg and Brent—until that September evening.

Since then, Sally has devoted her life to trying to find her sons and bring them back. She convinced the district attorney to issue a felony warrant for Russ, which was forthcoming because of the letter he left behind stating he intended to keep Greg and Brent concealed. And Sally also had a few letters from Russ postmarked outside California, proof that he had taken the boys across state lines.

But Sally hasn't been able to find Russ and her sons. Her ex-husband obviously planned his flight in advance and covered his trail well. "Russ works in construction, usually for cash," she explains. "That's why he can hide so easily now, because he can collect cash and there's no record, no Social Security." Russ's neighbors say they knew nothing of his planned disappearance, although they saw a moving van in his driveway a week before he and his sons left Los Angeles. None of them has any idea where the van was headed.

In the face of frequent bitter disappointment in her search, Sally is leaving no path unfollowed. "I've been to private investigators, I've been to psychics, I've been to lawyers . . ." she says. Her personal expenses have mounted into the thousands of dollars, wiping out her savings. She's been forced to add after-hours jobs and weekend work to her full-time secretarial job. But, at the same time, she hesitates to move from her spacious town house into cheaper quarters. "I want nothing changed when the boys come back," she says. "They need *something* stable in their lives."

She has spent hundreds of hours and a great deal of money mailing flyers asking for information on her sons

to every elementary school, both public and private, in four states where she thinks Russ may have gone. "The postage alone on the flyers was more than a thousand dollars. I sent about ten thousand of them."

And, sadly, Sally feels she was victimized by a private investigator who took a substantial deposit from her and hasn't filed a report in over a year.

Her frustration and depression over the apparent loss of her children is painfully understandable. And, in addition, she lives with the fear that, while Russ has the boys, he's poisoning their minds against her. One minute, she's afraid that time has run out for her dream of getting Greg and Brent back and recreating a happy home for them. But the next, she vows, "I don't care if it takes till my boys are eighteen or nineteen. I'll find them and I'll get them back. They're my *babies!*"

While stories like Sally's are indeed tragic for the parent left behind (usually, but not always, the mother) what of the children? What do little boys like Greg and Brent, suddenly snatched away from their mother in the night, believe happened to her? Do they think she abandoned them? Or that she died? And what possible explanation can small children make for the life of constant running and hiding into which their father has pulled them? Surely, there's no way they can emerge unscarred. Even more than the mother, it's the children who are the biggest losers in this destructive game.

Divorced fathers like Russ are rarer than another kind, the ones who completely withdraw from their children. "My father just disappeared about a year after my parents were divorced and I didn't see him again for ten

years, not until I was twenty-one," says Leigh. "I think he sent my mother a little money once in a while, and I suppose she knew where he was most of the time, but he sure wasn't much of a father to us." Leigh's mother and father were divorced when she was only ten, the oldest of three children.

"My mother couldn't live on what my father paid her. That was made real clear to us. So we went to live with my grandparents for a while and she got a job in a grocery store. She'd come home tired at night, saying her feet hurt her. I used to hate it because I had to watch my brother and sister after school every day instead of playing with my friends. I always thought my mother did something to drive my father away and that's why things were so tough for us. When I was sixteen, my mother got married again and things were better financially, but somehow I never completely accepted my stepfather. There was an ache inside me for my real father. Sometimes I still feel it, but now I know it's for a dream, not my father as he really is."

Leigh is twenty-eight now and able to articulate what becomes a very common feeling for the children of divorced, and absent, fathers. They begin to fantasize about these men, one day making them into saints kept away from their children only by cruel fate—which may take the form of anything from exotic wars to their mothers. Another day, they feel a consuming hatred for the men who abandoned them. Still other times, they feel guilty and "bad," as though they did something terrible to make the father leave them.

One day, Leigh's father returned, so she was able to check her dreams against reality. "My father called me

up one day right after I turned twenty-one. I'll never forget it. I was a senior in college and I was studying for final exams. Right out of the blue, there he was on the phone. I nearly fainted." Leigh didn't know what to do. She describes her emotions when she took that phone call as running the gamut—happiness, fear, excitement, anger. At first, she wasn't sure she wanted to see this man who hadn't contacted her for ten years, who had let her grow into young womanhood without so much as sending her a birthday card, but "I finally decided I'd always regret it if I didn't see him at least once."

This father of fantasy turned out, of course, to be much different from the way Leigh remembered him. He was smaller, less affluent, much older, a bit bent by life. "He became real for me, and I think that's good. He's just a man who doesn't cope with life very well. He couldn't cope with a wife and three kids, particularly when she wasn't his wife anymore and he saw us only on Thursday nights. One day, I guess he'd just had enough and he walked out of my life without so much as a 'So long, see you around.' I think he's sorry now, but I can't lose any sleep over it. I see him occasionally, but he doesn't seem much like a father to me. He wasn't there when I needed him, so frankly I don't feel much obligation to be there for him."

As a young woman, Leigh can see how difficult her mother's role was. "In some ways, I suppose she was happy not to have to contend with my father's being around all the time, but we really made her pay for it. When we were kids, we'd often say, 'Dad would let us do that,' or, 'You can't make us do that; we'll tell Dad on you.' Of course, Dad wasn't around to tell and she knew

it. When she'd point that out to us, we'd accuse her of sending him away. It must have been terrible for her."

For children of divorced parents, like Leigh, seeing the absent parent on a regular basis has been found to be vitally important to the formation of self-esteem. According to University of California, Berkeley, child psychologist Judith Wallerstein, who directed a five-year study on the effects of divorce on children, almost all children suffer intense unhappiness when their parents divorce and, unless they receive frequent and regular visits from the parent who has moved out of the house, their self-esteem may be severely diminished. "Little boys, ages six to eight, are the most vulnerable group," she adds. "They experience longing for their fathers with almost physical intensity."

Wallerstein found, in her study of 131 children aged two to eighteen, that "the happiest children were those who were visited two to three times per week. And the best relationships were those where the children could ride their bikes down the street to see the father. They didn't like the concept of being 'visited.'"

Most of the children in Wallerstein's study were in the custody of their mothers, but for the few who lived with their fathers, the mothers' absence was felt "even more so in the child if he didn't receive frequent visits."

Wallerstein also pointed out that children who saw their fathers only infrequently because of geographical distance from them were less emotionally damaged than those whose fathers lived in the same community. In the first case, the children had a reason they could understand for not seeing the fathers more often. But in the

second, they felt abandoned, cast aside and somehow personally unworthy of the missing fathers' love and attention.

Why do so many fathers fail to see their children regularly? Wallerstein says one reason is because visiting them is as stressful for the father as it is for the child. "In the first place, visiting fathers often don't know what to do with the children, particularly if they're different sexes and ages."

Second, she adds, the visit is often "ghost-ridden. The stress on adults, as well as children, is extraordinary, because all the anger, frustration, jealousies that preceded the divorce are at home, waiting with the child."

And third, Wallerstein has found, many mothers sometimes discourage the fathers' visits, either by overt sabotage or by more subtle methods.

As a result of these and other obstacles, 25 per cent of the parents in Wallerstein's study visited their children on only a monthly basis and another 25 per cent visited only infrequently and erratically. And the children involved exhibited increased anger, depression and fear.

The role of single mother, of course, is never an easy one and it can be even more difficult for her as well as for her child when the father is not around. In the child's mind, the absent father can sometimes be made into a hero and the present mother into an ogre. One mother I know recently found herself in the middle of a common crisis of this type. Her former husband lives several states away and, according to their divorce agreement, has visitation rights for their twelve-year-old son at Christmas and summer vacations. "My ex-husband is constantly broke," she said. "He doesn't send the child support on

time, if he sends it at all, and, of course, this Christmas he kept us hanging until the last minute. Would he send the plane ticket for Ricky or wouldn't he? Well, he didn't. The poor kid was counting on seeing his father, so, when his father said he couldn't afford the ticket, Ricky started to wheedle it out of me. I tell you, I'm really trying hard not to cut down his father to him, but it's very difficult not to. I don't know what to do. The man earns three times what I do, but he has his priorities all screwed up. One of his top ones is definitely not seeing his kid at Christmas. But I couldn't tell Ricky that. He's miserable enough as it is. What I really resent, though, is Ricky's getting mad at me because I won't, or can't, make up for his father's selfishness, because I won't use up all my savings to buy him the ticket."

This woman is understandably angry at her former husband and frustrated with Ricky. The boy, however, is probably upset with her only because it's safer for him to transfer his rage at his father to her. If he tells his dad off, his dad is likely to disappear completely from his life. But he can trust Mom to stick around and take it. It's not a pleasant way to experience motherhood, but Ricky's emotions are understandable. What he needs is some help in learning how to express them more appropriately.

Her story also brings to mind the almost universal problems connected with the holidays in families of divorce. They can be terribly frustrating, sad and lonely times for everyone involved—the divorced parents, the children and sometimes even the attorneys. In fact, former Missouri divorce attorney Lee Shapiro told me that one of the reasons he left law was because he could no longer tolerate "the hassle of hundreds of calls about cus-

tody rights at Christmas and hundreds of calls in the summer just before vacation starts."

A divorced friend of mine uses custody of her sons at holiday time as a weapon against their father, who lives five hundred miles away. "If he's late once more with that support check, all hell can freeze over before he sees *my* kids at Christmastime," she'll say. Or she'll exchange an extra visit with the boys at Easter for their father's chipping in on braces for their teeth. The only problem, of course, is that the boys have begun to feel as though the pleasure of their company is being sold to their father—and it is.

Holidays are a difficult time even for adult children of divorced parents. Often they're afraid that Dad will be offended if they ask Mother to come for Christmas dinner, or vice versa. It's generally inappropriate to include both in a family celebration, and basically impossible if one or the other has remarried, so what's a son or daughter to do? Los Angeles psychiatrist and author Dr. Irene Kassorla recommends "dividing up the day. Invite Mom for Christmas breakfast, Dad for Christmas dinner. There's a lot that can be done separately." To make this sort of scheduling work for our children, however, it's vital that we not make them feel guilty for inviting the other parent to spend holiday time with them.

It seems that the issues of custody, particularly at holiday time, and money are the two biggest battlegrounds where divorced parents use their kids as ammunition against each other. It's usually the mother who has custody and the father who has the money, but it takes two to battle it out. If the mother refuses to use her inappropriate weapon, the father will usually give his up as well.

After all, an army can't fight a war if the other side doesn't show up.

Nell, a California divorcee, used a creative method of disarming her ex-husband, who was extremely bitter and resentful of her because she'd had a lover before they divorced. As a result, he used every method he could think of to snipe at her, and withholding money was the closest at hand. "A year ago," Nell told me, "I told my former husband I needed more child support, and he flatly refused. I'd been getting an amount that was set ten years ago and it just wasn't enough anymore. I thought it over and finally told him, 'Okay, I don't want any money from you. You can send the checks directly to the children and they can pay me room and board and buy their own clothes.' He huffed and puffed about that a little bit. I told him, 'They're both working part time and they have checking accounts. They're financially responsible.' So he agreed to do it that way.

"As soon as he agreed, the kids started putting pressure on him for things that the $225 a month for each of them didn't cover. And he paid them. I think that his real bitterness toward me was what was holding him back from giving. He had the money. That was not the issue." Nell reduced her former husband's power over her when she insisted he pay the children directly. And she also took her children out of the middle in her decade-old dispute with their father.

Money is closely connected with power in our society and both mothers and fathers sometimes tend to use money, or the lack of it, as a way to gain power and influence over their children—with the children being the losers. I've seen some women who constantly tell their

children they could have every toy in the store if only Daddy hadn't left them. And Dawne Schoenholz, in her study of middle-aged women, found many who felt their former husbands had bought their children's affection away. "There is a great tendency for these women to feel as though they lost their children to their ex-spouse really based on his ability to provide them with financial goodies," she says. True, it's hard to compete with a father's gift of a sports car for high school graduation, but why is such competition necessary? There has to be something very wrong with the values by which a child has been raised if he's willing to write off his mother for a new car. He should not feel he has to forget either of his parents for financial—or any other—reasons.

Most of us, at some time, feel tempted to use our children as weapons in our divorces but, if we stop and realize it's doing them, and ourselves, more harm than it's doing our former husbands, we'll stop. Dr. Kassorla says that children should not be subjected to pressure to take sides or be made to listen to gossip or complaints about the other parent. And, when their parents remarry or form new relationships with others, the children should not be made to feel disloyal to the other parent for liking the new partner.

"Often, kids feel this kind of pressure, so they say to themselves, 'I don't want Mom to worry, so I'll tell her Dad's new woman is horrible, she's ugly, she smells, she doesn't keep house,'" says Dr. Kassorla. "They'll knock her and, as a result, they won't get to enjoy a lovely new friend.

"If the child can make the separation and say, 'Mother, I love you and I'm not going to talk to you about this

new lady,' and, 'New Lady, you're fun, you must be lovely or Dad wouldn't want you,' he or she can have a good new friend. There's no loss of loyalty if you realize there's plenty of time and unlimited amounts of love available for everybody." It's up to us as parents to be mature enough to realize the stress we put on our children to take sides.

The loss of a parent through either divorce or death can be devastating for children, and it's difficult while we are suffering that loss ourselves to be much help to them. But we must, and, in doing so, we often find ourselves forced into a relatively quick recovery. One divorced mother told me that, right after her marriage ended, "The only reason, I think, that I didn't kill myself was because of my kids. I had to get out of bed every day and feed them, dress them, see they got to school. It gave me something to do. During that time, I kept fantasizing about death, imagining all sorts of ways I could kill myself—to make my husband sorry he left me, maybe. But I didn't do it, because I didn't want my kids to have to live with that the rest of their lives. Now I'm glad I'm alive for a lot of other reasons, but then they were what saved me."

The mature woman recognizes that she's responsible for the welfare of her children, at least while they're young, and she watches for signs of stress in them. If they need psychological help to deal with the changes in their lives, she makes it available. And she allows them to ask her questions and get honest answers—without hearing their father berated.

Dr. Kassorla strongly recommends some kind of psychological help for most children of divorce. Eventually,

children who've spent part of their youth in an unhappy home will show the scars, she says. "When parents have stayed together for the sake of the kids, the kids see how to despise another human being, how never to touch, how never to say anything positive. It's a double whammy for the child. Number one, every time the parents fight, the child feels guilty because, if it weren't for him, the fighting would stop. And number two, the child sees how a man and woman can despise each other. So the child, when he gets married, goes and looks for someone to despise." That's what marriage is to him. "People tend to repeat their parents' patterns," she says, "or they go a hundred and eighty degrees in the opposite direction. But it's all neurotic behavior."

So, if our children have spent a good portion of their lives being negatively influenced about marriage and relationships because of our slowly disintegrating marriages, it might be time to find them low-cost counseling through such organizations as county mental health agencies. And certainly it's time to call off that pattern of negative influence and try to make peace with our ex-husbands.

Micki well remembers how difficult it was to be a child of an unhappy marriage, and she still feels its influence years after her parents divorced. "My parents really laid a guilt trip on me," she says. "All the time I was growing up, my father would tell me how miserable he was with my mother, but that he stayed with her because of me. I think what he really wanted was martyrdom, and he used me as an excuse for not changing things."

With some distance from her parents' divorce, and a family of her own, Micki realizes she's still angry for the

burden placed on her shoulders. "I think staying together for the sake of the children is a selfish cop out parents use because they're too cowardly to face their own failures," she says. "I wish my parents had gotten a divorce years earlier while they were still young enough to find happiness with someone else. Blaming me that they didn't is ridiculous."

Even after years of reassessing her parents' marriage and her part in their unhappiness, Micki still feels a touch of guilt. Part of her has believed for all these years that everything was her fault, even though that's an illogical conclusion.

Guilt is one of the primary emotions children feel when their parents divorce. One of Dr. Kassorla's patients, for instance, harbored a feeling of guilty responsibility well into adulthood. In therapy, he finally realized that he'd always believed his father had left home because he, as a child, left his bicycle in the driveway. These feelings may seem ridiculous to us as adults, but they can be very real to children and, as their mothers, it's up to us to understand what our children are feeling and help them overcome their negative and destructive emotions.

Guilt is also a primary emotion for children whose parents die. Often, experts say, the child will feel he caused the death by occasionally wishing the parent were dead—something we have all done at one time or another in our lives. When the parent really does die, even if it's months later and totally unconnected with the child's wish, his mind makes a connection and guilt surfaces.

With adult children who lose a father, guilt may also play a part. They may not have been as attentive to the parent as they think they should have been, for example,

or they may have quarreled recently. Jeannie's father died when she was nineteen, and their relationship had been rocky for most of her teen-age years. "I'm afraid I'll always feel guilty about the fight we had before he died," she says. "I was going out on a date with a guy I really liked a lot, a guy I was thinking about marrying. My father told me to be in by midnight, which I thought was a pretty archaic rule. He was on my back all the time about getting in late and he finally told me if I was late again, I'd have to move out. I told him I had no intention of being in so early, that I was an adult, and that I'd just move in with my boyfriend if he kept on bossing me around like that."

Two days after their argument, Jeannie's fifty-two-year-old father had a heart attack while shoveling snow and died. Even though the doctors have repeatedly told her that her quarrel with him had nothing to do with his death, she doesn't completely believe them. She's been profoundly affected by her loss, so much so that she broke up with her boyfriend. "Every time I saw him," she says, "I just kept thinking that because of him I killed my father. It was too much for me to handle." Obviously, Jeannie needs help in overcoming her feelings of guilt over her father's death, because, when guilt is misdirected or inappropriate, it can be extremely destructive.

Guilt, of course, also is an emotion that motivates many displaced homemakers in their relationships with their children, as well as vice versa. Again, it can be most destructive both to the relationship and to the children's future lives.

A common direction for guilt-ridden displaced homemakers to take is using too much leniency in raising their

children without a father, particularly in homes where the father was the chief disciplinarian. Faye went through such a stage in raising her teen-age son. "Joey was only ten when his dad died. I ached for him as much as I did for me. I felt so awful that he didn't have a daddy anymore and that I had to go out and work that I let him get away with murder. I thought if I came down hard on him—and I often wanted to—that Joey'd think I didn't love him anymore. I made a lot of mistakes."

During most of the five years after Faye's husband died, young Joey ran the household. He got into trouble at school, he stole money from his mother's purse, and he often took off for hours on his bike while Faye worried about where he'd gone. As things deteriorated, she blamed herself. "I thought that if I were at home Joey wouldn't be getting into trouble all the time," she says. "And I thought, if he had a father, there'd be a man to discipline him. I tried dating men for a while, thinking maybe the best thing to do was remarry, so Joey'd have a stepdad. But he resented my going out and I had to admit that it did seem unfair. Here I was gone all day at my job and then I'd go out in the evening on a date. The poor kid was alone too much, so how could I expect him to get himself straightened out? No matter what I did, it was wrong, and I felt Joey's being messed up was my fault."

Faye curtailed her social life and began spending her evenings at home. When she did that, however, Joey started going out with his friends or locking himself away in his room watching television. Faye ended up sitting by herself and the cozy two-person family she'd imagined never materialized.

Then Joey got into real trouble. He was caught shoplifting a record album and, Faye says, "That was when I realized something had to give. I just couldn't take it anymore. I saw Joey's life getting farther out of whack and I could see his future as a drug addict, in prison, anything horrible I could imagine."

Faye and Joey entered counseling at a local facility where she could pay according to her income level and she learned that her lack of discipline had been interpreted by her son as a lack of love. He felt he'd lost both his parents—his father through death and his mother through what he perceived as her indifference to him. His misbehavior was a combination of misdirected anger over his father's death and a plea for attention from his mother. Joey did resent his mother's not being home and available to him as much as she was when she was a homemaker full time, but he realized her working was necessary for their survival once she explained the financial facts of life to him. Before the counseling sessions began, Faye had hidden their precarious financial condition from her son in trying to protect him from more disappointment.

Faye set rules and regulations she felt appropriate for a fifteen-year-old, complete with sanctions, and their homelife gradually improved. And so did their communication. "Things are pretty decent around here these days," she says. "I feel okay about setting limits for Joey now. I don't feel anymore that my running the show my way is unfair to him and I don't feel guilty about it, either. After all, I'm the adult and he's the kid and someone has to be in charge. I decided it was better for both of us if that person was me."

Faye also now sets aside two nights a week for herself. Some nights she dates, others she attends a lecture or concert alone, still others she socializes with women friends. The cycle of resenting Joey's restriction of her life is broken, because she no longer allows her single mother status to overwhelm her.

Unlike many displaced homemakers with whom I spoke, Faye now recognizes her need to get out and have a life of her own, and she acts on that need realistically so that both her needs and those of her son are met. She no longer uses Joey as an excuse not to participate in life, an action that almost invariably ends up in the mother's resenting her child. My friend Rosie, for instance, claims the reason she's staying home and living on child support money instead of getting a job is that she's more available for her children. Her boys are now ten and twelve and they're in school most of the day. The reality is that Rosie's afraid of life and she's using her sons as an excuse to stay hidden at home. When she finally realizes what she's lost, she'll undoubtedly resent her "sacrifice."

Gretchen, a widow of fifty-two, wonders if she's hiding from life, too. Although she has a far more active life than Rosie, Gretchen has stayed home for the four years since her husband's death because of her teen-age daughter Heidi. Her daughter also is the reason she gives for not dating. "I can't say I'm totally happy," she told me. "I feel boxed in. I look at my daughter and she looks like an adult to me, but she's only sixteen years old. She's very bright and responsible, but she doesn't seem to be going anywhere, so I'm being held back." Gretchen is a strong woman in many ways and she's made most of the adjustment to widowhood rather well. A native of Germany,

she met and married her husband in France, where she moved to find work after World War II. She came to the United States, leaving her family behind, learned a third language, and managed to raise her family well on her husband's limited income. While he was suffering a terminal illness, Gretchen went to a community college and graduated with honors. But now she feels responsible for patching up Heidi's life and, as a result, is holding up her own progress because of her daughter.

"She's one child who maybe is not as emotionally able to handle things as my other children were," Gretchen says. "She had to go through a lot of emotional trauma at a very early age. She lost two of her grandmothers, she lost her father, all of her sisters moved out of the house at the same time. So the only one for her to come home to is me. I don't know, if I were to go out and not be home for her, if she'd be able to handle it emotionally." So Gretchen has not tried to get a job.

Her social life, too, is curtailed because of Heidi. "I'm not dating and I wonder at this point in my life whether I use my daughter as an excuse. I have lots of male friends who I can sit down and talk with, but I would be afraid of a very close relationship. I've talked about this many times with my daughter. I asked her how she would feel if a man were coming in to see me and she told me, 'Mother, I couldn't stand for you to bring a man into the house.' She is a very studious type of person and she was very close to her father. They used to play guitar together and go fishing together. Now she has literally buried herself in her studies.

"I've said to her, 'Honey, don't you think Mother has a right to some happiness?' And she says, 'I don't mind if

you go out, but don't bring anyone home.' I went out several times with a man and she would sit up and wait for me. I said, 'Honey, why don't you go to bed?' and she said, 'I can't go to bed until you're home.'"

When it comes to dating, Gretchen and Heidi have virtually switched roles—Heidi is playing the protective mother and Gretchen the dutiful daughter. This is not unusual; many displaced homemakers have told me that their teen-age children became regular chaperones. The children felt the memories of their fathers were threatened when their mothers began to date again.

If Mother lives just as she did before, kids can feel it's almost like having Dad back home again. Each change—whether it's a new man or a new house or a new job—reminds them of their father's departure. But perpetuating the myth that nothing has changed when, in fact, everything has changed, is not emotionally healthy. Children, like their displaced homemaker mothers, must face reality eventually.

And as adult women, displaced homemakers have "a right to some happiness," as Gretchen puts it—if they have the courage to grasp it. It's easy to disguise fear of getting out in the world as duty to the children but, in the end, kids lose and so do their mothers. The children gain only an image of a martyred, self-sacrificing mother and Mom gains eventual resentment of her children for restricting her life.

One thing Gretchen must consider is the role model she's offering Heidi—that of a woman as one who sacrifices everything for her children. How, then, will Heidi live her own life any differently than her mother is doing?

It's important to realize that mothers are the major role model for their daughters, whether they're living a life as a homemaker, being divorced or widowed, starting a career, taking or rejecting lovers, or anything else. We must ask ourselves if what we're modeling for our daughters is really what we want them to be. As Irene Kassorla says, children are affected by their parents whether the parents want them to be or not. They will either repeat their parents' behavior or try to do the opposite, and it's with the daughters that a mother has the greatest influence.

The best example I have to illustrate how daughters can react to their mother's becoming a displaced homemaker involves Gail and Anne, the twenty-three- and twenty-two-year-old daughters of Myrna, a woman who was divorced when she was in her mid-forties. Both Gail and Anne were married and living away from home when their father left their mother, the end result of more than twenty years of marital strife, but that's where their resemblance to each other ends. Both young women felt the influence of their mother's example throughout their childhood years, but they reacted to it in opposite ways. And they reacted to their parents' divorce in opposite ways, too.

During their teen-age years, Gail and her mother fought constantly—about Gail's dates, her grades, her clothes and hair, her drinking, her use of marijuana. Anne, on the other hand, got along well with Myrna and fights between them were infrequent. When she was nineteen, Gail moved away from home and went to live with her boyfriend, the man she married a year later. Once married, she seemed to be over her rebellion and settled in to repeating her mother's life. She gave birth to

her own daughter when she was twenty-one. Myrna, seemingly pleased that Gail had "shaped up" and become an obedient wife, called off her constant criticism of her older daughter and an uneasy truce was declared between them. Gail became determined to play the role of traditional, subservient wife and mother better than her own mother did, however, and as a result seems destined to repeat her mother's mistakes.

Anne also married at twenty, possibly because she wanted to escape the home tensions, and that was easier to do by marrying than by striking out on her own. But she didn't settle into homemaking the way her sister did. Anne took a full-time job and earned a college degree at the same time, becoming her mother's antithesis—a superachieving career woman. At the same time, Anne has decided never to have children, and she refuses to cook, sew, keep house, or do anything else she defines as homemaking. She will go to almost any extreme to avoid being like her mother and, in the process, is denying herself many of the pleasures of womanhood.

The reactions of these two young women when their father finally did what he'd been contemplating for years, filed for divorce, were also quite opposite. Ironically, Gail readily sided with her mother, the parent with whom she'd endured continual strife as a teen-ager. Despite the fact that her father had often sided with her during these altercations, Gail identified with her mother and took her part, cutting off her father completely.

"A married woman whose parents divorce often feels very threatened and vulnerable," says Dr. Kassorla. "She might be afraid it could happen to her. 'Will my mate get

the idea from this?' she asks herself. There are all sorts of negative feelings that arise from this situation."

Both Gail and Anne felt that threat to their marriages. Gail reacted to it by blaming her father. "It won't happen to me," she told herself, "because I'm married to a man who's a much better person than my father is." Instead of learning to be more independent than her mother, to give herself some protection if, indeed, she someday has to support herself and her baby, she's retreated further into dependency on her husband.

Another part of Gail's reaction is that, if only her mother had been better at the role of wife and mother, she could have held her man and she wouldn't be divorced today. So Gail is putting her extra efforts into her home. Her floors will be shinier, her oven cleaner, her cooking tastier than her mother's ever were. That way, she feels, she'll be protected from ever becoming a displaced homemaker herself—something every one of the millions of displaced homemakers in this country can tell her is faulty reasoning.

During the divorce Anne, unlike her sister, tried to maintain contact with both her parents and not to blame either. She played the efficient businesswoman role even during this time of family crisis—relaying messages, helping divide her parents' assets, trying to soothe flaring tempers. But it took its toll on her. Inevitably, both parents asked too much of her, then became angry with her when she couldn't deliver. Both vented their rage with their divorcing spouse on her. And Anne suffered. In the end, she and her husband moved a thousand miles away, largely to get out of the middle of the squabbling.

Both Anne and Gail are feeling the effects of their cha-

otic and stressful childhoods as well as their parents' divorce. Because they are reacting in opposite ways doesn't lessen the fact that both are being harmed by those reactions. Gail is missing her father's companionship and drinking in her mother's venomous attacks against the man who gave her life and was her strongest supporter when she was a girl. She's also failing to learn from her mother's mistakes and seems destined to repeat them. If anything, Gail is even more of a dependent child-wife than her mother was.

And Anne is denying herself frequent contact with either of her parents. She's also avoiding both having a family of her own and domestic endeavors she might enjoy in her determined attempt to be unlike her mother and sister.

Myrna, for her part, is helping to create her daughters' unhappiness, as she's done throughout their childhoods, because it's become far more important to her to try to turn them against their father than to see them have a healthy and happy relationship with him. She's providing them with a role model of women as bitter, whining, dependent creatures, as well. And her actions are making it very difficult for either of her daughters to grow into strong, emotionally healthy adults.

As mothers, if our children's welfare is important to us, we must be cognizant of the pressures and stresses the ending of our marriages places on them. And we must help them to deal with those pressures and stresses as best we can. Sometimes this means getting them psychological help. Always it means curbing our tongues when we're tempted to speak ill of our former husbands. We

must remember that these men are our children's fathers and, in that role, deserving of their sons' and daughters' respect and love. Or, if that's undeserved, it's up to the kids—not to us—to determine that fact.

Sometimes, of course, all our best efforts to help and guide our children result in disappointment—as they sometimes do in two-parent families. After all, our children are separate people and, in the end, they direct their own lives. Gail's father, for example, finds he can do nothing to win back his daughter. Gail is an adult and she has decided, for whatever neurotic reasons, to excise him from her life and that of his only grandchild. She may someday regret that decision and take steps to rectify it but, until that happens, her father is powerless to change it. And, if Gail's decision had gone against her mother instead of her father, Myrna, too, would have found herself powerless to re-establish a strong connection with her older daughter.

Such a disappointment does sometimes happen to mothers, no matter what they do or say. It happened to Tina, a trim and attractive forty-nine-year-old divorcee. "My husband just completely left our life when we divorced," she told me, "and I was left to raise Steve by myself. That was thirteen years ago, when Steve was eight. I sacrificed everything for that kid—money, jobs, dates. And what did it get me?"

Tina managed to move economically from being a displaced homemaker who hadn't worked in years to a status as a well-paid professional. Some of what she's earned has put Steve through a private high school and paid his tuition for college, which he has yet to complete. "I tried to give him everything he needed—money, atten-

tion, love—but no matter what I did, it was never enough," Tina says. "He's never given me back anything, not even courtesy. I'll give you an example. Three years ago, he moved into his own place and I bought him a living room set for his new apartment. I asked to see how it looked after it had been delivered. Well, I still haven't been invited to his place. Obviously there have been times that would have been convenient. It's been three years! But I still haven't been invited to see the furniture Steve allowed me to pay for."

Today, Tina is working with a therapist on several emotional problems, one of which is her non-relationship with her only child. And she's learned to be philosophical about her power in that situation. "There's nothing I can do to force Steve to love me or to treat me the way I want my son to treat me. I can't make a twenty-one-year-old man love me. All I can do is try not to let this depress me, and refuse to allow Steve to abuse me."

It's not the warm mother–son connection Tina would like to have, but it's all she has and there's really nothing she can do to change him. She can change only herself.

Sometimes such relationships do improve, however, with time. Tina hopes hers will. Angela has two sons and she feels that, during the six years since her divorce, her relationship with them has gone at least from bad to acceptable, though not yet to superb. Maybe that will come someday, too.

When Angela was divorced, her sons were thirteen and nine, and both chose to live with their father rather than with her. "For several years, I didn't even tell people I had children," she admits. "It really hurt that they would choose to go with him. It's not that he's a bad person.

He's not. It's just that I always thought kids should be with their mother. I guess I was ashamed as much as I was hurt."

Angela's ex-husband was better able to provide for his sons than she, at least on a financial basis. And he did put a great effort into "mothering" them as well as "fathering." After an initial period when Angela allowed her shattered ego to keep her away from her children, she reinitiated contact with them. "I know now they never really hated me, even though I thought at the time that they did. It's odd. I never would have concluded that they hated their father if they'd chosen to live with me instead of him. It's the sex stereotypes we all carry, I think. Children are supposed to be with the mother unless she's unfit and I didn't like feeling my kids thought I was an unfit mother."

Today, Angela's older son has gone to work in another state, but she sees her younger son frequently and she and his father are co-operating in getting him psychological help to handle some problems he's having in school. The boy often spends the night with Angela when his father is out of town on business and she feels much better about her relationship with him. "I am no longer ashamed to tell people about my sons," she says. "To be honest, part of that is probably because they're older now. It doesn't sound quite so bad to say my fifteen-year-old is living with his dad. But another part of it is that I've realized that I love both of them and my cutting off connections because of hurt feelings will only hurt all of us."

Even with her improved attitude, however, Angela realizes that her control over the situation is limited. Her

ex-husband has legal custody of the younger boy and will have until he reaches eighteen. He makes the decisions vital to his son's life. Angela has input, but only so far as her former spouse wishes to heed it. She, on the other hand, has the freedom traditionally awarded to divorced men. She needn't cope with the day-to-day irritations and headaches of raising children, and she needn't be the primary disciplinarian. So she can play the "father-Santa Claus" role if she wishes.

Perhaps the most valuable thing we as mothers can do when our marriages end—as at any other time in our lives—is to recognize and speak the truth. We must recognize the crisis our children face as clearly as we recognize our own. We must be truthful with them about the changes in their lives and ours, and about the reasons for those changes. We must realize that what they say and do is not always what they really intend, that they may either be acting out their frustrations and disappointments or burying them. And, if their emotional reactions become negative or destructive, we must act on their need for psychological help in dealing with their loss. No matter what their age, we must be careful not to lay our burdens, our frustrations, our disappointments, our anger on their shoulders. They have enough of their own. And we must have the maturity to recognize what we can and cannot change about our children's lives. They are individual human beings and, as they grow older, we find we cannot control them forever. We can do for them what we feel is best and we can change ourselves and our reactions to them, but that ultimately is where our power over our children ends. At some point, they will make their own decisions and live their own lives.

With the end of our marriages, we are no longer wives. Our lives are drastically altered and, along with that, our relationships with our children are equally changed. But one thing does not change, whether we're widowed, divorced or separated: we remain our children's mothers. And, as loving, concerned mothers, we want the best possible life for our children. Helping them achieve that goal is not easy, but the effort can be one of the most rewarding we'll ever make.

7

The Altered Kinships He Left Behind

When a woman becomes a displaced homemaker, many relationships besides her marriage undergo change. As we have just seen, her connection with her children is primary among these altered kinships. In addition, she must learn to deal with her own parents, who, in the case of divorce, may make her feel she's failed them. She must deal with her former in-laws. And, most of all, she must deal with her former spouse. Coming to terms with this last altered relationship is vital to her mental health. If she is widowed, this means terminating the marriage in her

mind. And, if she is divorced or separated, she must learn not to squander her energy in bitterness against her ex-husband.

When a woman encounters a major crisis in her life, such as the loss of a husband, she often craves comfort and reassurance of the kind she got as a child. So, in many ways, it's a natural desire to want the comfort of one's parents, an opportunity to revert into that protected child state with the people who offered it to her originally.

While such a retreat might seem a temporary balm for the wounds of a recently widowed, divorced or separated woman, it's seldom possible. Many of the parents of the displaced homemakers to whom I spoke were either deceased or so elderly that they were of little solace to their daughters. Others lived far away. And even those women whose parents were alive and lived nearby often found them to be of little help when their marriages ended.

Rachel, for instance, the woman whose husband raped and beat her before she left him, went to her father for help and advice. "He was against my walking out," she said, "because he felt you stayed together no matter what —even if you were miserable—because of the children. My father really is just as authoritarian as my husband and he thought I belonged at home." When her father refused to give her emotional support, Rachel was too proud to ask him for financial support of any kind, and none was offered. "I guess I'm better off just keeping my privacy," she says.

Many parents of displaced homemakers, often in their sixties or older, simply do not understand a world in which one couple in three divorces. So, many times, they

tend not to help their daughters even when the split has not been at their instigation. A parent's lack of support becomes one more blow to a battered ego. Yvonne felt this when her marriage broke up after her husband's three-year affair with her former best friend. Her elderly parents had been missionaries and lived under a strict religious code, one which did not include divorce. "My parents were devastated when we told them we were divorcing," she says. "They were really overwhelmed. There had never been a divorce in the family until the last few years and my parents were old. My older brother also applied for a divorce and, with him, my mother just simply stopped thinking of him as her son and turned his picture to the wall. Awful things. She felt you just didn't get divorced. I'm sure it reflected some of the unresolved problems in her own marriage, problems that she'd never even talked about.

"With me, she was a little more supportive. Somehow, I had been her white hope. She had been a teacher as a young woman, she'd gone to China and had borne her two sons there. I was born in the States and I was a daughter. I had two sons, too, and only after my daughter was born did I realize there is a difference. There's a true kind of identification between mothers and daughters. So, with me, she felt I'd been a good person. She'd always seen my brother as kind of wild. But she didn't know all my bad parts, or she didn't choose to see them." So Yvonne had to be content that her picture, at least, wasn't turned to the wall. Her parents didn't disown her, but she still feels that her divorce has caused them great heartache. She still feels a responsibility for their deep

disappointment. And she still feels she has somehow failed them.

Often traditional religious views, like the ones held by Yvonne's parents, keep parents and children apart when they could most use some support. Beatrice, a New York displaced homemaker, found that her strict Catholic upbringing worked against her when she divorced. "My family just didn't want to hear about it," she told me. "I really don't see them very often. My mother realized that her two daughters were both getting divorced and she just couldn't handle it. Now she's changed somewhat and become more supportive, but at the time she really didn't know what to do. She was almost seventy and she'd lived all her life with this very Catholic idea that marriage was forever. And she didn't know how I could ever make it with six kids. She said to me, 'You better stay and put up with whatever's going on and try to make the best of the situation.' She was very practical. I couldn't talk to my father about it at all."

Beatrice's mother's practical attitude is one I have heard many displaced homemakers express. One said, "Here I was, thinking I was doing this very brave thing, filing for divorce after years of hell with that man. I wanted my mother to applaud my courage. But all she said was, 'How can you and the kids possibly live? You'd better go back while he'll still have you.' I was really hurt. But I guess her generation saw marriage as largely a financial proposition. She was right in a way. I'm glad I didn't go back, but I did have a terrible time with money."

There are, I think, several reasons why parents withdraw from their daughters when they become displaced

homemakers. The first, which applies only to divorcees, is that they have a great deal invested in our following their own life patterns. When we divorce, we threaten the very foundations of their lives. They feel in one way that they have failed—either by not giving us a proper value system so we'd have stuck it out no matter what, or by not marrying us to the right man. And, also, they feel they must look at their own marriages in an attempt to find differences. Sometimes this is just too painful for them to do, so they avoid it—and us. As Carol, a divorcee of forty-two, said, "My marriage was practically identical to my parents', which may be the main thing that was wrong with it. Like my father, my husband was married to his career. He was gone all the time while I stayed home and ran the house and raised the kids alone. We had a nice house and membership in the same church and club as my parents. If anything, we had even more material possessions than my parents, and they thought that was fine. So, when I told them I wasn't satisfied, that I wanted something more, and that we were separating, they didn't know what to do. It was as though I'd told them their own marriage was garbage, as though I'd insulted them. So they pretended it wasn't happening. They didn't want to discuss it with me. They didn't want to know why. They didn't offer me any help. Nothing. I think they thought that, if that kind of life was good enough for them, why wasn't it good enough for me?"

Likewise, if the daughter's husband instigates the divorce, many parents have to believe she's done something terrible to cause it. If she hasn't, they then might have to recognize that the same thing could happen to their own marriage. In either case, our parents' generation has often

put more faith in the institution of marriage than in the people involved in it. There's no room for individual differences.

Another reason I see why parents withdraw at such a time is that they fear we'll become a burden on them, that, if they extend us any aid, we'll drain them. And this can apply to either divorcees or widows. Many parents, just at the time when they're worrying about retirement incomes or are planning a long-awaited cruise in the Mediterranean, are afraid their daughters will again become dependent on them, perhaps with a passel of kids in tow. "As soon as I told them my husband had left me," one displaced homemaker said of her parents, "they started telling me about how their house needed a new roof and my father's arthritis was acting up again. I got the whole litany of their financial problems. The really rotten thing was that I wouldn't have asked them for a dime."

If our parents' view of life says women are incapable of taking care of themselves, then what's the logical outcome when a married daughter's husband exits? That she'll again become dependent on them, of course. And, if they cannot afford or do not wish that dependence, they feel guilty and selfish. So the easiest thing for them to do under the circumstances is to urge the daughter back to her husband, in the case of divorce, or to withdraw from her before she has a chance to become dependent once again.

There's another reason, too, why our parents may feel guilty when we are left alone at midlife—because they lied to us about marriage as the ultimate security. The fairy tale they, along with the rest of society, fed us as

The Altered Kinships He Left Behind

children obviously has not worked out. And, even when happily-ever-after didn't work in their own lives, they have a lot invested in our following in their footsteps, miraculously avoiding the heartaches they felt and hid from us. This brings to mind a family I've known all my life. The mother, Leah, was married and a mother at seventeen. She and her husband had four children during a stormy twenty-year marriage tainted with alcoholism and liaisons with other women. He never allowed her to work outside their home, proclaiming, "If you get a job, it better pay enough to support you and four kids, because that's the day I walk out." In time, of course, he did walk out. Leah, at thirty-seven, without a high school diploma and never having worked a day for pay in her life, was suddenly a displaced homemaker.

Suffering the misery of a bad marriage, Leah advised her daughter, Leanna, "Don't marry a drinker." Two years before Leah's husband left her, Leanna, then eighteen, got married and had a child eight months later. In the following years, Leanna has had two more children. Her husband's love is not drink; it's his job, one at which he spends as many as sixteen hours a day while she sits at home doing the housework and chain-smoking cigarettes. Her authoritarian husband, who was also eighteen when they married, feels his wife's place is at home. He hasn't allowed Leanna to finish high school or get a job because he's jealous of the men she might meet. When he's home, they bicker constantly. It seems merely a matter of time before Leanna, now thirty-five years old, ends up like her mother.

What is surprising is that Leanna's advice to her own daughter, Ellen, now seventeen, is not, "Don't marry

young. Train for a career. Learn how to support yourself." It's, "Marry an older man who'll take care of you. Your father was too young to get married."

It's obviously too painful for either Leah or Leanna to admit that their choices in life were unsound, even when such an admission could help keep Ellen from making the same mistakes. They won't concede that marrying young and having children immediately might be the major problem. They won't recognize that marrying the kind of man who wants a dependent little girl for a wife might be a mistake. They refuse to realize that the idea that a woman will be provided for by her husband all her life is basically faulty—even when their own life experience proves it is. And Ellen, who has a steady boyfriend she's thinking of marrying, will likely be the next victim of this myth passed from mother to daughter through the generations.

When we were little girls, most of us were told again and again that we should marry a good, successful man who would take care of us forever. We believed this was possible. And we believed it because the people who reinforced it for us over and over again were our parents. Even when we saw that their marriages were not good, we didn't opt for a different life-style. We simply assumed that they didn't get the role quite right; we'd do better. When the charade falls apart for us, our parents, if they have any sensitivity at all, will feel a little guilty . . . because the promise they made to us has been broken.

All these reasons, and more, make it difficult for aging parents to cope with their daughters' changed circumstances. In addition, even if parents are able, finally, to

accept that the American dream has holes in it and that their daughters are now without a man to shield them from the seamy side of life, they often remain uncomfortable with many aspects of the single life. Primary among these is sex. "I've been divorced six years now," a forty-year-old woman told me, "and my parents have never once asked about anyone I'm dating. I think they're afraid I'll tell them I'm sleeping with somebody. They would disapprove, so they'd rather not know." Many elderly parents are caught in a bind here. They would like to see their daughters remarried and "safe" in the world, but they can't cope with the idea that they're dating and possibly having sex with men outside of the marriage bond. When these daughters were teen-agers and searching for a first husband, parents could cope through their belief that their girls were virgins. But now, after a lengthy marriage and perhaps several children, they know their daughters have become sexual women. Mores have changed, too, so they know it's likely the men their daughters date today want more than hand holding. And so do the daughters.

"When my mother found out I'd gone away for the weekend with a man, she wanted to know when we were getting married," another displaced homemaker said. "She couldn't understand that one didn't necessarily follow the other anymore. She also couldn't understand that I might not *want* to marry this man. She's sixty-eight and, to her, it was impossible to understand wanting to make love to someone and not wanting to be his wife."

The fact is that we cannot expect to get approval from parents who may subscribe to a different value system, one that never considered women could become dis-

placed homemakers. And we cannot expect them to change their values to suit our new status in the world. The answer, it seems, is not to seek their approval. As adult women we do not need our parents' permission to divorce, to earn and spend our own money, to have love affairs, to raise our children as we see best. We must overcome that little girl within each of us who still wants praise and approval from Mommy and Daddy for being "good." When we finally accept that we do, indeed, have a right to make our own decisions without being judged by our parents, they will probably accept that stance. When a woman becomes a displaced homemaker, her maturation process includes growing away from her parents' domination, as well as her husband's.

Most displaced homemakers can count on their children and their parents sticking by them when their marriages end, even if the relationship seems to be worsened temporarily. But, with our former in-laws, things can be very different.

The majority of displaced homemakers say their communications with their in-laws cease abruptly in the case of divorce and taper off in the case of widowhood. And this often comes as an unhappy surprise. Particularly hurt was Julia, whose husband had walked out on her after thirty-five years. "His family dropped me as soon as he moved out," she says. "After all the years of seeing their kids grow up and sharing . . . His family was always my family, because I didn't have any. I've known them for years, since I was seventeen, and I'm fifty-seven now. It hurts. I really feel I wasted all those years with them, I truly do. What is it with people? I don't understand. Now

that he has a girl friend, he takes *her* to all the family parties and they accept her."

Julia has found the hard truth behind the old adage "Blood is thicker than water." If anyone feels forced into a choice in a marital separation, it has to be his relatives. And logically they're going to choose him.

When there are children involved, of course, there still may be some contact with our former in-laws. They remain, after all, our children's relatives. So many displaced homemakers try to maintain a cordial relationship for their children's sake. That's what Yvonne did. "My father-in-law had always been very fond of me, very close to me, but when we divorced, he just cut me off at the pockets. I had to reopen the relationship for the sake of my children." She kept initiating contact, refusing to be snubbed, and eventually her children's grandfather came around. "He and my father have birthdays that are only one day apart, so we have birthday parties and the kids all come." Helpful is the fact that Yvonne's former husband is now living outside the country, so there is no crossing of paths at such family gatherings. "I think my ex-husband is grateful that I look out for his family, in a way," Yvonne says, "but he never communicates that. It's really too bad."

Despite her ability to patch things up with her former father-in-law, Yvonne had worse luck with her brother-in-law. "My husband's brother and his wife had been good friends of mine and they totally cut me off. My daughter used to spend time with them and she told me they never wanted her to talk about me. Subsequently, I heard they were having terrible problems with their own marriage. I was too threatening to them."

Even widows find relationships with in-laws often become strained, and this can cause even more heartache. It's understandable to most divorcees that their former in-laws would feel somewhat disloyal if they maintained closeness. But when a woman is widowed, a new coldness comes as a shock even though it is a common experience. "My mother-in-law still invites me to dinner on holidays," one widow told me, "but it's not the same. When Bill was alive, she was a lot happier to see me. Now all she wants to talk to me about is Bill, even though my life has changed. I loved my husband very much, but I'm starting to see other men and I think that hurts her. She doesn't want me to change; she wants me to build a shrine to her son. I suppose, too, that seeing me change and grow reminds her too painfully that Bill's dead."

Unlike her mother-in-law, this woman has accepted Bill's death. She has, in effect, come to terms with the facts of her altered life. She has changed the bond with her husband and has worked through her grief.

For widows, this process ends when the husband's death is recognized and accepted. But for divorcees, there is an ongoing relationship. The spouse is not gone forever; particularly if there are children, he may become a recurrent participant in many a divorcee's life. And this can be the most difficult altered kinship of all.

"A divorce is more difficult than being widowed," says counselor Mary Hirschfeld. "It's not like having lost a husband, because that ex-husband is around and you need to relate to him throughout the lives of your children." And this contact can be particularly painful until both former spouses recognize that a divorce is never only one person's fault. In fact, it can be essentially no

one's fault. Hirschfeld emphasizes that people change during a marriage and, when they change in different directions, "a divorce can eventually be a freeing thing."

It can take a long time for a divorcee to get to the point where she can think of herself as a free woman and recognize that both she and her former husband are better off. But when there are children involved, it's worth the effort.

Some of the women with whom I spoke were almost unable to talk to their ex-husbands about anything without becoming extremely upset. Feelings of hurt and betrayal were still too fresh for them. Others found their former spouses refusing to see or speak to them. Some managed to be civil when required, and they carefully refrained from using their children as repositories for their negative feelings about the former husband. And a few actually maintained friendships with these men who had been a major part of their lives for so many years, despite the unhappy end of the relationship. The last stance takes the most maturity, from both the woman and her ex-husband, and it seemed to be the most satisfying for both.

"We spent too many years worrying together about our kids, the house, whether or not he'd get his next promotion, how to pay all the bills, that kind of stuff," one displaced homemaker said, "never to speak to each other again. I felt bitter for a while, I'll admit, but when our daughter got married and we both were involved in giving her a beautiful wedding, I could see how silly it was for me to spend my energy keeping a war going. I feel a lot more relaxed now. If I have to call him about one of

the younger kids, I don't spend days getting an ulcer about it. I think we can be friends."

It's important, however, mental health experts agree, not to interpret friendship on the part of an ex-husband as hope that the marriage can be rekindled. One divorcee told me how she continually made that mistake. "I spent the first five years after I was divorced on an emotional roller coaster," she said. "Every time he asked me, I'd crawl back into bed with him. He had this strange hold over me sexually. Afterwards, I'd see he hadn't changed at all; he was still the same domineering guy he'd always been. I'd spend the next few weeks determined never to see him again . . . until the next time he called and was nice to me. Then it would start all over again."

A good relationship between divorced people is very different from one between married people, a fact that is often underlined by the entry of a second wife or girl friend. "My ex-husband used to write to me on our anniversaries and my birthdays," said one displaced homemaker, "and he would sign his notes, 'Love, Your Friend.' When he was in town a little while ago, he called me up to make a date for lunch and then he called back and said his wife didn't want him to go. That made me absolutely furious. I'm sure she runs him around with a ring in his nose. I haven't heard from him since."

Another displaced homemaker anticipated such a problem and averted it in a sensible way: "When he decided to get married again, he told me. Normally, I'd see him twice a month and we'd have lunch together, or sometimes we'd have dinner with our daughter. He said we could still maintain a relationship after he remarried, but I said to him, 'Why don't you call me every Wednesday

and that way I'll never have to call you? If anything comes up, I'll just save it until then.' So I'm never in the position of having to call him at home or at his office."

After a year or two, Dawne Schoenholz found in her study, most divorcees "were no longer bitter. When you share children and you care about them, there is contact. I think maybe three out of ten were still overtly hostile. Two of ten had former husbands who refused to see them. Five out of ten seemed to have worked out some sort of equitable relationship—'You live your life and I'll live mine and it's worked out better for both of us this way.'"

Becoming a displaced homemaker does rearrange a woman's relationships. It's vital to accept this simple fact, because expecting that nothing has changed or will change can be extremely destructive. Once we have accepted that a new single status brings with it altered expectations on everyone's part—our children's, our parents', our former in-laws', our ex-husband's, and our own—we can get on with our lives. We can work to improve those relationships over which we have some influence and to accept the end of those relationships over which we have no real control. And we can decide not to waste our energy on bitterness but to use it creating new friendships with those who will accept the new woman each of us— step by step—is becoming.

8

Money Is the Root

"It's terribly difficult to go down. When you've had insurance and money and a car and such and you took it all for granted—then suddenly you can't afford anything—it's very hard. I know what it is to have no money for food. I have gone hungry. My mother and father would turn over in their graves if they knew."

Divorced at fifty-six without a financial settlement or alimony, Dorothy still expresses rage on one subject—money. "It's absolutely degrading," she says. "My God, I gave all those years to this thing—this marriage, this relationship. I stayed home and had the kids so that he could

go out and do his thing, right? I have given one hell of a lot and I bitterly begrudge that nothing is owed me.

"Money is not my god; it's not the big thing in my life—but to eat is. And that, I think, we're owed, we displaced homemakers. And the worst thing is that we have to hide the fact that we're hungry. Our friends don't want to hear this, so we don't go around saying it. I used to put food for my son on a small plate so it would look like the plate was filled up. But I didn't tell my friends about it."

Sadly, Dorothy's situation is not unusual. Two thirds of the people living in poverty in this country are women, and older women who live alone constitute the single poorest group. More and more middle-aged and older women are finding out the hard way that their husbands simply are not going to support them for their lifetimes. Only 7 per cent of divorced women collect alimony regularly, and child support, when it is forthcoming, is usually not enough to keep a family in necessities without additional income. Women who remain married to their husbands have no guarantees of lifetime economic support, either. Many men have little or no life insurance coverage. And, in most states, a wife has small claim to a husband's estate if he chooses to exclude her in his will. Abigail McCarthy, herself a midlife divorcee, recently told Catholic women, "One wife on record helped her husband save two hundred and fifty thousand dollars by the most stringent economies—forgoing a home of their own, and raising and canning as much of their food as she could. He left it all to an animal shelter in memory of his dog!"

Tish Sommers of NOW's Task Force on Older Women constantly hears such tragic stories. One woman wrote

her: "I came out of the divorce court with a cash settlement of twenty-five hundred dollars and was told I was lucky to get it. I figured it out—twenty-three cents a day for thirty-one years of hard labor."

Tish is appalled that, even in supposedly fair community property states, women generally get a raw deal. "A first question to ask," she told a California committee studying legal equality, "is, 'What is community property?' For example, a woman came to talk to us this past week who was in the process of divorce after a twenty-year marriage. The husband had charged almost three thousand dollars in business expenses on his American Express card—such a credit rating! She is responsible for one half of these, as well as half the capital gains on the sale of their house, which she is forced to sell to pay him his half of the value. But his earning capacity, which she worked with him to create, is considered his alone. It's like the image of the fish and the fishing pole. She gets the fish, which will give her something to eat for a while, but he gets the fishing pole to continue to fish. Should not that pole be considered as community property?"

Since California enacted the first no-fault divorce law in the nation—it went into effect January 1, 1970—forty-six other states have followed suit. No-fault divorce, while it has eliminated the painful adversary nature of earlier courtroom scenes, has been termed a disaster for wives. The truth, however, is that divorce has never been a bonanza for women, regardless of the mythology surrounding it.

Dr. Karen Seal of Grossmont College in El Cajon, California, recently compared six hundred divorce cases in San Diego County before and after the enactment of the

no-fault law. She found that the median amount of alimony awards to wives fell 38.4 per cent—from $99 a month in 1968, under the adversary system, to $61, in 1968 dollars, under no-fault. The median child support awards dropped 18.7 per cent—from $75 a month to $61 a month in 1968 dollars under no-fault.

Dr. Seal, however, recognizes that things have simply gone from bad to worse. "Contrary to popular opinion, women divorced under the adversary system rarely received high alimony or substantial assets. In fact," she said, "the study indicated that support awards for alimony and child support on the average were substantially below poverty levels—and sometimes no awards were made at all (especially alimony awards). As bad as the financial settlements were under adversary, they got worse under no-fault."

Dr. Seal also found the following statistically significant changes since the introduction of no-fault divorce: husbands more frequently initiated divorces; alimony was awarded less frequently; child support was more likely to stop before the age of twenty-one; family assets were not so likely to be granted exclusively to the wife; and wives were increasingly required to help pay off the family's debts.

And, she stated, as small as the awards were, husbands' and fathers' full compliance with the courts' rulings were the exception. A classic 1968 study by Kenneth Eckhardt of 163 Wisconsin fathers agreed. It found that, at the end of the first year, only 38 per cent of the fathers were in full conformity. At the end of the tenth year, this figure was only 13 per cent. Wisconsin law clearly stated that non-support was a criminal offense, and although 84 per

cent of the fathers were in non-compliance at some time during the ten years, only 36 per cent experienced any legal action against them. Eckhardt found that those most likely to be prosecuted were blue collar workers, those men whose families had applied for welfare assistance, and men with prior criminal records.

In a 1974 study by Marian Winston for the Rand Corporation, a high incidence of non-support was found among affluent fathers, some of whom were professionals with six-figure incomes. Many of these men's former wives and children ended up on public assistance. Because of minimal efforts to prosecute the fathers, Winston found, the wives and children became public charges and the fathers were essentially relieved of their obligations.

There are a variety of reasons why support awarded by the court may not be forthcoming. Many men simply do not earn enough money to be able to support two families —at least not to support them well—so, when they remarry, they often decide the second family takes precedence over the first and terminate support. Anger is another strong factor. When a marriage has disintegrated into hate, some men feel justified in not supporting a woman to whom they're no longer married and toward whom they have such negative feelings. With child support, a common scenario connects visitation rights and financial support. What may happen is that a man is late with a payment, so his ex-wife refuses to allow him to see his children, even though this is an illegal action for her to take. Then, because he feels he's been wronged, he holds back on more support money. This cycle, of course, could just as easily begin with the ex-wife's keeping the

children from their father for some reason other than money and his retaliating with withholding the support.

Once a pattern of non-support has been set, it's very difficult to break it. It's particularly hard for the woman who has a minimal income but is not on welfare. She usually doesn't have the money to hire the necessary detectives and lawyers to track down and prosecute her former husband and, because she's not on public assistance, she will probably receive little aid from the authorities.

Ironically, figures show that it can be even more difficult to force those husbands and fathers who are most able to support their families to do so. Well-to-do men have more money to hire their own lawyers, often selecting ones who will intimidate their ex-wives with threats of custody fights or reductions in the amount of their awards if they prosecute. Wealthier men are also much more mobile in their jobs, often taking positions in other states. This adds greatly to the red tape involved in forcing them to comply with divorce court orders. And, as with any crime, the wealthy are far less likely to pay than are the less privileged. They have more connections among the powerful, so they are less likely to spend time in jail; often the only penalty they pay if they're successfully prosecuted is the back support money. The next week, they're back to withholding it, forcing the wife to prosecute once again.

Even under the best of circumstances, where a displaced homemaker is able to collect her support award on time and in its entirety, we are not talking about a lot of money. Dr. Karen Seal's San Diego study, for example, found that the median alimony award under no-fault divorce laws was only 42 per cent of what it costs a woman

to live at poverty level as defined by the U. S. Department of Commerce. The median child support award was only 37 per cent of what it costs to support that child on a moderate budget as defined by the U. S. Department of Labor. And child support, of course, terminates when the child reaches adulthood—usually defined as either eighteen or twenty-one.

Because of these discouraging facts, it's essential that women face their own financial futures squarely and unemotionally, develop their own earning capacity, and become educated in handling and investing money.

Displaced homemakers have not had to earn their own money, at least for many years, and for many this has been a point of pride. Ridiculous as it sounds when they are faced with having to support themselves because of an insufficient inheritance, financial settlement or alimony award, many women still feel never having earned their own money favorably labels them as feminine and lovable.

As little girls, we all learned that fathers give mothers money as proof of their love—and the more money, the greater the love. If mothers have to earn their own money and support themselves and their children, it proves either that the fathers don't love them enough (or they are inherently unlovable) or that they are castrating women who steal the fathers' function in life. This is a very simplified explanation, but I think it's a core reason why so many women feel uncomfortable earning and controlling their own money. They're afraid that to do so will cost them love. This myth that femininity—or lovability in women—equals dependency is one that's cost women dearly through the years, but it's also one that's

firmly entrenched in their psyches. Because of this conditioning from an early age, with women's resulting inability to earn a living and ignorance of the financial facts of life, females often become mere possessions themselves. And the road from being a possession to being able to earn enough money to maintain a desired standard of living is a long and difficult one—perhaps one that only partially can be achieved in midlife.

The first step is learning to understand money and overcome fear of it. Most longtime housewives have treated money in one of two ways—they handled it carelessly because there was always plenty of it available, or they never handled it at all, leaving that task solely to their husbands. Carolyn, a divorcee who was born into a rich family and was married to a rich man, was of the first type and she's lived to regret not having had the proper respect for money.

"When I was divorced," she says, "I didn't know what I really needed, what I deserved, or what I rightfully should have. I'd always had money, lots of it, and I couldn't imagine being without it. So I was really taken to the cleaners in my divorce. I've had to deal with a lot of feelings of resentment since then because he's making a quarter of a million dollars a year and I'm making nine hundred a month. He pays me a lousy two hundred dollars a month for the two children who are still under eighteen. The third one, who's in college, he pays me nothing for. I make nine hundred as a teacher and I have two children in college, myself in college, and it is a tremendous struggle. The really sad part about it is that, if I'd had the proper consultation and guidance, I wouldn't have any of these problems. I was so sheltered all those

years I didn't know what the real world was—as though I'd been living in another century."

Ironically, Carolyn now believes she married at twenty for financial security, which she had for the seventeen years the marriage lasted. Today, at forty-two, her world is filled with economic insecurity, but she feels freer and more in control. "It was a disastrous marriage from the first day," she recalls. "There never was any real depth of communication. There was tremendous loneliness and rejection and he was an alcoholic, too."

But he did give her the main thing she'd married him to get—"He was very successful financially. He's an insurance executive. Making money was his whole world. He hardly even learned the children's names. They're all girls, so he felt there was no possibility of their ever amounting to anything; he just washed his hands of them."

Carolyn's world was filled with houses at the shore, yachts, private airplanes, expensive clothes and entertaining in an upper-class social milieu. She was miserable. She needed human companionship, but instead she got charge accounts. They weren't enough. And this life-style definitely left her ill prepared for life as a displaced homemaker. "I barely knew how to write a check, never mind plan a budget," she says. "I only knew how to spend money, and very well. I had very expensive tastes and I've had to adapt to another sort of life-style since then, one that I don't like at all. I think it's very healthy that I've experienced this, but the other life is much more comfortable. Now it's a struggle all the time."

Carolyn found out what many other divorcees know—that it's very expensive, both financially and emotionally,

to get a good divorce settlement—and it's also very rare. She feels hers was extremely poor in consideration of her former husband's income bracket. She did get a lump sum cash settlement, but she used that to live on for five years while she earned her college degree, went on for a master's and got started on a Ph.D. She has the $200 a month, when it comes. "He has lapsed on that several times and has had to be threatened with being taken to court. He always pays the hour before he's due in court." The first time that happened, Carolyn and her daughters were living in Mexico so she could attend school there. As soon as she crossed the border, her husband stopped the child support payments. "I was there six months, I contacted hepatitis, and I had no support. I had to come back and I spent the next six months trying to collect the support from him."

That kind of game costs Carolyn even more money, because she's the one who has to hire a lawyer. "I've spent close to nine thousand dollars on lawyers so far," she says. Most of that amount was for the divorce itself, because "he fought it and he hid all his money, so I had to pay for the whole thing." Despite the fact that she's spent so much on attorney's fees, however, Carolyn does not feel she's been adequately represented. No one told her she was entitled to alimony or higher child support from a man with her ex-husband's earnings. "I think there are some things to be told to women who are getting divorced," she says bitterly. "One of them is you don't get divorced with a man judge. You also don't divorce with a male attorney, and you don't become a victim. At the time, I was so aware of how I was hurting my husband—how I was always his strength and I was taking that

away from him, in essence—that I did not take care of Carolyn. I didn't hire a lawyer who took care of Carolyn. And there wasn't a judge who took care of Carolyn, or anyone else. Nobody helped me and nobody advised me properly."

Even with the low amount of child support she was awarded, Carolyn says, "I can never be dependent on its coming. There's always the fear he won't send it."

In her vocational planning, too, Carolyn could have used some guidance she didn't get. She'd had three years of college when she was divorced, so it seemed to make sense to return and finish her degree. But six years later, she's still there, studying an interesting but not very marketable field for a white woman—African studies. "I had always attended school part time for something to do, but never toward a degree," she says, "so going seemed a natural thing to do. I knew when I divorced that I needed to make myself marketable." She went to school without working for the first two years and "the third year out, I got a part-time job with Head Start." She finally got a full-time job as a teacher when she'd been divorced more than five years and her financial settlement was fully depleted. She's now teaching elementary school in the ghetto, a job she enjoys but one that is emotionally draining. She comes home exhausted each day to face raising her children, a desk full of unpaid bills, and work on her dissertation.

"I don't see my load lightening," she says, "and that depresses me. I see it getting heavier because of the children going to college and the support being cut off, all support. I'll lose the support for the child who's turning eighteen this June, and she's going to college. I don't see

any hope of a permanent contract for me in the teaching field, because of tax cuts. They just don't give teaching contracts anymore. So I think my salary could be frozen at nine hundred dollars almost indefinitely. Particularly since I have so much education past my B.A., they will not want to contract with me, because they'd have to pay me too much. I wish I could see the load lightening, but I just can't."

Although Carolyn would like to teach at the college level, she feels that's an unlikely goal. "I wasn't wise enough to get my doctorate in anything that would be of help to me. I'll never be teaching apartheid of South Africa. As I look back, I started in this field years ago when I was just beginning to have some knowledge of what my economic straits were going to be, but I wasn't totally aware back then. At the time, I didn't know I'd end up teaching school. It's too late now. I think I'll finish the doctorate and, I don't know, look for other avenues of income . . . but I don't think that's very realistic. I don't have any business experience and I'm not very skilled, so I think it's highly unlikely that it would ever happen."

Right now, Carolyn's financial problems are overwhelming her, making it nearly impossible for her to see an end to them. And most of them could have been avoided had she reacted less emotionally and more logically at the time of her divorce and in the years since.

Marjorie, a fifty-nine-year-old widow, has also regretted the way in which she handled money when she became a displaced homemaker. "I knew nothing about money; I'd never had any that belonged to me before," she says. "I was fifty-six years old and I didn't even know what my

husband earned." Marjorie's husband had been a foreman in a manufacturing plant and they'd always lived frugally. They owned their own small house in an Illinois suburb and had managed to send their son to college and their daughter to secretarial school. Marjorie ran the household on a weekly allowance.

"I'd always thought he was just tight with money. Honest, I figured he was stashing it away somewhere because we had so little to spend. It seemed like I was always asking him for money for some little thing and he was always telling me, 'No.' When I got my hands on that insurance money, I felt like a kid in a candy store. I bought new furniture, new carpets, new clothes, a new car." With the funeral expenses, her $25,000 insurance policy was spent in less than a year. When Marjorie finally woke up to what she had done, she took a job as a sales clerk selling bras and girdles in a department store, sold her house and moved to a small apartment. "I didn't even get to take most of my new furniture with me," she says with irony. "It wouldn't fit in the apartment."

Marjorie's husband believed in rigidly traditional sex roles in marriage. "He felt that finances were his business and I didn't need to know anything about it. I loved him very much, but I'm furious with him for that. I could be living a whole lot better than I am now if I'd just known how to manage my money. Now all I've got left is about eight thousand dollars from selling the house and I'm using that up, a little at a time, because I don't earn enough to live on. I was lucky I could get a job. And I really don't know what I'd have done if we hadn't had that house."

Today, Marjorie realizes there were two things happen-

ing when she spent her way through that insurance money. One was that she didn't have any experience in handling money, but the other was that she was using it in a very emotional way. She was angry with her husband for dying and leaving her, so she spent "his money" with a vengeance. "I was getting back at him for all the years he wouldn't give me a dollar for stockings, I guess." And she was simultaneously drowning her grief over being widowed in new possessions. Like many of us, Marjorie felt temporarily better when she had a new piece of furniture or a new dress to admire. She became a financial junkie for a while. And now she's paying the price.

Even people who have all the money they need and want often suffer from inappropriate emotional attachments to it. My friend Marcie, for example—a woman who's been divorced twice, who earns more than $40,000 a year, and who owns real estate worth close to a million dollars—told me of a weekend trip to the country she recently took with a boyfriend who's considerably less well off than she. Marcie prides herself on being self-supporting and independent. "We were driving down a road," she told me, "when I saw a stand selling oranges. I asked him to stop the car so I could buy some. He did, but he didn't even offer to pay for them. What a cheapskate!" She was indignant that her date had not paid the dollar for something she wanted to buy. To Marcie, his failure to pay for the oranges equaled a failure to love her. To him, undoubtedly, it was simply allowing her the independence she's constantly saying she wants.

Many women feel ambivalent about money. It's hard to learn to use it seriously and to overcome our emotional

attachments to it, but a failure to try can have serious consequences. This failure cost Carolyn her divorce settlement and a decent monthly income. It cost Marjorie her inheritance and economic security for her old age. And it's cost Marcie several romantic relationships.

Displaced homemakers, experts agree, need sound financial advice before they make any major moves. "For too many women who receive a lump sum of money from a divorce settlement or insurance money," says counselor Mary Hirschfeld, "it's like there's no future. Their thoughts don't go beyond the end of that money. Some of them think they're going to find the knight on the white charger just in the nick of time—but if they do, he'll probably be feeding mouths in another home." And while they're looking, the money, like Carolyn's and Marjorie's, disappears.

Stan Benson, who sees many people in economic crises in his job as president of Consumer Credit Counselors of Los Angeles, lists divorce as one of the major reasons people today are floundering in debt. "Nationwide, half of the marriages are not making it," he says. "At the same time, one of the major causes of divorce is bad money management and arguing over bills. Add to that the cost of going through a divorce."

Benson says his organization is seeing many women with serious financial problems because "alimony and child support that were awarded them by the courts are not forthcoming. Maybe the father can't be found, he's skipped. If there were joint credit obligations and he can't be found and she has a source of income, the creditors have recourse against her.

"In addition, the woman has the problem of setting up a separate household. She may never have worked. Without the alimony and child support payments, she's now faced with a baby-sitting problem, with going back to school to learn how to make a living. She has big problems. We also see widows where the husband was not a good provider from the standpoint that he had no life insurance. Often women in this situation are forced into the welfare system."

Long before this can happen, Benson advises, displaced homemakers should set up a workable spending plan, decide whether or not they have enough income to live the way they desire, and, if not, make plans to increase their income. "They can get help anywhere with the spending plan," he says. "There are two hundred and twenty of our offices nationwide and you do not have to be in debt to use us." Consumer Credit Counselors is a service to debtors and credit users that is financed by creditors, the banks and department stores that issue credit to consumers. This community service is free and CCC also offers free courses in money management that displaced homemakers can attend.

The first move for any woman suddenly left alone in life is to determine exactly what her total income and assets really are. Her major assets probably are her divorce settlement or insurance benefits and her home. If the amount of money or the equity in her home are sizable, she should get sound financial advice immediately to help her decide how to invest what she has. A safe, well-chosen investment can provide a monthly income from earnings alone, leaving the principal intact.

Older displaced homemakers should explore possible

Social Security benefits to which they may be entitled. While housewives are not yet covered on their own behalf, new developments for some divorcees may help certain older displaced homemakers. The new rules state that a woman must have been married to a man for ten years in order to be eligible to collect any of his Social Security benefits. The previous requirement was twenty years. A divorcee can begin collecting such benefits when she is sixty-two, provided her former husband has retired. If her ex-husband has died, she can begin collecting benefits at age sixty. The catch here is that, if she remarries, she loses her claim to her previous husband's benefits.

Widows, at age sixty, are entitled to collect Social Security benefits, too, and a new ruling allows them to remarry after they reach that age without having to give up their deceased husbands' benefits. The advantage to widows in this new system is that a widow's benefits are approximately twice as much as a wife's benefits. If the widow remarries before age sixty, however, she's entitled to only the wife's portion of her new husband's benefits.

In any event, it's wise for a displaced homemaker approaching age sixty to contact her local Social Security office to determine what benefits, if any, she is entitled to collect.

Another source of income for divorcees is, of course, child support and alimony. But, as many women warn and statistics prove, it's unwise to count on this money arriving consistently. Divorcees should be aware of their legal right to have the government help them collect support money from their ex-husbands, however. For the woman who's been forced to go on welfare, the govern-

ment is delighted to try to collect from her ex-husband, because what he pays reduces her welfare benefits and therefore saves the taxpayers money. In fact, government estimates state that 90 per cent of welfare families are receiving benefits because of missing parents. As a result of these statistics, welfare recipients are required to aid authorities in locating and prosecuting their missing spouses. But despite new federal money available to help find missing welfare fathers, progress has been slow simply because there are so many of them. In Chicago, for instance, a new courtroom to hear cases involving collection of child support payments from such men was set up in late 1978. At that time, however, there was a backlog of about 1,500 cases waiting to be filed to collect payments and another 1,000 awaiting court hearings. Overall, the Department of Health, Education and Welfare considers its Child Support Enforcement Program to be very cost effective and successful, however. Nationally, in 1978, this program collected more than $1 billion from missing fathers, thus taking some 19,000 families off welfare.

For women who are not receiving welfare benefits, though, it's a different story. Theoretically, the local district attorney's office is available to help them through the Uniform Reciprocal Support Enforcement Act, a law designed to help women collect support even when their former husbands have left the state. While this can be helpful, it's far from a full solution to the problem of unpaid support. Enforcement takes a minimum of six months and often the authorities are unwilling to help women not on welfare. They claim their first priority is

welfare mothers and that they don't have enough time to help even them adequately.

A Baltimore mother of five, for example, who had a thirty-hour-a-week job where she earned less than $400 per month, told me of her efforts to get government help in collecting child support from her former husband, who had left the state. "My experience was totally negative," she said. "There is federal money to track down non-supportive parents, but while the money is there, you get very little support in terms of local officials in other states. They could care less about whether your husband is paying you alimony or child support if you're four states away. And I'm not on welfare, so even in Maryland, I don't get a whole lot of sympathy. They say, 'For God's sake, lady, you're out working. What do you want from us?' It makes me furious. I pay taxes and that's the money that's being used to pay people to do this."

If enough displaced homemakers insist on their legal rights, however, perhaps official action will someday be prompter. In any case, this service costs divorcees nothing and sometimes the threat of legal action is enough to spur errant fathers and husbands to meet their legal obligations. Women who wish to use this service should contact their local district attorney's office for help. They will need their divorce decrees and as much information about their former spouses as possible—such things as his address if known, his Social Security number, his driver's license number, and the name and address of his employer.

For women hoping for quicker action, a good attorney may be helpful. Here, of course, the woman must weigh how much she is likely to have to pay a lawyer for help-

ing her collect support against the amount she expects to collect. Most reputable attorneys will estimate clearly how much their fees will be and they will not encourage a woman to initiate an expensive court action until the former husband is at least several months in arrears.

If a displaced homemaker has or can readily get a job, she will add her wages to her total income as well. And any additional income, such as stock dividends, rental income or interest on savings accounts also should be included.

When each of these figures is computed on a monthly basis, it's time to finish the budget by estimating expenses. Basically, any budget must include such expenditures as housing, food, medical expenses, transportation, clothing, insurance payments, savings and miscellaneous expenses. Each of these categories has some flexibility, depending upon one's needs and desires. For example, living in a luxury apartment in New York City could cost more than $1,000 a month. But sharing a large house in rural Iowa could cost less than $100 a month. What kind of living space to choose depends upon one's income and goals. Or one woman might choose to—or have to—do all her own cooking, using the least expensive ingredients. Another might choose to eat all her meals in plush restaurants. Big problems start when the woman with the home-cooking finances begins to live like the woman with the restaurant budget. And almost any lump sum of money can be depleted by irresponsible spending habits or inflation.

In addition to a realistic understanding of what things cost and the income she has available, Stan Benson says,

it's vital that each woman establish her financial priorities. "You've got to have goals," he says, "and your goals have to be reflected in your spending plan. What do you want out of life financially? What's important? You can't have it all. If it's important to you to go to a concert once a week, then that's got to be part of your budget."

One area in which many people get into trouble is the category of miscellaneous expenses. That might include those concert tickets, an occasional evening baby-sitter, Christmas gifts, an emergency car repair. Because it can encompass so many expenditures, it's easy not to budget enough or to let it get out of hand.

To help them realize how much money can be spent almost unconsciously, when Benson and his associates counsel consumers, they ask them to write down all their expenditures for an entire month. Every cup of coffee, pack of gum, movie ticket, tube of lipstick. "It's an eye-opener," Benson says. "They're amazed at how much money just disappears every month, money they can save for things they now recognize as important to them." After a woman has gone through this exercise, she can do one of two things—either budget her expenses according to her actual expenditures, if she can afford it; or cut down on the less essential things.

In addition to making a spending plan, Benson advises that women have a checking account. "Paying your bills by check is a great way to keep personal records," he says. "But there's a danger in writing checks to cash. Avoid that."

Next, he advises opening a savings account. "Pay yourself first. Some money every month should be set aside for emergencies, a vacation, Christmas gifts, whatever

your goals are, immediate and long-term." This is even more important for displaced homemakers than for other people and it's a good idea to take enough to live on for at least six months from that divorce settlement or inheritance and put it in a readily accessible savings account. That will provide funds to pay the bills if the alimony doesn't arrive next month or if it takes longer than planned to find a job. Or it can pay college tuition or training expenses while the displaced homemaker prepares to earn a living. Living from hand to mouth is definitely not recommended for a woman alone in her middle years, if she can possibly avoid it.

Benson's next suggestion is to establish credit and learn to use it properly. There are many reasons to have credit, he says. It's important for emergencies—when the car breaks down on the freeway and we have only five dollars in our pockets, for example. It's often necessary for identification. Credit cards are safer than carrying cash. And, perhaps most important of all, credit allows us to purchase those necessities that cost more than we can save in advance—the $6,000 car or the $60,000 house.

Unfortunately, establishing credit as a displaced homemaker may be difficult, particularly if the woman took no steps to do so before her marriage ended. For many years, married women simply had no credit in their own names. When their husbands died, the wives' credit ratings died, too. When they divorced, wives often had to help pay off community debts, but their husbands walked off with the family credit history. In 1975, however, the Equal Credit Opportunity Act, which prohibits credit discrimination on the basis of, among other things, sex and marital status, went into effect. In addition, begin-

ning in 1977, the act provided that creditors who report histories to credit bureaus must report information on accounts shared by married persons in both the husband's and wife's names—if one of them requests that be done. A spokesperson for the Federal Trade Commission recommends to women, "If you are married, divorced, separated or widowed, you should make a special point to call or visit your local credit bureau to make sure that all relevant information normally carried by the credit bureau is in a credit file under *your own name*."

If a displaced homemaker feels she has been discriminated against because of her sex, marital status or age, she can complain to the creditor, sue the creditor in federal district court, or file a complaint with the FTC. Often the threat of a lawsuit or a formal complaint is enough to force a creditor's compliance with the law. I have used that procedure successfully. Despite having worked and earned either a salary or free-lance income for some dozen years and having had an excellent credit rating when married, I was denied a major bank credit card after I separated from my husband. When I inquired why, I received a form letter saying that the bank could find no credit rating in my name. I told them to check the state where my husband was living and where I had requested creditors to list my rating under my own name. They said they would do so, but again I was turned down. I once more requested an explanation and got a second copy of the same form letter. By that time, I was incensed, so I wrote a letter to the president of the bank in question, outlining my knowledge of my legal rights and threatening to file a complaint with the FTC.

Within a week, I received a phone call from the bank saying my credit card was in the mail.

I had similar trouble with a national department store chain with which my husband and I had had an account for thirteen years. I called their local credit office to protest being turned down for a card in my own name and demanded an explanation. I was told the reason was that my husband had made two late payments during the previous year—a year in which I had been separated from him. When I made it clear that I knew my rights under the Equal Credit Opportunity Act, again a card was forthcoming.

Ruth Baker, a Los Angeles real estate investor who has parlayed a $25,000 divorce settlement into a net worth approaching $2 million, advocates using a very aggressive approach to credit, which she did when she bought her first property. Ruth was divorced in 1969 at the age of thirty-nine. She had an eleven-year-old son to support and she felt real estate investing was a good route to eventual financial security for her and her child. She took the $25,000 equity from the house she'd received as a divorce settlement and found a ten-unit apartment building in which to invest it. "I was worried that I wouldn't get a loan, because I'd never had a mortgage in my own name before," she said, "but I decided I wasn't going to take no for an answer. I very carefully filled out the mortgage application and, when I turned it in to my bank, I accompanied it with a letter. I told them that I was positive I had a good credit rating, based on the years I was married, and that if they didn't give me the loan, I'd have to assume they were discriminating against me because I was a woman." Ruth got her loan. Over the following decade,

she's obtained many more mortgages in her own name—including a recent one in Texas for $4 million—as her financial success has pushed her to millionaire status. Ruth says, "You have to put them on notice right away that you won't stand for discrimination." Once her credit was established, she encountered no further trouble because of her sex or her divorced status. It's often only that initial step that's difficult.

For some displaced homemakers, establishing credit may take time. Experts advise beginning with a local department store charge account, which may carry a limit of around $100. Another recommendation is to take out a savings account loan, borrowing a few hundred dollars secured by funds in a savings account. These loans are generally available at favorable interest rates, and paying one back on time will help establish a credit rating. Such beginning steps should not be unattainable for most women. Being aware of their legal rights*—and pressing them when challenged—will definitely help, also.

Once credit is established, Stan Benson advises using it sparingly and carefully. In general, he says, no more than 20 per cent of one's net monthly income should go to credit obligations. "That would include all of your revolving charge accounts, department stores, oil company cards, loans with financial institutions, automobile payments, but not the housing, whether you're renting or paying a home mortgage." And a particularly good way to keep credit purchases under control is to pay off each bill in full when it arrives. That eliminates interest payments as well.

* A helpful pamphlet outlining the provisions of the Equal Credit Opportunity Act is available free from the Federal Trade Commission, Legal and Public Records, Room 130, Washington, D.C. 20580.

Another essential step in establishing a good financial plan, Benson says, is never to gamble—have insurance. "If you have an auto accident and there's a personal injury," he warns, "your income could be tied up for the rest of your life." Medical insurance is a must, too. Without insurance, even a simple operation can wipe out a displaced homemaker's savings and put her in debt for years. It's simply not worth the risk.

A final reality that must be planned for is inflation. With current inflation rates in double digits, no displaced homemaker on a fixed income can afford not to consider how much that income will buy her in years to come. If, for example, she lives comfortably on $1,000 a month today, current inflation rates continue and she establishes no hedge against them, she will need twice that much to live in the same style in only about seven years. From where will the second $1,000 come? Will her free spending and lack of planning today mean great hardship in the future?

Many divorcees, in particular, believe inflation won't be a problem for them because of clauses in their divorce agreements providing, at the court's discretion, for increases in support payments. "I'll just go back to court and get it increased" is a common attitude. First, of course, collecting child support and alimony at all over time is difficult. Second, a woman must have the money to hire a lawyer to procure such an increased award. Third, most support awards are not lifetime awards anyway and it's foolish to live as though they were. Children reach adulthood and their support terminates. And for that small percentage of women who receive alimony or spousal support, it's usually meant to be rehabilitative—

Money Is the Root

money for them to live on while they prepare to earn their own living. Fourth, if the former husband dies, the support terminates. I know a woman who is getting $600 a month in lifetime spousal support payments but, if her ex-husband dies, she will get a one-time life insurance payment of $10,000—only slightly more than one year's spousal support. Then she's on her own, an eventuality for which she's made no plans. Even for women who have been awarded a share of their former husband's pensions—and a recent Supreme Court ruling allows divorce courts to do this in the case of private pensions—this money can be collected only as long as he is alive. When the former husband dies, private pension support is terminated for the displaced homemaker.

For women who do have the lawyers' fees and the inclination to ask the court to order an increase in support payments, the prognosis is not particularly good, either. A typical defensive measure employed by ex-husbands is suddenly to discover financial reverses when dragged into court. That happened to one divorcee who'd been married to a successful psychiatrist and who was receiving support payments for three young children. "I guess I was lucky that my husband never reneged on the child support," she told me, "but the child support was precisely one hundred and fifteen dollars more than my rent. I know there are people worse off than that, but it was horrendous. I did not have enough money to buy milk, and I had an infant. After a few years, I tried to take it into court, because I knew he'd had an increase in income in that time. Then I got a letter from his lawyer that said, 'Thanks so much for bringing this matter to our attention. Now that we look at it, we see he's actually lost some in-

come and we're going to have to reduce your support.' They supplied copies of his income records put together by his CPA—not even IRS forms—and my support was reduced sixteen dollars a month."

There seem to be only two logical ways for a displaced homemaker to combat inflation. The first is to invest her money, if she has enough, in something that also inflates—perhaps real estate or a business. Expert advice is mandatory to minimize her risk. The second is to go after her own fishing pole—a job or self-employment that will allow her to earn her own living and her own retirement plan, so that her income future will be not fixed, but flexible. When she develops her earning capacity, it's also possible that she can earn a nest egg that can be invested in something that will grow and cushion her later years against financial hardship.

With a good understanding of budgeting, careful spending habits, and an unemotional approach to money, displaced homemakers should be able to avoid severe financial troubles. There are two reasons why some people do get into trouble, Stan Benson says—misfortune and mismanagement. "But they really blend. If I lose my job, that's misfortune. The mismanagement portion of it is that I didn't have three months' income set aside in a savings account to hold me over until I get another job. A medical setback is a misfortune, but the mismanagement is that I didn't have health insurance to pick up eighty per cent of the cost."

Most displaced homemakers have already had their share of misfortune. They know it can happen to them. But with a determination to take power over their own lives—in financial as well as in all other ways—they can

avoid mismanagement. They can overcome their fear and learn to make money work for them. They can learn to invest it and make it grow or to earn it themselves, and in the process they will gain independence, a core independence from which their new lives as single women will blossom.

With such determination and the right new attitudes toward money, no displaced homemaker need stay as economically destitute as Dorothy once was. She may never become a millionaire like Ruth Baker, but she can build a full life free of constant money worries.

She can, indeed, fashion her own fishing pole.

9

"I'm Just a Housewife, I Can't Really *Do* Anything"

When Jean went back to work at age forty, she took an entry-level position as a clerk typist, the same kind of job she'd held before becoming a full-time homemaker twenty years earlier. She felt this was the only position for which she was qualified, completely overlooking the fact that during her twenty years away from earning a

salary she'd held management positions as a volunteer for several charities and political organizations.

"I can't say I was discriminated against," she says, "because that was where I thought I belonged. That's where the work world thought I belonged, too, so we really weren't in disagreement."

Over the next five years, though, Jean earned a college degree while working and moved up in her organization, eventually capturing the director's post. If she had it to do over again, she would present her skills and abilities to potential employers in a very different way. She would aim much higher than a clerk's position. And she very likely would save herself several years of working in a job that bored her, paid a low salary, and failed to use more than a fraction of her talents.

Jean was a victim of a typical housewife's phobia—an unrealistic belief that she has no skills to offer a paying employer. This can be terribly debilitating for a displaced homemaker. Most find obtaining paying work to be absolutely necessary to their survival—if not immediately, then within a very few years. And, at the same time, many divorced and widowed women are suffering from battered and bruised egos. As a result, some hide within the walls of their homes, avoiding facing the employment market as long as they can. Others present their skills in such an apologetic and unprofessional manner that employers continually reject them. And still others, like Jean, get jobs, but are hired for positions which don't begin to use their total abilities.

All these pitfalls can be avoided—and have been by displaced homemakers who refused to be victims, either of their own poor self-images or of the work world's prej-

udices against them as older women. They learned to assess logically their value to an employer or to themselves as self-employers, they refused to endure discrimination, and, often with the support of other women who'd been in the same situation, they learned to believe in themselves. And, in many cases, they learned to look away from low-paid, traditional women's jobs to invade formerly male-dominated fields offering better pay and working conditions.

Cindy Marano of the Baltimore Center for Displaced Homemakers sees on a daily basis the damage the housewife's phobia does. "When many displaced homemakers go into a job interview and they're asked why they think they're appropriate for the job, they're not prepared to answer. They don't know what their skills are; in fact, they think they have no skills.

"I think one of the biggest issues is this whole societal idea that a person who's been a homemaker doesn't have skills. Not only does the woman feel that, but the employer feels that. Homemaking means many different things to different people. To some, it means professional sewing skills; to some it may mean magnificent craft skills; to some it means cooking and taking care of a home; to others it might be entertaining and doing almost political work for their husbands and the husbands' jobs. One woman we had here had repaired everything in her home."

Certainly all these things have paid counterparts in the work force, and many displaced homemakers have found them. One woman who'd sewed all her life found a well-to-do friend to back her in business and she became a fashion designer and clothing manufacturer. Another had

for years made hand-decorated Christmas ornaments that her family and friends admired. She, too, formed her own business—manufacturing kits so other people could make the ornaments. She operates it out of her home and now employs a staff of thirteen part-time workers. Still another woman, a gourmet cook, began a catering company. Other good cooks have opened small restaurants, supplied creatively decorated cakes to parties and taught cooking courses. Two imaginative women on the West Coast even began a business using all the errand-running skills they had acquired during the years they spent as homemakers. Correctly deducing that many of today's two-career families need someone to take the car in for repairs, get the poodle clipped, let in the washing machine repairman, shop for Christmas gifts, they hired themselves out at premium rates to do such chores and found a grateful clientele.

Opening one's own business, of course, can be extremely risky, particularly the type of business that requires an inventory of merchandise. In today's economic climate, starting a product-oriented small business should be done cautiously and only after obtaining expert advice and adequate financing. An easier kind of small business to establish, however, is one that provides services. For example, the Baltimore Center for Displaced Homemakers has helped clients set up eight successful cleaning businesses providing a much-needed service with little overhead.

Not all displaced homemakers who've learned to earn enough to live comfortably have started their own businesses, of course. Some have found they possessed skills that would get them jobs in traditionally male fields. For

example, one profession to which many women have always looked for work is sales—but it's usually been to selling blouses in a department store, telephone soliciting or punching a cash register in a supermarket. All are relatively low-paying jobs with little or no hope of advancement. Males who go into sales work, however, have generally fared much better and today many women are demanding—and getting—the jobs that once were held exclusively by men. One woman, for example, went to work for a department store, but got herself assigned to the furniture department, working on a commission, and made more than $15,000 her first year. "I know all about furniture," she said. "I redecorated my house several times. I helped my friends redecorate. I took a course once in furniture styles. The store was reluctant to hire me at first, I guess, but I told them, 'Who knows more about what furniture other women will buy than somebody like me? A middle-aged suburban woman? I've lived with the stuff, I've dusted it every day. I know what people will buy.' They gave me a chance. After all, how much could it cost them to try me? If I don't sell, I don't get paid."

Another woman became an insurance saleswoman, finding many of her customers among other women. She used many of the skills she'd developed in her years of club work. Still another took a sales personality she'd always had and learned to sell computer time. These jobs have a potential of well over $30,000 a year, a salary most women, even young ones, seldom even dream about. And it's a salary that even those women who are highly trained for "women's work" will never see—teachers, nurses, dental assistants, secretaries.

Barbara Zitelli, who counsels divorcing women about their financial future for a Los Angeles attorney's office, highly recommends sales work. "Most of the women I see have been married to highly successful men. They may get $30,000 a year in temporary spousal support, but in five years, that will be gone and they don't want to have to lower their standard of living. Where can a woman who hasn't worked for pay in many years make that kind of money? I think she's got to look to some kind of sales."

One of Zitelli's divorcees began in clerical work. "She went to work for an escrow company, where she got exposed to the real estate business. She decided to spend her evening hours studying for a real estate license. She passed the exam, got her license and worked herself into a spot selling second trust deeds. She's forty and now earning about thirty thousand dollars a year."

Another is a "lady who is selling wholesale handbags and watches. She gives parties—like Tupperware parties—in people's homes and shows her merchandise there. This is a new business for her, but so far she's making about two thousand a month," Zitelli says. This woman stumbled into the field while she was working as a job counselor in an employment agency, a job she hated. One day, someone came into the agency and asked her if she wanted to buy a watch. She began asking questions about the business and eventually went into it herself.

These women, Barbara Zitelli says, had spent their adult lives as housewives. "One of my ladies is a former Miss Las Vegas type, very pretty. She was married fifteen years and I'm sure she never opened her mouth all that time. She had absolutely no self-confidence. She told me she'd have to get a job in a boutique or department store.

But I asked her why, if she thought she could sell, she was willing to settle for three dollars an hour." With a less conventional sales job, this woman has now learned to be self-supporting and, with every sale she makes, her self-confidence grows.

A career in sales offers women flexible hours, a chance to be their own boss and average earnings of more than $20,000 a year. And today, women are no longer relegated to the low-paid, futureless sales clerk jobs. Now there are burgeoning opportunities for women in fields where sales*men* have always made excellent livings.

"Think about the typical supermarket," says Barbara Pletcher, president of Creative Sales Careers, Inc., in Sacramento, California. "Somebody sells the market every food product on those shelves." And somebody sells fabrics to dress manufacturers, drugs to hospitals and lumber to construction companies, too. Those salespeople earn much higher than average incomes and their earnings depend solely on their own efforts and success.

There are three basic types of sales jobs, Dr. Pletcher says. The first is retail sales, dealing with people who buy products and services for their own use. This includes that low-paid store clerk's position, but it also includes commission sales of "big ticket" items such as automobiles and condominiums.

The second is trade sales, selling to firms that in turn sell to customers at the retail level. A job in this field might be selling frozen foods to supermarkets or toys to toy stores.

And the third variety is industrial sales, selling products and services to buyers for use in producing other goods and services. Examples, Pletcher says, would be

selling sodium silicate to Procter and Gamble or steel to Ford Motor Company.

"Too many women, when they think of selling as a career, think only of Avon calling or Willie Loman dying," says Kathy Aaronson of Careers for Women, but sales can be much more—a career that offers women independence, financial freedom, creativity and a measure of security as well. Careers for Women was formed in New York in 1973 to consult with corporations wanting to add women to their sales staffs and to offer seminars and job placements to women desiring careers in selling. With offices in Los Angeles and San Francisco as well as New York, the firm now serves forty different industries and will handle only those jobs where a woman can earn between $25,000 and $50,000 per year after a short time on the job. "First year earnings average about eighteen thousand dollars," Aaronson says.

With Census Bureau statistics showing that the average American woman working full time earns only $8,618 per year, only 10 per cent of them earn more than $15,000 per year, and only 1 per cent earn more than $25,000, those figures sound awfully good. "And when you really take a look at that data," Aaronson says, "you'll find that most of the women in that top one per cent are in selling jobs."

What are some of those jobs? Audrey has one of them, selling lobsters to restaurants in Los Angeles. "I've been selling fish for about five years," she says, "and before that I was a secretary." Audrey was divorced nine years ago, after a fifteen-year marriage, and she was left with two sons to support. "When I was divorced, I'd never worked before. I couldn't even type. Luckily, I had a girl

friend who ran a secretarial service and she just let me sit there and practice until I learned."

When she was first divorced, Audrey was terrified of having to support herself and her children—and convinced she could never do it. "I even lived with a man for four years during that time so we'd eat on schedule. I think that was good for me, because it allowed me a transition period to get me into the work force." While the man was partially supporting her and her family, Audrey sharpened her secretarial skills and built up her self-confidence until she could get a good office job.

After four years as a secretary, though, Audrey says, "I finally thought, 'This is ridiculous.' If I were lucky, the most I could make doing this is a top of twelve hundred dollars a month. I think I was making nine hundred or a thousand then." So she took a risk and opened up her own secretarial service, getting free office space in a hotel in exchange for doing its secretarial work. While she was running her service, a friend who had access to wholesale clams asked her to call some restaurants and try to sell some of the clams. "I just opened the Yellow Pages and started calling," she says, "and the first week I sold forty-two bushels." Audrey was so successful that she closed her secretarial service and, with her friend, opened a fish business. When they later ran into financial trouble and sold the business, Audrey went with it as a salesperson and "that's when I really began to learn on the job," she says.

A few months ago, she learned someone was leaving a company that supplies lobsters to restaurants and she went after the job. "The manager checked me out, found I have a good reputation and a good list of clients and

hired me." She got the salary and commission she wanted.

Today, Audrey sells lobsters to restaurant chefs, working flexible hours that allow her ample time at home. Her earnings potential, she says, "is at least sixty or seventy thousand a year." She now makes about $35,000.

She sets her own hours and works as hard as she chooses. "It's difficult to say how many hours I put in," Audrey says. "I usually go to work about seven in the morning and stay there until noon or one o'clock, when I go out into the field. I'm out until somewhere between three and six. There are no set hours in this business. Someday, if I get valuable enough to a company, I could even work out of my home."

Audrey likes the money she earns—"I'm supporting myself and my sons much better than any man ever did," she says—and she also likes the personal freedom she enjoys. "I have a much greater feeling of self-worth now, more than I did when I felt like a machine in an office. I have freedom to come and go as I please; there's no clock watching here. I really am my own boss. And my selling has enhanced my social life, too. Not only do I meet people in my work, but my self-assurance attracts them to me. I'm out there on a basis other than looking for a man to support me."

Audrey has broken into a field she describes as "one hundred per cent a man's business," and she admits it was not without its difficulties at first. "I got a lot of verbal abuse as the first woman," she recalls, "and it took me a long time to establish myself as Audrey the businesswoman in this chauvinist world. But now I've earned the

respect of my customers and suppliers and I love it. It's extremely exciting."

Audrey's work has not interfered with raising her sons, she says. She never has to travel overnight, for one thing, a problem many women think all selling jobs entail. That's just not true, however, according to Barbara Pletcher. "If you live in a large metropolitan area, it shouldn't be too hard" to avoid traveling in a sales job, she says. "Just think in terms of the product before you take a job. There are basically two kinds—one is the kind where a small amount is sold to a large number of customers and the other is where a large, costly product is sold infrequently." An example of the former is a grocery item, which could easily be sold within a city or county. The second might be a data processing system, of which a salesperson might sell only one or two in a given city, necessitating at least regional travel.

Kathy Aaronson concurs. "If I sold office supplies, I might be able to make a good living sticking to three large high-rise office buildings. But if I were in charge of a national magazine's circulation, I might have to travel many states. Look at the product and its geography to see how much travel is likely to be required."

There are a variety of reasons why sales job availability is expanding for women and creating a good source of employment for those with homemaking skills. One reason, Dr. Pletcher thinks, is related to women's success in other fields. "As women earn more money, they are able to buy more big ticket items like automobiles. That makes it easier for other women to get jobs selling them these items. Women who want to make a large purchase appreciate being able to deal with someone who under-

stands their problems—and who understands better than another woman?" As a result, some companies are becoming very anxious to hire women, she says, including a large insurance company that recently contracted with her to run seminars designed to entice women into selling careers.

Aaronson adds that predicted business recessions will produce additional sales jobs for women. "Sales is one of the least vulnerable fields in a recession," she says. "Manufacturing and support people are laid off first. In a recession, women are allowed to enter new fields because companies don't want to pay fifty thousand dollars a year for a new employee. They'd rather pay fifteen thousand and give a woman a chance." Also, a recession is a time when businesses have too much inventory on hand, so they're likely to increase the size of their sales staffs in an effort to reduce it.

What does it take to become a top saleswoman? A combination of empathy and high ego drive, according to Barbara Pletcher. She defines empathy as the ability to put oneself in another's shoes—to understand the customer's needs from his or her point of view. "Ego drive," she says, "has been described as the need to make the sale, the need to succeed, the need to win. It is the internal force that gets you up and keeps you going. High ego drive is a combination of high energy and self-direction." Most women who've been homemakers for many years have developed a strong sense of empathy in their many nurturing roles. High ego drive may seem a bit less natural to them, but many, many women have it.

It took Audrey a few years to realize she had it. "I should have been in sales years ago," she says. "That's

where my abilities lie. But I never could have done it nine years ago, when I was divorced. I had absolutely no self-confidence then." It took her a few years in a traditionally female, non-aggressive job to improve her self-image, and then she was ready to go on to a more challenging and profitable career. Other displaced homemakers, those who feel their self-images need work before they're ready to handle a job where they're basically selling themselves, can follow Audrey's lead. They can spend some time in a "woman's job," maybe selling in that department store or boutique while working on assertiveness and self-confidence, and then move up to a selling job with career potential.

The number of products and services a woman can sell, of course, is practically endless, but Barbara Pletcher recommends limiting the search to ones a woman enjoys and about which she can be enthusiastic. "Women can use their existing experience to help them get a selling job, too," she says. For example, displaced homemakers with home sewing skills might sell textiles to fabric shops, those with an interest in houses could sell real estate, good cooks might sell foods to supermarkets, those with interior decorating skills could sell furniture or carpeting. Dr. Pletcher also recommends that women consider selling in those industries expected to grow over the next decade, for example, "anything in computing."

Perhaps the best thing about a selling career, as far as a displaced homemaker is concerned, is that the qualifications don't include anything she can't offer despite having spent many years in her home. Kathy Aaronson outlines the qualities for which she feels employers of saleswomen are looking: intelligence, good character, personality, mo-

tivation, verbal (and sometimes written) skills and appearance. Many larger corporations want their salespeople to have college degrees, often as evidence of their motivation, but not all. And the "medium to small ones function more off gut reactions to the woman," in Aaronson's experience, "and they're less likely to require a degree." In addition, once a woman has established a track record selling something major on commission, her educational record generally becomes unimportant to future employers.

Sales is just one of the fields in which displaced homemakers have used their housewives' skills in their new professions, skills they acquired running Girl Scout cookie drives and raising funds for the PTA. If they could collect door to door for the Cancer Fund, they found out, they could later sell real estate with just as much proficiency. One woman, who'd run a successful fund-raising drive for a local public television station, told me, "If you can raise thousands of dollars as a volunteer, with only volunteer workers, I think that takes a lot more skill than being able to do the same thing with paid workers." And it does. In the business world, if someone doesn't do his job, he gets fired. But, in the world of volunteerism, there's no such luxury as being able to fire an incompetent underling and hire someone else. The job has to be done despite such serious drawbacks. With her fund-raising experience on a volunteer basis, this woman acquired fantastic skills in administration, supervision, finance and fund raising, all of which are worth a high premium in the job market.

Many, many of the skills women have acquired and used in the home are translatable to paying jobs once

they're identified and promoted. A few examples—Cooking skills can lead to a job as a cook, chef or baker. A woman can use her housewife's driving skills to become a truck driver, cabdriver, chauffeur or bus driver. A typical mother's teaching skills can be turned into a job giving classes in something she does well—perhaps swimming, sewing, crafts or flower arranging. Gardening skills can be used toward a career in landscape architecture or a business supplying plants to offices and stores. Home decorating skills can be used to gain employment as a paperhanger, painter or interior decorator. Other assets, such as a gracious style of entertaining or an outgoing personality, can be used in sales, fund raising or political careers. The important thing for displaced homemakers is to look at their abilities in a different light; rather than discount them as "just homemaking," they must learn to translate them into those skills for which other people have always been paid.

Creative thinking about which jobs to pursue is becoming more important every day. Women can no longer afford to limit their earning potential as they did when their work was meant to earn only a second, peripheral income. Today, as displaced homemakers all eventually know, women need to be able to earn enough to support themselves and possibly their children as well. And this will mean being open to new kinds of careers for women, some of which will require training and some of which will require only a new way of presenting their existing talents. In the upcoming decade, many of the jobs that women have traditionally held simply will not be as available as they once were. Those that are still available

will become very competitive, a situation that invariably lowers salaries.

Today, the average woman earns only 60 per cent as much as the average man, and one important reason for that is "occupational segregation," according to Alexis Herman, director of the Women's Bureau of the U. S. Department of Labor. She points out that the Census Bureau lists 441 occupations, but almost all working women are concentrated into only twenty of them. "Seventy-nine per cent of women are in clerical work," Herman says. "Women account for 96 per cent of all typists, but only 1 per cent of the typewriter repairers. Most electricians—99.7 per cent of them—are men, and most stenographers are women; electricians earn an average of $330 a week, and stenographers, $159. Sure, lots of men are locked into dead-end jobs, too, but at least they pay more."

Because most working women are secretaries, sales clerks, bookkeepers, elementary school teachers and waitresses, laws mandating equal pay for equal work have not made much difference in women's earnings. Men and women have not been doing the same jobs, generally speaking, so the laws usually don't even apply. The earnings gap between men and women, in fact, is widening.

It seems clear that women, particularly women who must earn their complete support and who haven't the time to spend in lengthy education programs, must look to men's work. And women have done such work before—when society needed them to do it. Now they need it for themselves.

"We are the old Rosie the Riveters and Winnie the

Welders," says Milo Smith. She tells Oakland area employers that "we need short-term training for a relevant job market. During the war, they could do that, so why not now? I had absolutely no mechanical skills whatsoever, yet I was a riveter and I was trained in three weeks' time. I learned how to read a blueprint, how to cut out metal, how to build a framework, how to drill holes, how to countersink those holes, how to bend metal over that framework, and how to do blind riveting—all in three weeks' time. And every one of those steps I could go out and do again tomorrow."

Milo encourages displaced homemakers to look to the jobs the work world needs to have done, not to those in which women have traditionally been concentrated. There may be slightly more initial resistance to hiring women for such posts as lithographer, computer operator, government health inspector, truck driver, landscape architect, marketing researcher, medical records technician, paperhanger—all of which the Labor Department says will experience greater than average growth in the next ten years—but times are changing. Women are becoming more accepted in all fields. And if they go where the jobs are, their chances of being hired are better than they are in competing for a handful of positions as elementary school teachers.

The attitude of many employers is changing toward women workers but, unfortunately, the attitude of displaced homemakers toward non-traditional work often is not changing as rapidly, something that is of great concern to Cindy Marano. "When you look at the manpower statistics on the kind of jobs that are going to be available in the next ten years, it is terrifying. They're all the things

that women have not traditionally wanted to do. For example, air conditioning and heating work, data processing kinds of things, carpentry, a lot of technical fields. In the fields women have relied on in the past, they're not going to be able to get jobs." Many displaced homemakers are reluctant to change their thinking, and Cindy believes a major reason is that "a person who has just experienced something that relates very directly to her sense of herself as a woman finds this a real hard time to take a risk on her femininity. Her femininity feels like it's being threatened anyway."

Again, women are holding fast to a misconception about femininity that greatly harms them. Just as they believe that being dependent and childish equals femininity, they believe that if they have to work and exhibit some amount of independence by doing so, they can soften the situation by sticking to "women's work." Maybe, they hope, they'll somehow manage to feel womanly despite earning money. The problem is that the kind of work one does has little if anything to do with sexuality. But as long as women believe it does, they'll compete against each other for a declining number of jobs that pay only 60 per cent as much as "men's work." The only winner in this situation is, perhaps, the business world, because it will continue to have women as a source of cheap labor. Certainly the big losers are the women themselves.

There are many, many jobs displaced homemakers can do—and do well. And they're available in a wide variety of fields. These jobs require many different skills, some obtainable only through training and education and some

that displaced homemakers have acquired during their years as housewives.

One useful exercise to help women discover both their worth as individuals and their salable skills is to make a list of their achievements, even if, on first glance, they appear to have nothing to do with paid employment. For example, one woman's partial list might include:

> I am a good cook and I make one of the best chocolate cream pies in town.
>
> I was a Campfire Girl leader for eight years.
>
> I have an accident-free driving record.
>
> I once won a garden club prize for flower arranging.
>
> I am an excellent bridge player.
>
> I was president of the PTA for two years.

On the surface, none of these accomplishments may seem to provide immediate employment potential, but they all imply skills that might. Let's take each one and see what abilities this woman has that can be translated for the job market.

Her cooking skills, for example, could get her a job as a cook in a restaurant, hospital or nursing home. Or she might decide to go to school and train to become a full-fledged chef. She might also start her own business—either a small restaurant, a catering service or bakery specializing in that chocolate cream pie.

Anyone who has been a leader of a group of small girls for eight years knows well how to deal with children. She might find a job as a day care leader or take children into her home who need care while their parents work. She

might also teach classes for children in things she knows how to do well—perhaps cooking or handicrafts.

Her accident-free driving record, if she is a confident driver and enjoys it, has great potential for employment. After passing a test for an additional driver's license required by most states, she could become a chauffer, a cabdriver, a school bus driver, a municipal bus driver, a delivery person, a truck driver. Women are making inroads in these areas today. In many large cities, for example, a majority of the school bus drivers are now women. This is an example of a job that would combine her driving skills and the abilities she displayed as leader of the Campfire Girls.

Her abilities in flower arranging could land her a job doing just that in a flower shop. Or perhaps she could open her own flower shop. Alternatively, she could teach flower arranging in her spare time, earning a few dollars to supplement her income from another job. Perhaps she might decide to get additional training or begin in an entry-level position that could lead to a career in landscape architecture. Some women have even become gardeners, driving their own trucks and establishing a neighborhood route where they mow lawns, trim bushes and tend flowers.

Her bridge-playing skills might lead to her becoming a bridge instructor. But this talent also implies that she has a mathematical and logical mind. Probably she has the ability to train as a computer programmer, statistician, bookkeeper, accountant or for any of a dozen other math-related jobs.

Her tenure as president of the PTA testifies that she has administrative skills. She knows how to address

"I'm Just a Housewife..."

groups of people and how to call upon others to accomplish the tasks the organization needs to have done. She may have experience in running events and fund raising, as well. There are a variety of jobs using these particular skills in industry. A few include administrative assistant to an executive, director of volunteers for a hospital or charity and fund raiser or special events planner for a university.

From just this partial list of this woman's accomplishments, we've thought of more than two dozen possible jobs she could pursue. Working from a more complete list, she undoubtedly could come up with well over fifty.

Her task after such a brainstorming session is to begin narrowing down the possibilities to perhaps five or six to be sought actively. The three major tools for such a culling-out process are interests, values and feasibility.

Every displaced homemaker will know immediately whether or not she is interested in doing a job she might be able to get. For example, she might enjoy driving her car on shopping trips and to visit friends, but driving a cab all day might bore her. So she should strike cabdriver from her list of possible jobs. A problem has been known to arise with displaced homemakers who find themselves uninterested in doing *any* of the jobs on their lists. Usually this unrealistic attitude amounts to pouting over the necessity of having to work at all and it cures itself eventually—either when the woman matures and faces the reality of her situation or when she reaches her financial bottom and is forced to recognize it.

Her personal values are just as important as her interests, and she should carefully consider the following categories. First, how does she feel about the hours she will

work—the numbers of hours, the time of day or night, and the importance of flexible working time. A woman who wants to make sure that her working time doesn't interfere with her hours with her children, for example, should not pursue a demanding executive career or a sales job where she will have to work many nights.

Second, how important is the physical proximity of the job to her home? Is she willing to travel some distance for a better job? Or is she willing to move to another city?

Third, how important is money? How much must she earn to live? Is she willing to earn less now for hope of a future increase? Are fringe benefits such as health insurance more important to her than a higher income without such extras? If a woman has five children to support, for example, a job that includes paid medical and dental insurance for her entire family might be far more valuable to her than one that pays fifty or sixty dollars a month more without such benefits. A woman whose former husband pays her medical insurance might be better off with the job with the higher salary.

Fourth, does she work better under close supervision or alone? Someone who needs close supervision to get a job done, for example, will not do well in her own business or in commission sales. And someone who can't stand a supervisor looking over her shoulder will find working on an assembly line or in a stenographic pool slow torture.

Fifth, how does she feel about risk? Is she willing to take some risks now for possible future benefits or is security paramount? Someone who breaks into hives over thoughts of sporadic paychecks should avoid a job requiring extensive retraining or one that pays on a commission basis. She should aim for one with perhaps less future po-

tential but more immediate security for the sake of her mental health.

And sixth, does she work best alone or with others? Two women with excellent driving skills, for example, might pursue different jobs. One might do best driving a delivery truck, where she can be alone most of the day. The other might find that boring and lonely and would better enjoy driving a taxicab or a bus, where she would see other people.

The final, and perhaps most important, step in narrowing down possible jobs for a displaced homemaker is feasibility: is it realistic to believe she could be hired for and perform these specific jobs? For example, a middle-aged woman might make a marvelous flight attendant. She could combine her skills as a hostess with her cooking ability, her love of travel with the knowledge of first aid she practiced on her children as they grew up. The fact is, however, that airlines will not hire people over the age of about thirty for this job. For a displaced homemaker to waste her time pursuing such an occupation, at least until a lawsuit or government action opens it up to her category of worker, is to court rejection. It's simply not a feasible goal for her.

One of the most common mistakes displaced homemakers make is failing to check out carefully the availability of the job they desire and for which they prepare themselves. For example, Milo Smith said, "We had a woman in here last week, sixty years old, with a brand-new early childhood education credential. No way on God's green earth will any school system hire a new teacher at sixty years of age." Milo's particularly angry with schools and services that prey on displaced home-

makers, selling them things they can't use and don't need, such as the new credential in early childhood education. "This is the kind of thing they've been sold," she says, "re-entry and getting new degrees and so forth, and it's not helping them a bit."

This hopeful teacher didn't look realistically at her potential for employment once she'd earned that degree. Much the same thing happened to Carolyn when she decided to study for a Ph.D. in African studies. If she'd done it simply because she enjoys the subject as a hobby, that would be fine. But as a credential for future employment, it's not a realistic use of her time and money.

Yvonne found herself in a similar situation twice. She lost time, but now she feels she's recovering and beginning a career that is feasible for her. Her first move after she was divorced was to go back to school and study for a master's degree in art history, "in hopes that I could get a teaching job at a community college. I didn't have any career guidance. I had nobody to advise me that nobody wants a Medieval Byzantine art history scholar. I loved my two years' work, but I couldn't get a job."

Yvonne was distressed when she finally figured out that she wasn't going to be able to use her new degree. And she had examined her values well enough to know "I wanted something that had a professional caste to it. I worked in a bank once and it was awful." So she decided she'd like to become a counselor and went back to school for a second master's in counseling. But she'd picked another overpopulated field. "I still couldn't get a job," she said. "The main reason now was that I didn't have any recent paid experience. I had lots of people who were

willing to give me volunteer work, so I did some of that. I worked in a jail for a while and then I did some work with teen-agers." With this experience behind her, Yvonne got a CETA job teaching assertiveness training, a subject she'd never even taken. But she researched it well and, "I put together a really neat class that was geared toward helping women find jobs. It became a mainstay for the program."

But then that program closed down and Yvonne was once again unemployed. She collected unemployment insurance and took more classes. "When my unemployment money ended, I decided to use my new skills in how to get a job. I called everybody I knew and sent out resumes all over the place." She finally landed a job at one of the displaced homemakers centers, counseling other women who are divorced or widowed in midlife. One thing she tells them from her own experience is, "Going back to school is not the answer. I advise women that, if they like to study, going back to school has its own intrinsic value today. If they've got the time and the money, they should go, but it's not going to get them a job." A look at the number of unemployed and underemployed new young graduates should convince any displaced homemaker that a new degree is not a job guarantee. In fact, a better educational investment for her might be an assertiveness training course such as the one Yvonne developed—one that would help her learn how to present the credentials she already has to potential employers.

Whenever a displaced homemaker finds herself attracted to a job, it's imperative that she research its future before she spends her time and money pursuing it.

Many jobs are in particularly high demand today—college teaching and counseling, for example, as Yvonne found out. Others are glamorous and, as a result, always in short supply—broadcasting the news, for example. It's unlikely that a middle-aged woman with no recent paid work experience will be able to land a job like this. Other careers, however, according to government figures* are in plentiful supply—most positions in the health care industry, for instance—and would seem more attainable choices. Since displaced homemakers are already at a disadvantage in the job market, it makes good sense for them to pursue jobs that are now and will continue to be in plentiful supply.

Another important element of feasibility may be the financing a woman has available. Any displaced homemaker who contemplates starting her own small business, for example, must have enough capital if she is to succeed. According to Dr. Herbert Kierulff, head of the University of Southern California's Entrepreneur and Venture Management Program, most new businesses must be able to operate in the red for about six months before seeing a profit. And a major cause of failure of small businesses is undercapitalization. So any woman who aspires to be an entrepreneur must ask herself if she has the financial resources to weather such a time period. If not, can she obtain additional financing from banks or investors? Or perhaps she may decide to go into business with a partner. Intelligent, realistic planning can mean the

* A publication of the Labor Department, *Occupational Outlook Handbook*, lists employment prospects for hundreds of professions and is an excellent source of job ideas. It is available at most libraries or from the Government Printing Office, Washington, D.C. 20402. Enclose an $8.00 check payable to Superintendent of Documents.

difference between a business failure that costs a displaced homemaker her nest egg and a rousing success.

While no responsible advisor would tell a displaced homemaker she has as great an opportunity to achieve success in each and every profession as she would if she were twenty-one, the other extreme is also ridiculous. Homemakers, like everyone else, have skills, ones that can earn them a living. And they have the basic ability to learn a variety of new ones as well.

But a woman's biggest asset—one that many displaced homemakers must learn to develop—is a belief in herself. With a feeling of self-confidence, coupled with a careful analysis of her abilities and a thorough examination of the job market, any displaced homemaker can choose several occupations for which she is qualified and then embark on one of the most exciting journeys of her life—the one toward financial independence.

10

In Pursuit of a Paycheck

Selecting a handful of interesting jobs that a displaced homemaker feels she is qualified to do is a major part of her struggle toward economic self-sufficiency. The other part, of course, is actually finding and being hired for one of those jobs. And with the right kind of planning and the right attitudes toward herself and her future, that can be accomplished, too.

There are numerous books and pamphlets available on how to get a job and I won't attempt to duplicate them here. But there are some specific problems in job hunting

that are either unique to displaced homemakers or of more concern to them, and they are the ones about which I interviewed both the women themselves and several experts in job placement.

For a woman who's worked in her home for many, many years, the paid work force can be a threatening, frightening place. But the Catch-22 here is that, when a woman presents herself as a threatened, frightened job seeker, she generally doesn't get hired. The first problem any displaced homemaker faces, then, is to present herself as a confident, skilled potential employee despite her inner fears of inadequacy. And there are several ways to accomplish that.

It's vital to avoid going helter-skelter on job interviews before being totally prepared, because constant rejection makes it more difficult than ever to emerge from a downward spiral of self-pity. "We've had some displaced homemakers come to us who've had a hundred unsuccessful job interviews," says Cindy Marano of the Baltimore Center for Displaced Homemakers. "And if they were in bad psychological shape when the displacement happened, you can imagine what they're like after that many rejections. Certainly age and sex discrimination have an impact, but I think very few women in this category know how to present their skills to an employer." That's one of the tasks the center has undertaken and one it does best. Many of the women I spoke with across the country had made use of displaced homemakers centers and, to a person, they praised them highly. The centers provided them with a vitally important support group of other women who'd been in their position and had emerged successfully. They also provided peer counselors

to help displaced homemakers designate skills they had to offer employers and learn how to present them best. The centers, some of them funded under Title II of the Education Amendments of 1976 and others through state laws, exist in many parts of the country and their services are available free or at a nominal charge. Among the ways to find out where one may be operating locally are calling the state department of education, contacting the women's studies department of a local college or university, and asking the women's or family section staff of the local newspaper.

A woman may also write to the Displaced Homemakers Network, c/o BPW Foundation, 2012 Massachusetts Avenue, Northwest, Washington, D.C. 20036, for the name and address of resources for displaced homemakers available in her area.

For those women who do not have access to a displaced homemakers center or who choose not to use one, a similar support network can be formed among friends and many of the techniques the centers use can be borrowed.

Besides sex and age discrimination—things over which displaced homemakers have little, if any, control—the main reasons a woman may be turned down for a job are that she is unqualified (or not the best qualified candidate) or that she does not present herself professionally in an interview.

One excellent technique for making sure she is adequately qualified for a particular job is to research it as though she were preparing to give a report or write an article about it, a technique psychologist Mary Hirschfeld has recommended to many of her clients. "Find out as

much information as you can about what's going on out there," she advises. "I've encouraged some of my people to go out and do a survey. Go into a company and say, 'I'm doing a research study on career opportunities and would you be willing to talk to me?' People love to talk about themselves." This is an excellent method of finding out how others got their jobs, what a particular job is really like, and what qualifications are considered minimal for employment in the field. It also establishes contacts for the time when a displaced homemaker is prepared to begin interviewing for employment.

Sometimes such a study will determine that a woman does not have quite the necessary credentials for the job she desires, and this presents her with a couple options. One is that she can pursue a lower-level job with the same company and try to work her way up to the spot she ultimately wants. Hirschfeld cautions that women should not "define themselves by the jobs they're doing." So, if a woman sees herself as an eventual middle manager in a company, she shouldn't discount herself because she has to start as a bookkeeper or secretary.

Entry level positions in many companies today are fairly readily available, and the ones traditionally held by women are no longer as dead-end as they once were. Many businesses, because they have begun promoting from the ranks of clerical workers, are finding themselves left with bottom-rung vacancies that are hard to fill. "More women are being hired as managers or promoted to management, leaving secretarial positions open," according to Dennis Del Valle, director of Arizona's Lamson Business College. And those secretarial positions, as a

result, are becoming a source of employment for displaced homemakers.

Nancy McIntosh, executive director of Western Personnel Associates, agrees, adding, "The changing attitudes among women and their search for new and varied careers has also reduced the supply of clerical workers. A lot of students ignore clerical classes in high school because they plan to go on to college or enter another career field. Some economists say jobs aren't available, but we find that the biggest problem in the clerical field is finding people to fill the jobs." Because of this, McIntosh says, monthly salaries for clerical workers have risen about $100 over the past year, with starting salaries in the Phoenix area averaging between $750 and $980 a month. That's not a fortune, of course, but it's enough for a woman to live on until she can work herself up the ladder or obtain further schooling in her spare time—or even until she gains enough self-confidence from earning a salary to tackle a more demanding career.

Edith, a New York City displaced homemaker who was divorced at forty-nine, began with a low-level job and worked her way up. "I was married thirty years, since I was nineteen," she told me, "and I'd never worked for pay in my life. I didn't have a college education, either. I didn't know what I could do, but I like people and I have an outgoing personality."

Edith found a job as a receptionist in the personnel department of a major New York department store. The pay was low and the status not much higher, but she did her work well. And she took advantage of her opportunity. "During the months I was the receptionist, I talked with the job applicants while they were waiting to see an em-

ployment counselor. Sometimes we'd chat for half an hour or so, and I found I was getting a pretty clear impression of each one. I started discussing these impressions with the employment counselors and pretty soon somebody told the boss, 'You're wasting her talents using her as a receptionist. Make her a counselor, too.' And he did."

Edith stayed with the department store for another year, when, at the age of fifty-two, she was offered a job as a "head hunter" for the retail industry. Now she works on commission finding executives for department stores across the country. She has a professional level job where she earns a good income and she's essentially her own boss. Edith achieved her current status not by going back to school or getting new training, but by starting as a receptionist and progressing upward. Other women with initiative and drive can do it, too.

Another route for displaced homemakers who need additional credentials before they can obtain the jobs they want is the volunteer contract, created and implemented by Milo Smith and her staff at the Oakland Displaced Homemakers Center. "By using the contract," Milo explains, "you get your work validated at the level at which you worked. It's a negotiated contract between a place where a woman is seeking work experience and the woman herself. There's a payoff. The woman gets the type of work she wants, at the level she feels she's capable of handling, and the agency gets an employee without pay. But in return, that employee is there on time and her days are negotiated so the employer doesn't have to count on anyone floating in and out whenever she feels like it as a volunteer. It's a very structured thing. The

woman gets recent, validated work experience and references." She may eventually be hired for a paying job at the same organization, or she may use that experience to gain a similar job elsewhere.

The contract is just that—a written agreement signed by both the displaced homemaker and the employer. The Oakland Center's literature explains it as "a formal recognition that volunteer work is employment like any other, with mutual expectations and obligations from the volunteer and the agency. The contract spells these out, provides a written job description and specific needs of the volunteer, and in general treats the non-paid employee in the same manner as the paid. If future employment is a goal, this is clearly stated, so that the volunteer will be considered for job openings in the agency or elsewhere."

The beauty of this arrangement is that a woman is much more likely to be hired, and hired at a higher level, if a business or government agency doesn't have to pay her. On her part, she has an opportunity to prove herself and to learn a job by doing it. She gains the recent experience so many employers insist upon. Many colleges and universities use similar arrangements for students, often terming them unpaid internships.

The responsibilities of the agency contracting with a volunteer include: initial and ongoing training and supervision; keeping a personnel record that includes the contract, time sheets, work evaluations, etc.; promoting the woman or recommending her for further responsibilities when appropriate; giving her future work references; and covering her out-of-pocket expenses if the budget allows. The agency also designates an appropriate job title and the salary the woman would have earned if she had been

paid for her work, so she has a record of having worked in a specific position and at a certain income level when the volunteer contract ends and she is prepared to seek paid employment.

The woman's responsibilities include: fulfilling the agreed-upon time commitment; evaluating the supervision, training and volunteer policies of the employer for her displaced homemakers center; and evaluating her contracted responsibilities for the center.

As Milo Smith states, the volunteer contract is a way of validating the labor that women provide on a volunteer basis while they gain additional skills. For those women who can afford to live without income for the months they work on this basis—or for those who can set up a part-time paid work schedule elsewhere to mesh with a part-time volunteer contract schedule—it can be a great catch-up tool.

A similar volunteer contract idea has been implemented successfully by Project Re-Entry in Boston. "Our program is four years old," explains co-director Phyllis Adelberg. "It was started because we at the Civic Center and Clearing House were seeing women on an individual basis for career counseling and education. Even though they had counseling and learned to evaluate their skills, they were not being hired for jobs because they had no recent work experience. They'd generally been out of the work force for at least three to five years, often longer, and that can be deadly, particularly in the Boston area.

"We decided to add volunteer internships to the career counseling and education program we already had and we called that portion Project Re-Entry." While the project is not designed solely for displaced homemakers,

many of the women who've used its services fall into that category.

The original plan called for two to three months of career counseling and education, followed by a six-month, twenty-hour-a-week internship. After four years, however, "we found that women could gain the experience they need for paid employment in less than six months, so we cut down the internships to four months."

Project Re-Entry uses what it calls a reciprocal agreement between the woman and the agency. "It spells out the responsibilities of both so that the interns are not exploited," Adelberg says. The only major difference between Project Re-Entry's contract and the one used by the Oakland Displaced Homemakers Center is that the former does not designate a salary level for the volunteer. The volunteer job selected by Project Re-Entry must be one for which the agency would not hire anyone, Adelberg says, and it's usually part of a project the agency could not afford to implement if it had to pay salaries. "That way, our interns do not take a job away from anyone else." In addition, the position must be a closely supervised learning experience for the intern. And group discussion sessions for the women are offered by the project every two weeks.

"Most of our internships use general skills for non-specialized work," Adelberg explains. "For example, we don't offer internships in X-ray technology, because a woman who's trained to do that could easily get a paying job. Our women have transferable skills, such as communication, structuring, planning, co-ordinating skills, but they need recent, documented work experience to be employable."

The average age group served by Project Re-Entry is between thirty-five and forty-eight, and the average salary of women who become employed following their internships is $13,000 per year.

Nelda is one woman who used the program and she feels it was invaluable in helping her find paid employment. Nelda had been an elementary school teacher before her children were born, but she'd been a homemaker for more than seventeen years when the loss of her husband forced her into the work force.

"At first, I had some pretty unrealistic ideas about what jobs I could get," she admits. "I thought that, if I were interviewed for something, I should be hired, even if I didn't have the right background and couldn't do the work. Needless to say, I was rejected a lot. It can be very, very wearing on a person to be turned down over and over."

Then Nelda heard of Project Re-Entry and enrolled. She had two short internships arranged by the program. The first was with an art college, where she had a variety of administrative duties. "One thing I did was to make all the arrangements for a convention of national art administrators. I visited hotels and made arrangements with them and I contacted the City of Boston. I also did all the preliminary work in preparation for a summer institute for art students."

The second volunteer internship was with a theater company, where she worked "on demographics—making up a mailing list and determining which segments of the population to saturate with mailings." She also learned a great deal about how to run an office.

While she was working on her second internship, Nelda applied for a job managing a religious bookstore

and was chosen over forty other applicants. "I think the fact that I had the recent, documented volunteer experience was absolutely the determining factor in my being hired," she says. "I had an up-to-date resume with words like demographics on it. Without the support of Project Re-Entry, I'd probably still be trying to get a teaching job, because that's the only thing I'd ever done. And I'm sure I'd still be getting turned down, too."

Not only did the internships give Nelda recent work experience to put on her resume, they gave her confidence that she could do whatever was required of her in a paid position and do it successfully. "I experienced failure on my volunteer assignments and I overcame it. Now, if I do something wrong, at least it isn't hitting me for the first time, so it doesn't bother me so much." Her job now entails interviewing and hiring personnel, handling the store's budget, purchasing all the books and making a variety of management-level decisions. "On one hand, I'm doing all sorts of powerful things," she says, "but on the other hand, I'm still learning the ropes myself."

Other women who have used this kind of volunteer program—projects modeled after Project Re-Entry have been started at Columbia University in New York and at Drake University in Iowa, as well—have also been successful. One, for example, worked in a volunteer administrative capacity for the local bus company. Today, she's earning $20,000 a year as director of a van pool commuter project. And another who did a project involving signs and posters as a volunteer for the same bus company is now working as an executive director in art administration.

While it's obviously easier for a woman who has access to a Project Re-Entry or a displaced homemakers center to help her find and contract for an appropriate volunteer position, the methods these organizations use can be borrowed by women anywhere. All it takes is a thoughtful analysis of where they want to go professionally and what government agencies or non-profit organizations can provide them with the right experience. Most agencies of this type are happy to have unpaid help, particularly for special projects such as Nelda's convention planning and theater mailings. And, with the use of a contract similar to the ones described here, a woman can gain invaluable recent, documented experience to spur her into a desirable spot in the work force.

While having the appropriate skills and credentials for a job are vital, equally important is the personal impression a woman leaves with a potential employer. If she doesn't present herself in a professional and appealing way, chances are someone else will get the job. Unfortunately, because they have been sheltered from the work force for so long, many housewives simply do not know what they're expected to do and say in a job interview. Therefore, they don't present themselves to their best advantage, according to Bob Ehrman, associate dean of UCLA's Placement and Career Planning Center. "It's very difficult for women who've been out of the work force for fifteen or twenty years, who've not continued their education, who've not stayed active and who have let themselves physically go to pot, to re-enter the labor force," he says. "They have a hard time because they present themselves as housewives," and the work force is looking for professionals.

Ehrman's comments may seem harsh, but they were reinforced by many other personnel experts with whom I spoke. They agreed that one of the problems faced by many middle-aged women who've been away from paid labor for years is their physical appearance. It's easy to say that women are devalued by society as we get older—and that's very true—but it's also true that we often become stuck in the styles and fashions of past eras, usually the one in which we felt best about ourselves. Therefore, many housewives are still wearing their hair and doing their makeup the same way they did twenty or thirty years ago—when they were first married. Prior to a job search is an excellent time for a displaced homemaker to reassess how she looks to others, visit a beauty shop for a new hairdo and up-to-date instruction in makeup techniques, and perhaps shed those few extra pounds as well. Not only is a modern appearance an asset in a job search, it's a wonderful ego boost as well. Barbara Zitelli has recommended such action to many of the divorcees she's counseled, but she warns them, "You must pick styles that are appropriate to your age." Long straight hair hanging to the waist, for example, might be stunning on a slender twenty-year-old, but it would be very inappropriate for her mother.

Clothes make an important impression, too, and can greatly influence a job interview's outcome. "Some of my ladies have told me they can't possibly go to work because they'd have to buy a whole new wardrobe," says Zitelli, "but that's just not true." Today's styles for professional women, if anything, have become nearly as uniform as men's business fashions, so an extensive wardrobe is simply not required. Zitelli recommends women

looking for work invest in one or two dark, skirted suits, possibly in gray or navy, and accessorize them with a few different blouses. With the addition of conservative, mid-heeled shoes, a woman presents an up-to-date, businesslike image.

The third vital element in any job interview, of course, is what the woman says. Here, too, Ehrman says longtime housewives tend to have trouble. "They talk about their husbands and they talk about their kids and it's very difficult to get them out of that mind-set." Employers want to know only what a woman has to offer them, why she is the best candidate for a job. Cold as it may sound, they don't care how much she needs the job or how many children she must feed since her husband died or walked out on her. Discussing such details in an interview, far from appealing to the employer's sense of humanity, is likely to cost her the job. It's just not professional behavior.

Ehrman's technique for teaching displaced homemakers how to look and act professionally in an interview includes the use of videotapes of the women in staged employment interviews. After the interview, "we'll play the tape back and ask them how they feel about themselves, how they think they came across," he says. "We ask them, 'Is that somebody you'd want to hire?'" Very often it isn't, but they're learning what they're doing wrong.

UCLA's technique can be used by women everywhere. Most of us do not have access to videotape equipment, but we can, with the help of a friend, rehearse our interviewing technique—just as though we were preparing for a part in a play—until it's perfected. Another useful idea

is to begin with interviewing for the jobs we want least, using them as practice sessions for the later interviews for more desirable jobs.

To be fully prepared for an interview, Ehrman says, requires self-evaluation—knowing exactly what we have to offer a specific employer. In addition, he says, it's vital to research the company involved. This can be done by requesting and studying an annual report prior to the interview, talking to friends or acquaintances who work there, checking the local library for news stories on the company, and so on.

Armed with a professional appearance, a facade of self-confidence, an intelligent and assured assessment of the skills she has to offer and those required for the position she wants, the displaced homemaker is ready to attack the job market. And finding that job is a job in itself, Ehrman says. It should be made a full-time occupation until the objective of employment is achieved.

There are many methods with which to find job openings. They range from the most obvious—looking in the newspaper want ads—to far more sophisticated techniques. While jobs requiring few skills—waitress work, filing, baby-sitting—may be advertised in newspapers, the vast majority of opportunities do not appear there. One survey showed that as many as 85 per cent of companies in a major city hired no employees through newspaper ads in an entire year. So it's wise to check the ads daily, but unwise to depend on them for an entire job search.

Employment agencies are another popular search method, but again one that should not be seen as adequate by itself. There are four kinds of such agencies and it's important for any woman seeking a job to know the

difference between them. First is the placement agency. In forty-seven states,* these agencies are licensed. No fees are required by legitimate ones (other than an occasional nominal registration fee) until employment is secured. Often, the employer will pay all fees. Not all these agencies are as helpful or as ethical as one would like, however. Some displaced homemakers told me that interviewers in these agencies dashed their hopes by telling them cruelly that they were too old or had no skills. And a former placement agency employee in New York City told me about her agency's version of a typical scam: "We'd run an ad for a secretary at the United Nations every few months just to get new secretarial applicants. Then we'd call up companies and tell them we had some great secretaries in our files. I don't know if the UN job ever existed, but it didn't during the time I worked there." And many women told me that, despite their stating very precisely the kind of work they were seeking, such agencies wasted their time by sending them on job interviews for totally inappropriate positions. Because of these shortcomings, it's important that women looking for work not put too much confidence in placement agencies and that they not be afraid to assert themselves if they find the agencies wasting their time.

The second kind of employment agency is the executive search or recruiting firm, often known as "head hunters." These companies are hired by employers to find special kinds of employees, usually professional or upper management types. Displaced homemakers are unlikely to find them helpful.

Job counseling firms are the third type and generally

* All but Alabama, Mississippi and Vermont.

should be avoided in the opinion of most of the experts I interviewed. They charge applicants a fee for counseling about employment and, regardless of how strongly they imply it, they can't guarantee a job. Such counseling, it seems to me, is available to women free or much less expensively through displaced homemakers centers, colleges and universities, and organizations such as the YWCA.

The final type of employment agency is the temporary work agency, a frequent source of employment for many displaced homemakers. The women work for the agency itself, which rents them out to businesses needing temporary workers. Usually clerical work is involved, although some temporary agencies today specialize in engineering, technical writing and other fields. Temporary work agencies are particularly helpful to homemakers who are returning to the work force or entering it for the first time. Some even provide free clerical training because they need employees so badly. Such work, although it's not generally very highly paid, is an excellent way for a displaced homemaker to sharpen her skills and gain self-confidence so she becomes qualified for a permanent, higher-paid position. If she is a good worker, temporary work gives her an opportunity to establish a track record with a particular company, too, possibly working there for several months in various departments. When permanent employment becomes available with the company, she's more likely to be hired, because supervisors there are, by that time, aware of her talents. Even if a temporary job doesn't lead to permanent employment with a company, it can help a displaced homemaker with clerical skills through a rough financial period while she seeks permanent employment elsewhere.

Another source of job leads is the placement service of the college or university from which a woman was graduated. UCLA, for instance, makes its placement center services available to graduates of any of the University of California's campuses—no matter when the degree was earned. For displaced homemakers who are college graduates and who live within easy access of their alma maters, this can be a good source of both job information and employment counseling.

Perhaps the best source of job leads is friends and acquaintances. "Call everyone you know and tell them you're looking for work," recommends Ehrman. These contacts can include practically anyone—close friends, husbands of friends, people who shared or supervised volunteer work, clergy, former college professors. "Utilize every contact you've made for the past twenty years," he says.

Still another method that has worked for some displaced homemakers is to compile a resumé—based on skills rather than paid work history. Such a resumé can be very creative. "We helped a woman do one last week," Barbara Zitelli said, "and you'd have thought she'd been in management positions for years. But her experience was entirely on a volunteer level." The resumé, once it's been written, is circulated among companies that seem likely employers. For some jobs, this might mean visiting the companies in person, and for others it might mean composing a cover letter and sending it to the appropriate person. Whenever possible, it's best to avoid personnel departments and go directly to those with the hiring power.

No knowledgeable person says finding a job is easy—and it's less easy for women who've spent many years doing unpaid work in their homes. But it can be done. More and more displaced homemakers are finding rewarding work every day. And the ones who are having the least difficulty are those who plan and prepare in advance—both to find their first job and for a career path toward economic independence and emotional satisfaction. They are also the ones who are willing to be flexible, to go the extra mile for an employer. Phyllis, for example, a displaced homemaker who became a marriage and family counselor, feels she got her first job at fifty-one because she was willing to work three nights a week and weekends, something younger applicants refused to do. Other women find their starting salaries a bit less than what they could command if they were twenty years younger. But the first job is not necessarily the last. With flexibility and a willingness to work hard, women can advance with experience. Phyllis, four years later, is running her own counseling service, working the hours she desires.

It's not easy, but as thousands of displaced homemakers are proving every year, they can become valuable employees, perhaps among the most valuable a company can have, because they are so motivated to succeed. And among the fringe benefits they reap when they earn their own way is a tremendously rewarding sense of independence. With the ability to support themselves financially, displaced homemakers earn the right to make their own choices in all areas of their lives. They earn the right to be full adults. And they earn the right to freedom.

11

From Displaced Homemaker to Woman with Her Own Place

The journey from becoming a displaced homemaker to emerging as an independent, self-supporting and self-loving woman is a difficult one, as every woman in this book has testified. Each of them many times felt terrified, angry, inadequate, depressed, lonely—all the emotions anyone would feel when the rules by which she's lived her life have been changed without her consent. These

women spent many years subjugating themselves to their husbands and children, hoping for self-fulfillment. But few ever really found it in that way. New York psychotherapist Dr. Penelope Russianoff says it well: "The rewards of the compliant woman, the woman who is willing to love serving others and spend her life that way, really do not match the promises." And the women for whom those promises are most shattered are the displaced homemakers.

Among the women I interviewed, even those who had had good marriages found there was something missing in their lives because the one person each most needed to be able to depend upon—herself—was not strong and dependable. A few years after losing their husbands, however, most of them had changed and grown into very different women.

"I have endured the hardest thing that could ever happen to me," said one woman whose husband left her when she was forty-seven. "If I could cope with that, I feel I can cope with anything. I feel so much better about myself now." She speaks for all displaced homemakers. Losing everything—husband, security, financial and emotional support, sometimes children, in-laws, even a roof over her head—all at once is a wrenching, devastating experience. Surely it ranks high among the worst things a woman could be asked to endure. But she can survive and, as many women have learned, the struggle can be an opportunity for growth and the establishment of a whole new life—one of her own design.

A valuable by-product of the displaced homemakers' movement is that the visibility of these women can serve as a warning to their daughters and their daughters'

friends. "We go out and talk to women's groups," says Milo Smith, "and we're hoping to be odious examples to younger women. We tell them about the volunteer contract and encourage them to use it, to utilize the time they're at home with their children to volunteer in something they'd like to do for pay eventually. When they go back to work, they've built a dossier using the volunteer contract and volunteering selectively in things that can help them build a career.

"We can't play around anymore. We tell these younger women, 'You're one man away from being a displaced homemaker. You can sit there and think because you're home with children that this is fairyland. Well, every one of us thought that, too.'"

Society has changed radically since the time we were children. One of the unfortunate changes—the increasing divorce rate—has been a major force in creating the plight of the displaced homemaker. But another of society's changes has given these same women, and all others, opportunities they never would have had twenty or thirty or forty years ago. Today, women have the chance to become truly their own people. They can hold a job in many fields that were only recently exclusively male. They can earn their own living and make their own financial decisions. They can live or travel alone without either criticism or pity. They can choose to have a sexual relationship outside marriage without being condemned by society. They can be more honest and free in all their relationships with men because they feel more equal. They can establish new, closer friendships with other women. Single women today need no longer feel incomplete.

The benefits to women of these social changes far outweigh the disadvantages, although no one would choose to learn about them through the tragedy of widowhood or divorce. And while there has been progress in the status of women, things are far from perfect. Older women, in particular, often still find themselves devalued in the job world and counted out in the romantic arena by men their own age. But there is a difference from years past—today, these women are finally protesting. Perhaps for the first time, they are standing up and demanding their rights as full and equal human beings. They are banding together, finding a new support system in each other, and forming such political and social action groups as the displaced homemakers movement. They are demanding job opportunities, government assistance in retraining for the work force, economic and social equality, and dignity as they grow older.

Finally, as we enter the decade of the eighties, many women are refusing to assist in their own devaluation, by learning to value themselves.

Every homemaker who becomes a widow or divorcee at midlife has a choice. She can spend her remaining years in self-pitying loneliness and despair, perhaps even sinking into suicidal depression. Or she can decide to take charge of her life and mold it to her own specifications. She can examine the course she has taken so far and decide which elements to keep and which to change. She has an opportunity to become almost anything she desires—a chance for adult development—that she might never have had if she had not suddenly found herself alone.

As one woman at the Oakland Center said, "With support, being a displaced homemaker is not a hopeless thing

at all. It's a second chance." Taking advantage of that second chance can be a freeing, exhilarating process leading to a new identity and a changed, more satisfying life.

One woman, divorced ten years, told me, "I don't even call myself divorced anymore; I feel as though I'm single now." Four years ago, she said, "I went back to my birth name and it was a wonderful process. I was my own lawyer. I typed up the petition and took it to the county clerk and filed it. I didn't feel like Norma F. anymore. I wasn't quite Norma J. yet, either, but I knew I didn't want the identity of carrying Earl's name around any longer. My children supported my change, but when the judge questioned me, he said, 'You're going to have a different name than your children.' I told him that if I remarried, I'd have a different name, too, and he said he'd never thought of that." Symbolically, Norma said this process made her feel "as though I'd married myself."

It's hard to admit that our expectation of always having a husband to take care of us—actually, to live for us—was faulty from the start. The American dream was just that—a dream. But today, many of us have that second chance, an opportunity to start over, to be once again the people we were as girls, to create not a dream but a reality of our own making.

We are not alone in this journey toward self-sufficiency. Millions of other women have known the heartache and fear of having their marriages end in midlife. Some of them have shared their experiences with their sisters in crisis through the displaced homemakers centers, through other women's organizations, through networks of friends . . . and through this book. Although they have not yet shed the title of displaced homemaker, most of them have

outgrown it. Because they have changed and expanded their lives in so many ways, they can no longer truly be called displaced.

Like the many courageous women who will follow them, each has finally become a woman with her own place.

Bibliography

Abeel, Erica. "School for Ex-Wives," *New York*, October 16, 1978.
"All Our Children," *Time*, September 19, 1977.
Anderson, Harry. "Living in Debt," *Newsweek*, January 8, 1979.
Baker, Nancy C. "How to Stop Spending Money You Don't Have," *Self*, August 1979.
Bernard, Jessie. *The Future of Marriage*. New York: Bantam Books, 1973.
——. *The Future of Motherhood*. New York: Dial Press, 1975.
——. *Women, Wives, Mothers: Values and Options*. Chicago: Aldine Pub. Co., 1975.
Bird, Caroline. *Born Female*. New York: David McKay Co., 1968.
Bird, Caroline, et al. *The Spirit of Houston: The First National Women's Conference*. Washington, D.C.: National Commission on the Observance of International Women's Year, 1978.
Boston Women's Health Book Collective, Inc. *Our Bodies, Our Selves*. New York: Simon & Schuster, 1973.
——. *Ourselves and Our Children*. New York: Random House, 1978.
Burke, Yvonne Braithwaite. "Displaced Homemakers Act," *Congressional Record*, December 7, 1977.
Caine, Lynn. *Widow*. New York: Bantam Books, 1975.
Chesler, Phyllis. *Women and Madness*. New York: Doubleday & Co., 1972.
"Displaced Homemakers," *Newsweek*, August 23, 1976.
"Displaced Homemakers, A Growing Revolution," *National Business Woman*, July–August 1977.
Eckhardt, Kenneth. "Deviance, Visibility, and Legal Action: The Duty to Support," *Social Problems*, 1968.
French, Marilyn. *The Women's Room*. New York: Summit Books, 1977.
Friday, Nancy. *My Mother, My Self*. New York: Delacorte Press, 1977.

Friedan, Betty. *The Feminine Mystique.* New York: Dell Pub. Co., 1963.
——. *It Changed My Life.* New York: Dell Pub. Co., 1977.
——. "Up from the Kitchen Floor," *The New York Times Magazine,* March 4, 1973.
Goodman, Emily Jane and Chesler, Phyllis. *Women, Money and Power.* New York: William Morrow & Co., 1976.
Goodman, Erik K. "The Power of Plastic Money," *Your Place,* December 1978.
Greer, Germaine. *The Female Eunuch.* New York: McGraw-Hill Book Co., 1971.
Hailey, Elizabeth Forsythe. *A Woman of Independent Means.* New York: Viking Press, 1978.
Harris, Janet. *The Prime of Ms. America.* New York: G. P. Putnam's Sons, 1975.
"Hearing Before the Subcommittee on Employment Opportunities of the Committee on Education and Labor, House of Representatives, Ninety-fifth Congress. First Session on H.R. 28 (The Displaced Homemakers Act). Hearing Held in Washington, D.C., July 14, 1977." Washington, D.C.: U. S. Government Printing Office, 1977.
"Hearing Before the Subcommittee on Equal Opportunities of the Committee on Education and Labor, House of Representatives, Ninety-fourth Congress. Second Session on H.R. 10272 (The Equal Opportunity for Displaced Homemakers Act). Hearing Held in Los Angeles, California, November 18, 1976." Washington, D.C.: U. S. Government Printing Office, 1976.
"Hearings Before the Subcommittee on Employment, Poverty, and Migratory Labor of the Committee on Human Resources, United States Senate, Ninety-fifth Congress. First Session on S. 418 (Displaced Homemakers Act, 1977), September 12 and 13, 1977." Washington, D.C.: U. S. Government Printing Office, 1977.
"Help for Women Suddenly on Their Own," *Changing Times,* January 1978.
Hennig, Margaret, and Jardim, Anne. *The Managerial Woman.* New York: Pocket Books, 1976.
Hochman, Gloria. "Escaping Depression," *Family Weekly,* December 9, 1979.
Hochstein, Rollie. "What Happens When a Homemaker Loses Her Job," *Woman's Day,* August 7, 1978.

Hope, Karol, and Young, Nancy, eds. *MOMMA: The Sourcebook for Single Mothers.* New York: New American Library, 1976.
Horner, Matina. "Sex Differences in Achievement Motivation and Performance in Competitive and Non-Competitive Situations." Unpublished doctoral dissertation for the University of Minnesota, 1968.
Howard, Jane. *A Different Woman.* New York: E. P. Dutton & Co., 1973.
――. *Families.* New York: Simon & Schuster, 1978.
Howe, Louise Kapp. *Pink Collar Workers.* New York: G. P. Putnam's Sons, 1977.
"In Massachusetts: 'Divorced Kids,'" *Time,* June 11, 1979.
Jacobs, Ruth Harriet. "A Typology of Older American Women," *Social Policy,* November/December 1976.
Janeway, Elizabeth. *Man's World, Woman's Place.* New York: Delta, 1971.
――. *Between Myth and Morning: Women Awakening.* New York: Delta Books, 1975.
Korda, Michael. *Success! How Every Man and Woman Can Achieve It.* New York: Random House, 1977.
Levine, James A. "Real Kids vs. 'The Average' Family," *Psychology Today,* June 1978.
Luboff, Eileen Baris, and Posner, Constance L. *How to Collect Your Child Support and Alimony.* Occidental, Calif.: Nolo Press, 1977.
Lurie, Alison. *The War Between the Tates.* New York: Random House, 1974.
McCarthy, Abigail. "The Displaced Homemaker," *Commonweal,* January 16, 1976.
Masters, William H., and Johnson, Virginia. *Human Sexual Inadequacy.* Boston: Little, Brown & Co., 1970.
――. *Human Sexual Response.* Boston: Little, Brown & Co., 1966.
Mendelsohn, Ethel, and Galvin, John H. *The Legal Status of Women.* Washington, D.C.: U. S. Department of Labor, Women's Bureau, 1978.
Mondell, Cynthia and Allen. *Who Remembers Mama?* Dallas/Fort Worth: PTV Publications, 1978.
Morgan, Marabel. *The Total Woman.* Old Tappan, N.J.: Fleming H. Revell Co., 1973.
Morrow, Lance. "In Praise of Older Women," *Time,* April 24, 1978.

Nivens, Beatryce. "A Job Is Not Forever," *Essence*, September 1977.
———. "Kick the Debt Habit," *Essence*, March 1978.
"Of Women, Knights and Horses," *Time*, January 1, 1979.
Older Women's League. *Displaced Homemakers: Program Options . . . an Evolving Guide*. Baltimore: Older Women's League Educational Fund, 1978.
Olsen, Tillie. *Silences*. New York: Delacorte Press, 1978.
Phelps, Stanlee, and Austin, Nancy. *The Assertive Woman*. San Luis Obispo, Calif.: Impact Publications, 1975.
Quinn, Jane Bryant. "Women and Social Security," *Woman's Day*, August 7, 1978.
Rapoport, Robert; Rapoport, Rhona; and Bumstead, Janice, eds. *Working Couples*. New York: Harper Colophon Books, 1978.
Rich, Adrienne. *Of Woman Born: Motherhood as Experience and Institution*. New York: W. W. Norton & Co., 1976.
Rubenstein, Carin; Shaver, Phillip; and Peplau, Letitia Anne. "Loneliness," *Human Nature*, February 1979.
Scheele, Adele M., and Kaye, Beverly. "Designs for Transition: An Assessment of Life Planning for Women Seeking Change." Unpublished paper for UCLA project, 1974.
Seal, Dr. Karen L. *No-Fault Divorce: A Financial Disaster for California Women*. Unpublished doctoral dissertation for United States International University, 1978.
Sheehy, Gail. *Passages: Predictable Crises of Adult Life*. New York: E. P. Dutton & Co., 1976.
Smeal, Eleanor. "A Challenge to Congress—NOW's Bill of Rights for Homemakers," *MS.*, October 1979.
Terkel, Studs. *Working: People Talk About What They Do All Day and How They Feel About What They Do*. New York: Pantheon Books, 1972.
U. S. Department of Labor. *Displaced Homemakers: A CETA Program Model, Fitchburg, Massachusetts*. Washington, D.C.: U. S. Government Printing Office, 1978.
———. *Employment and Economic Issues of Low-Income Women: Report of a Project*. Washington, D.C.: U. S. Government Printing Office, 1978.
———. *Mature Women Workers: A Profile*. Washington, D.C.: U. S. Government Printing Office, 1976.
———. *Women with Low Incomes*. Washington, D.C.: U. S. Government Printing Office, 1977.

Winston, Marian P., and Forsher, Trude. *Nonsupport of Legitimate Children by Affluent Fathers as a Cause of Poverty and Welfare Dependence.* Santa Monica: The Rand Corporation, 1974.

"Women March on Houston," *Time,* November 28, 1977.

Women's Equity Action League, Greater Los Angeles Chapter. *Project Wider Horizons; A Study of Job-Related Problems of Women 40+.* Unpublished report of a project, 1978.

Index

Aaronson, Kathy, 208, 211ff.
Abandonment, 38–39, 42. *See also* Separation
Abeel, Erica, 255
Abuse (beating, etc.), 6, 51, 59–60. *See also* Self-esteem
Acceptance, 22
Accountant, job as, 220
Achievements. *See also* Jobs and careers; Self-esteem
 listing 219–21
Addiction, 34. *See also* specific addictions
 anger and, 41
 corporate wives and, 56
Adelberg, Phyllis, 236–37
Administrative work, 220–21, 238
Adolescence (teen-agers), 3, 21, 57–58, 61, 163. *See also* Childhood
 and author's self-esteem, 57–58
African studies, 181, 224
Age,
 and flight attendant job, 223
 and job discrimination. *See* Jobs and careers; specific jobs
 and marriage, 40
 Project Re-Entry and, 238
 and remarriage, 96–97
 and scholarships at University of California, 11
 and Social Security, 187
 and suicide, 27
 and teaching job, 223–24
 of widowhood, average, 7
Aggressiveness. *See* Growth
Agoraphobia, 53
Air-conditioning work, 218
Airlines, and flight attendant job, 223
Alabama, no licensing for placement agencies in, 244n.
Alcohol and alcoholism, 3, 6, 30, 33, 104, 105, 118, 161, 179
 anger and addiction to, 41
 corporate wives and, 56
Alimony, 7, 114, 172, 180, 185ff., 196–97
Allen, Nancy, 27
Alliance for Displaced Homemakers, 4
American Psychiatric Association, 115
Anderson, Harry, 255
"Angela," 151–53
Anger (rage), 22, 27, 28, 33, 36–41, 42, 79, 85, 90ff., 138–39, 148. *See also* Punishment
 children's, and visitation, 132, 133
 and child support, 175–76
 and self-esteem. *See* Self-esteem
 widows and, 36, 184
Animals, 54
"Anne," 146ff.
Appearance, and job hunting, 240–41
 and sales jobs, 214
Appetite, and depression, 28
Approval, 63–64. *See also* Self-esteem
Arizona,
 Lamson Business College in, 232
 salaries for clerical workers in Phoenix, 233
Arkansas, 18, 19
Art history, 224
Assertiveness training, 225
Assertive Woman, The, 258
Atlanta, American Psychiatric Association meeting in, 115
Attorneys. *See* Lawyers
"Audrey," 208–11, 212–13
Austin, Nancy, 258
Automobiles (cars). *See also* Driving
 changing oil, 116
 insurance, budget and, 196
 payments on, 195

Backaches,
 anger and, 37
 depression and, 28

Baker, Nancy C. (author), 4–6, 255
 and credit, 193–94
 and family's values, 110–11
 and friends, 78
 and growth in self-sufficiency, 116
 and marriage to escape parents, 107
 re-emergence of creativity of, 57–58
 and technique for self-esteem, 66–67
 and young adults of divorced parents, 122
Baker, Ruth, 194–95
Bakers, jobs as, 215, 219
Baltimore, Md., 18
 Center for Displaced Homemakers, 96, 204. *See also* Marano, Cindy
 child-support case, 189
Banks,
 and budgeting checking and savings accounts, 191–92
 and Consumer Credit Counselors, 186
 interest on savings accounts, 190
Bars, singles, 8
Batterers, wife-. *See* Abuse
Beatings. *See* Abuse
"Beatrice," 158
Bed, difficulty getting out of, 29
Benson, Stan, 185–86, 190–92ff.
Bernard, Jessie, 255
"Betty," 25–27
Between Myth and Morning, 257
Bibliography, 255–59
Bicycle riding, 35
Bicycle speedometer, 116
Bills. *See* Debts
Bird, Caroline, 255
Birthdays, 165
Bitterness. *See* Anger
Blue-collar workers. *See also* Working-class women
 and child support, 175
Bookkeepers, jobs as, 216, 220
Bookstore, job with, 238–39
Born Female, 255
Boston, Project Re-Entry in, 236–39
Boston Women's Health Book Collective, 255
"Bottoming-out" period, 24–25
Boyfriends. *See* Men
Boys, and absent fathers, 131
BPW Foundation, 231
"Brent" ("Sally's" son), 125–28
Bridge-playing, 220
Broadcaster, job as, 226
Budgets, 190–96
Bumstead, Janice, 258
Burke, Yvonne Braithwaite, 255
Bus companies, administrative jobs with, 239
Bus driving, 215, 220, 223
Businesses, 203–4, 226–27. *See also* Executive searching; Executive wives; Jobs and careers
 and inflation, 198

Cabdriving, 215, 220, 221, 223
Caine, Lynn, 36, 255
California, 2, 98–99. *See also* specific cities
 and community property, 173
 Long Beach Regional Medical Center, 33
 and no-fault divorce, 173–74
California, University of. *See also* specific branches
 Milo Smith at, 11
California, University of, at Berkeley, and children and divorce, 131–32
California, University of, at Los Angeles (UCLA), 258
 Placement and Career Planning Center, 240ff., 246
 Suicidology Department, 27
Capital, for business, 226
Capital gains, 173
Careers. *See* Jobs and careers
Careers for Women, 208. *See also* Aaronson, Kathy
"Carolyn," 178–82, 185, 224
Carpentry work, 218
Carpeting, selling, 213
Cars (automobiles). *See also* Driving
 changing oil, 116
 insurance on, budget and, 196
 payments on, 195
Carter, Billy, 35
Cashiers, jobs as, 6
"Castrating women," 177
Catering work, 204, 219
Catholics and Catholicism, 158, 172
CCC, 185–86. *See also* Benson, Stan
Celibacy, 84, 92–93
Census Bureau, 208
 list of occupations, 216
Center for Displaced Homemakers (Baltimore), 96, 204. *See also* Marano, Cindy
CETA, 53, 225
Chances, taking. *See* Risks
Changing Times, 256
Character, and sales, 213
Charge accounts, 194, 195
"Charles," 122–23
Chauffeurs, jobs as, 215, 220
Checking accounts, advice on, 191
Chefs, jobs as, 215, 219
Chesler, Phyllis, 255, 256
Chicago, Ill., 101
 and child support, 188
Childhood (girlhood), 42, 55, 61, 63, 162, 163. *See also* Adolescence; Children; Growth
 deprivation and tendency to

Index

depression, 28
and prolonged anger, 38–39
Childishness. *See* Femininity; Growth
Children, 7, 8, 18ff., 25, 26, 43, 58–59, 65, 66, 82, 105ff., 121–54, 160ff. *See also* Childhood; Child support; Growth
 author's, 5
 and choice of job, 222
 and empty nest syndrome, 27
 and finding new men, 86
 former in-laws and, 165
 jobs involving, 219–20
 and name change, 253
 and relief of depression, 35
Child snatching, 125–28
Child support, 7, 19, 22, 124, 131–32ff., 143, 172, 174–76, 180, 181, 187–90, 196, 197–98
 and dependency, 108, 109
 and no-fault divorce, 174, 177
Child Support Enforcement Program, 188
Christmas, 116, 132ff.
 decorating ornaments as business, 204
Churches, to meet new men, 97
Classes. *See* Education; Teaching
Clayton, Paula, 35
Cleaning businesses, 204
Clerical work, 206, 216, 233
 temporary work agencies and, 245
Clothing,
 budget for, 190
 improving wardrobe, 241–42
 manufacture of, 203
Colleges and universities. *See also* Education; specific schools
 administrative jobs at, 238
 and finding displaced homemakers center, 231
 job counseling, placement services at, 245, 246
 special-events planner's job at, 221
 teaching at. *See* Teaching
Columbia University, 239
Commerce, Department of, 177
Commonweal, 257
Community property, 173
Complaining, 79–80
Computers, 213
 operators, 217
 programmers, 220
 time sales, 205
Concentration, depression and loss of, 28
Conformity. *See* Values
Congressional Record, 255
Constipation, depression and, 28
Consumer Credit Counselors, 185–86. *See also* Benson, Stan
Cooking,

and budget, 191
and jobs, 204, 215, 219
sales jobs, 213
Corporate wives (executive wives), 55–57
Counseling, 32–33, 37ff., 142. *See also* Displaced homemakers centers; Therapy; specific counselors, groups, locations
 credit, 185–86
 job. *See* Jobs and careers; specific groups, locations
 as job or career, 20, 224–25, 226, 234
 and sex, 95
Courses. *See also* Teaching
 singles, 98–99
 taking to meet new men, 97–98
Creative Sales Careers, Inc., 207. *See also* Pletcher, Barbara
Creativity, author and, 57–58
Credit, 173, 185–86
 establishing, 192–95
Criminal records, men with, and child support, 175
Criticism, and self-esteem. *See* Self-esteem
Cruises, 23
Crying jags, 29
Custody. *See also* Children
 child snatching, 125–28

Data processing, 217
 selling systems, 211
Dating. *See* Men
Day-care jobs, 219
Death. *See also* Suicide; Widowhood
 and children's guilt, 139–40ff.
 ex-husband's, 197
 of "Lucille's" daughter and son, 29–30
 thoughts of, and depression, 28
Debts, 173, 185–86. *See also* Credit
 and no-fault divorce, 174
Degradation, and self-esteem. *See* Self-esteem
Delivery persons, jobs as, 220, 223
Del Valle, Dennis, 232
Department stores,
 cashiers' jobs, 6
 and credit, 194, 195
 Consumer Credit Counselors and, 186
 receptionists' jobs, 233–34
 sales jobs, 61, 205
Dependency, 3, 9, 25, 26, 42–43, 126. *See also* Femininity; Growth; Parents; Security; Self-esteem
 corporate wives and, 56
 and depression, 126
Depression, 8, 14, 22, 24–36, 40, 42. *See also* Loneliness; Self-esteem;

Index

Suicide
 children's, and visitation, 132
 corporate wives and, 56
Desertion, 61. *See also* Abandonment
Desperation, 95
Diaphragm, 93
Diarrhea, depression and, 28
Different Woman, A, 257
Disbelief, 22–26
Discipline, children and, 139–43
Discrimination. *See* Credit; Jobs and careers
Dislike of self. *See* Self-esteem
Displaced Homemakers (Labor Department), 258
Displaced Homemakers (Older Women's League), 258
Displaced Homemakers Act, 256
Displaced Homemakers Center (Oakland, Calif.), 2, 9–10, 13–15, 49–50, 70, 252–53. *See also* Smith, Milo
 and volunteer contract, 234–35, 237
Displaced homemakers centers, 225, 230–31, 245. *See also* specific locations
Displaced Homemakers Network, 231
District attorney's office, and child support, 188–89
Divorce, 6–7, 22, 25, 26, 43ff., 49, 105–6, 113, 114, 115–16, 122–39, 146ff., 156–64ff., 251. *See also* Child support
 and anger, 37ff.
 author's, 6, 57–58
 and denial, 42–43
 and financial problems. *See* Money and finances
 and lifting of depression, 27
 and living alone, 35
 no-fault, 173–74, 176–77
 rate, 7
 and social life. *See* Social life
 and Social Security, 187
 therapy workshop, 33
Doctors (physicians), and drugs, 33–34
"Dorothy," 43–46, 171–72
 and friends, 74–75
Drake University, 239
Dreams, recurrent, 46
Dress designing, 8
Drinking. *See* Alcohol and alcoholism
Driving, 18, 52, 53. *See also* Cars
 and jobs, 215, 220, 221, 223
Drugs (pills), 3
 anger and addiction, 41
 corporate wives and, 56
 and depression, 33–35

Eating. *See also* Food
 appetite and depression, 28
 overeating, 103
Eckhardt, Kenneth, 174–75, 255
"Edith," 233–34
Education, 3, 4, 6, 18, 180, 181, 202, 223–25. *See also* Courses; Teaching
 Milo Smith and, 11
 sales jobs and, 214
 state departments of, 231
Educational Amendments (1976), 231
Edwards, Marie, 98–99, 100
Ego. *See also* Growth; Men; Self-esteem
 and finding work. *See* Jobs and careers
 and improving appearance, 241
 and sales, 212–13
Ehrman, Bob, 240–43, 246
El Cajon, Calif., 173
Elderly, the, 9. *See also* Nursing homes; Poverty; Widowhood
 and money. *See* Money and finances; Social Security
Electricians, 216
"Ellen," 161–62
Embarrassment, sex and, 93
Emergencies, credit cards and, 192
Emotions. *See also* Depressions; Loneliness; Self-esteem
 and money, 184–85. *See also* Money and finances
Empathy, sales jobs and, 212
Employment. *See* Jobs and careers
Employment agencies, 243–44
Employment and Economic Issues of Low-Income Women, 258
Employment Development Department, Milo Smith and, 11
Empty nest syndrome, 27
Energy,
 as anger. *See* Anger
 loss, and depression, 28
Entertaining,
 corporate wives and, 56
 and jobs, 215
Epilepsy, child's, 126
Equal Credit Opportunity Act, 192–93ff.
Equal Opportunity for Displaced Homemakers Act, 256
Errand-running, and jobs, 204
Essence, 258
Estates. *See also* Widowhood
 and exclusion from will, 172
Executive searching (head-hunting),
 firm, 244
 job, 234
Executive wives, 55–57
Exercise, and depression, 35, 36

Face lifts, 23
Failure, 66
 redefining, 68
Families (relatives), 30–31. *See also*

Index

Children; Growth; Parents
altered kinships, 155–69
Families (Howard), 257
Family Weekly, 256
Fantasizing. *See also* Disbelief
about absent fathers, 129
and goal setting, 65
on suicide, 137
Fashion designer, work as, 203
Fathers. *See* Children; Parents
"Faye," 141–43
Fear. *See also* Anger; Depression
children's, and depression, 132
and social life. *See* Social life
of success, 114–15
Federal Trade Commission, and credit, 193, 195n.
Female Eunuch, The, 256
Feminine Mystique, The (Friedan), 54–55, 256
on ego-deterioration, 50–51
Femininity, 113–17, 177–78
and traditional jobs, 218
File clerks, jobs as, 6
Film-writing. *See* Writing
Finances. *See* Money and finances
Flight attendants' jobs, 223
Florida, 44–45
Flower arranging, and jobs, 220
Food, 54
anger and addiction to, 41
appetite and depression, 28
budget for, 190
hunger and poverty, 172
overeating, 103
sales (grocery items), 207, 211, 213
lobsters, 208–10
Ford, Betty, 35
Forscher, Trude, 258
Fortune, and corporate wives, 56
Freedom, 8, 9, 43ff., 117–18, 153, 210
French, Marilyn, 255
Freud, Sigmund, on depression, 28
Friday, Nancy, 255
Friedan, Betty, 54–55, 256
on ego-deterioration, 50–51
Friends, 74–84, 102. *See also* Men
ex-husbands as, 167–68
and job leads, 246
Frigidity, 90
Fringe benefits, 222
Fund raising, 214, 215, 221
Furniture sales, 213
Future of Marriage, The, 255
Future of Womanhood, The, 255

"Gail," 146–47ff.
Galvin, John H., 257
Gardening, and jobs, 215, 220
"Gary" (son of "Lucille"), 29, 30
"George" (husband of "Lorna"), 104–6

"Ginger," 76–77, 85–86, 92
Girlhood. *See* Adolescence; Childhood
"Gloria," 99–100
Goals, 64–66ff.
budgets and, 190, 191
Goodman, Emily Jane, 256
Goodwin, Frederick, 27–28
Government. *See also* Social Security; Welfare
health inspectors, 217
Government Printing Office, 226n.
Graduate school, 4
Greer, Germaine, 256
"Greg" (son of "Sally"), 125–28
"Gretchen," 143–45
Grief. *See* Depression
Grocery items, selling (food sales), 207, 211, 213
Grossmont College, 173
Growth, 4, 21–22, 97, 103–19
pain and, 15
Guilt, 28, 29, 95, 109–11ff., 139–41. *See also* Self-esteem
children and, 123–24, 129, 138, 139–40
of parents, 160–61
and promiscuity, 91–92

Hailey, Elizabeth Forsythe, 256
Harris, Janet, 256
Hatred. *See also* Anger
children and absent fathers, 129. *See also* Children
self-. *See* Anger; Depression; Self-esteem; Suicide
Headaches,
anger and, 37
depression and, 28
"Head hunters." *See* Executive searching
Health (illness), 9, 14, 44. *See also* Heart attacks, husbands'; Physical symptoms
budget for medical expenses, 190
child's epilepsy, 126
insurance (medical insurance), budget and, 196
and job choice, 222
jobs as health inspectors, 217
jobs in health-care industry, 226
Health, Education and Welfare, Department of, Child Support Enforcement Program, 188
Heart attacks, husbands', 1, 6
Heating work, 218
"Heidi" (daughter of "Gretchen"), 143ff.
"Helen," 17–20, 27
Helplessness. *See* Femininity; Self-esteem
Hennig, Margaret, 256
Herman, Alexis, 216
Heussenstamm, Frances, 95, 97, 100–1

and anger, 40–41
and denial, 42–43
on denial of sex, 93
describes her meetings with new men, 98
on growth, 103–4
on promiscuity, 91
and rage at widowhood, 36
on support groups, 69–70
warns about complaining too much, 79–80
Hirschfeld, Mary, 32–33
and anger, 36–37ff.
and avoidance of dependent relationships, 18
on difficulty of divorce compared with widowhood, 166–67
on feeling of helplessness, 51
and financial advice, 185
on goal-setting and self-esteem, 66ff.
and older women with younger men, 97
and researching for job hunt, 231–32
and sex, 91–92
Hives, anger and, 37
Hochman, Gloria, 256
Hochstein, Rollie, 256
Holidays, 133–34. *See also* Christmas
in-laws and, 166
Holtzer, Marion, 101
Homes. *See* Houses
Hope, Karol, 257
Horner, Matina, 114, 257
Hospitals, jobs directing volunteers, 221
Hostesses, jobs as restaurant, 6
Hostility. *See* Anger
and depression. *See* Depression
friends and. *See* Friends
Houses (homes), 23, 31, 65–66, 186. *See also* Housing; Real estate
capital gains on sale of, 173
as security, 52–53
Housing,
budget for, 190
and credit, 195
Howard, Jane, 257
Howe, Louise Kapp, 257
How to Collect Your Child Support and Alimony, 257
Human Nature, 258
Human Sexual Inadequacy, 257
Human Sexual Response, 257
Hunger. *See* Food

Identification, credit cards as, 192
Identify (who you are), 21, 25, 48, 102. *See also* Growth; Self-esteem
corporate wives and, 56
and social life. *See* Social life
Illinois, 183. *See also* Chicago, Ill.
Illness. *See* Health

Imagination. *See* Fantasizing
Income, 7, 8, 44. *See also* Money and finances
and fees at mental health centers, 32
Independence (self-dependence), 3, 21–22, 26, 126–27. *See also* Dependency; Growth; Self-esteem
corporate wives and, 56–57
Industrial sales, 207–8
Inferiority complex. *see* Self-esteem
Infidelity, 25–26, 52, 161. *See also* Divorce; Separation
Inflation, 114, 196–98
Inheritance. *See* Money and finances; Widowhood
In-laws, 164–66
Insurance. *See also* Life insurance
budget for payments, 190, 196
and job choice, 222
sales, 205, 212
Intelligence, and sales work, 213
Interest. *See also* Credit
on savings accounts, 190
Interior decorating, 213
Internships. *See* Volunteer work
Investments, 186. *See also* Businesses
and inflation, 198
stock dividends, 190
Iowa,
Drake University, 239
housing costs, 190
Irritability, depression and, 28
It Changed My Life, 256

Jacobs, Ruth Harriet, 257
Jail. *See also* Criminal records
and non-support, 176
Janeway, Elizabeth, 257
Jardim, Anne, 256
"Jean," 201–2
"Jeannie," 140
"Joanna," 46–48
Johnson, Virginia, 257
Job counseling firms, 244–45
Jobs and careers, 3, 6–7, 8, 18, 20, 31–32, 45, 53, 61, 65ff., 93, 106, 111ff., 141, 142, 161, 190, 201–27, 239–47, 252
author's, 5–6, 58. *See also* Writing
and inflation, 198
men married to, 6, 159
Milo Smith's, 10–15
mobility and child support, 176
"Julia," 52–54, 63, 68ff., 165

Kassorla, Irene, 134–35ff., 146
on divorce of married woman's parents, 147–48
Kaye, Beverly, 258
Kierulff, Herbert, 226
Kinships, altered, 155–69

Index

Korda, Michael, 257
Kubler-Ross, Elisabeth, 36

Labor, Department of, 177, 217, 226n., 258
 Women's Bureau, 216
Lamson Business College, 232
Landscape architecture, 215, 217, 220
Las Vegas, Nev., 106
Lawsuits. *See also* Lawyers
 and credit discrimination, 193
Lawyers, and divorce problems, 176, 180, 181, 189–90, 196, 197
"Leah," 161, 162
"Leanna," 161, 162
Legal Status of Women, The, 257
"Leigh," 129–31
Levine, James A., 257
"Libby," 123–24
Life insurance, 2, 22, 172, 183ff., 197
Life-span, 96
Lithographers, 217
Living alone, 35–36. *See also* Loneliness
Living together. *See* Men
Loans. *See* Credit
Lobsters, selling, 208–10
Loneliness, 14, 17–48. *See also* Social life
Long Beach Regional Medical Center, 33
"Lori" (daughter of "Lucille"), 29
"Lorna," 104–6, 118–19
Los Angeles, Calif., 32, 36. *See also* California, University of, at Los Angeles; Heussenstamm, Frances; Hirschfeld, Mary; Kassorla, Irene
 Careers for Women in, 208
 Consumer Credit Counselors in, 185–86. *See also* Benson, Stan
 job counseling, 206
Love, 177. *See also* Men; Self-esteem
 addiction as replacement for, 34
 discipline and, 142
Luboff, Eileen Baris, 257
"Lucille," 29–32
Lurie, Alison, 257

McCarthy, Abigail, 172, 257
McIntosh, Nancy, 233
Magazines, and sales work, 211
Maiden name, 70, 253
Managerial Woman, The, 256
Man's World, Woman's Place, 257
Marano, Cindy, 96, 217–18, 230–31
 on job hunting, 203
"Marcie," 184, 185
"Marian," 1–2
"Marjorie," 182–84, 185
Marketing research work, 217
Martyrdom, 80, 105, 111–12, 138, 145
Maryland. *See also* Baltimore, Md.

child-support case, 189
Masculinity/femininity. *See* Femininity
Masters, William H., 257
Materialism (material possessions), 23–24
 corporate wives and, 56
Math-related jobs, 220
Mature Women Workers, 258
"Maureen," 65–66
Mead, Margaret, 15
Meat-packing business, 8
Medical insurance (health insurance), budget and, 196
 and job choice, 222
Medical problems. *See also* Health; Medical insurance
 budget for, 190
Medical records technicians' jobs, 217
Medication. *See* Drugs
Memory, and depression, 28
Men (boyfriends; dating; romance), 7, 8, 18, 23–24, 65, 66, 74–102, 163, 166, 184, 185, 252. *See also* Social life
 in divorce therapy workshop, 33
Mendelsohn, Ethel, 257
Menopause, and suicide, 27
Mental health centers, 32
Mexico, 106, 180
"Micki," 105ff., 118–19, 138–39
Middle-class women, and disbelief reaction, 23
Military wives, 64
Mills College, used by Displaced Homemakers Center, 13
Minnesota, University of, 257
Miscellaneous expenses, budget and, 190, 191
Misfortune, and money management, 198
Mismanagement of money, 198, 199
Mississippi, no licensing for placement agencies in, 244n.
Missouri, 133. *See also* St. Louis, Mo.
Mogul, Kathleen, 115
MOMMA, 257
Mondell, Cynthia and Allen, 257
Money and finances, 2, 23, 110, 158, 171–99. *See also* Alimony; Businesses; Child support; Houses; Income; Jobs and careers; Poverty
 and choice of job, 222
 parents and, 160
"Monique," 111–12
Moods. *See* Depression; Emotions
Morgan, Marabel, 257
Morrow, Lance, 257
Mortgages, 116, 194–95
Mortuary, Milo Smith's job in a, 11–12
Mothers. *See* Children; Parents
Mother's Day, 25–26

Index

Motivation, and sales work, 213–14
Moving, 64, 80–82. *See also* Houses and job choice, 222
MS., 258
My Mother, My Self, 255
"Myrna," 146ff.

Name, maiden, 70, 253
National Business Woman, 255
National Institute of Mental Health, 28
 and mind-altering drugs, 34
National Organization of Women (NOW), Task Force on Older Women, 4, 12. *See also* Sommers, Tish
Nausea, depression and, 28
Navy, Long Beach Regional Medical Center, 33
Neck aches, depression and, 28
"Nelda," 238–39
"Nell," 135
Newscasters, jobs as, 226
Newspaper reporter, author as, 5
Newspapers,
 to find displaced homemakers center, 231
 and job hunting, 243
Newsweek, 255
New York City, 233–34, 250
 Careers for Women in, 208
 Columbia University, 239
 housing costs in, 190
 placement agency in, 244
New York Times Magazine, The, 256
"Nina," 92–95
Nivens, Beatryce, 258
No-fault divorce, 173–74, 176–77
No-Fault Divorce. *See* Seal, Karen L.
Nonsupport of Legitimate Children . . . , The, 259
NOW. *See* National Organization of Women
Nurses' aides, jobs as, 6
Nursing homes, 4, 24

Oakland, Calif., 4, 217
 Displaced Homemakers Center, 2, 9–10, 13–15, 49–50, 70, 252–53. *See also* Smith, Milo
 and volunteer contract, 234–35, 237
Occupational Outlook Handbook, 226n.
"Occupational segregation," 216
Office supplies, selling, 211
Of Women Born, 258
Oil, changing, 116
Oil company credit cards, 195
Older Women's League, 258
Olsen, Tillie, 258
Our Bodies, Our Selves, 255
Ourselves and Our Children, 255
Overeating, 103

"Pamela," 80–81
Paperhangers, jobs as, 217
Parents (fathers; mothers), 18, 19, 40, 155, 156–64, 177. *See also* Growth
 and abandonment, 38–39
 highly critical, 69
Passages (Sheehy), 258
Passivity. *See* Dependency; Independence; Self-esteem
Patterns. *See* Roles and role models
Pensions (retirement funds), 2, 197
 Milo Smith and, 10–11
Peplau, Letitia Anne, 258
Personality, jobs and, 215
 sales jobs, 213
Phelps, Stanlee, 258
Phoenix, Ariz., salaries for clerical workers, 233
"Phyllis," 247
Physical abuse, 6, 51, 59–60
Physical appearance,
 and job hunting, 240–41
 and sales work, 214
Physical exercise, depression and, 35, 36
Physical symptoms,
 and anger, 37, 41
 and depression, 28
Physicians (doctors), and drugs, 33–34
Pills. *See* Drugs
Pink Collar Workers, 257
Placement agencies, 244
Plants. *See also* Gardening
 selling, 215
Pleasure, loss of interest in, and depression, 28
Pletcher, Barbara, 207–8, 211–12, 213
Political careers, 215
"Polly," 87–89, 92
Posner, Constance L., 257
Poverty, 7, 172ff. *See also* Welfare
Power, money and, 135–36
Prime of Ms. America, The, 256
Professional men, and child support, 175
Project Re-Entry, 236–39
Project Wider Horizons, 259
Promiscuity. *See* Men
Psychiatrists. *See* Therapy
"Psychological autopsy," 39–40
Psychological help. *See* Therapy
Psychology Today, 257
Public relations work, author and, 5
Public relief. *See* Welfare
Punishment, 51. *See also* Discipline
 using children for, 124
Pursch, Joseph, 33–34, 35

Quinn, Jane Bryant, 258

"Rachel," 58–62, 68ff., 90, 92, 156
Rage. *See* Anger
Rand Corporation, 175
Rape, 51, 60

Index

Rapoport, Rhona, 258
Rapoport, Robert, 258
Rashes, anger and, 37
Real estate, 8, 194–95
 and inflation, 198
 sales, 65, 206, 213, 214
Reality. See Disbelief
 and depression. See Depression
Receptionists' jobs, 233–34
Recessions, and sales, 212
"Reciprocal agreement," 237
Recovery time, 41–43
Recruiting firm. See Executive searching
Rejection, 100. See also Jobs and careers
Relatives. See Families
Religion, 93, 157, 158
Remarriage, 95–97, 129, 163. See also Men
 and relationship with ex-husband, 68–69
 and Social Security, 187
Rental income, 190
Restaurants,
 and budgeting, 191
 hostess jobs at, 6
 selling lobsters to, 208–10
 starting, 219
Resumés, 246
Retail sales, 207. See also specific types of jobs
Retirement funds. See Pensions
Rich, Adrienne, 258
Risks, 62–63, 100
 and job choice, 222–23
Roles and role models, 146–49, 183. See also Children; Femininity
 parents and, 40. See also Parents
Roommates, as cure for depression, 35–36
"Rosie," 107–9, 143
Rubinstein, Carin, 258
"Russ" (husband of "Sally"), 125–28
Russianoff, Penelope, 250

Sacramento, Calif., Creative Sales Careers, Inc., in, 207
Sacrifice. See Martyrdom
Safety, 54
St. Louis, Mo., 105
 Washington University School of Medicine, 35
Sales jobs, 61, 65, 205–14ff., 222
"Sally," 125–28
San Diego, Calif., no-fault divorce in, 176–77
San Diego County, Calif., and no-fault divorce, 173–74
"Sandy," 122, 123
San Francisco, Calif., 80–81
 Careers for Women in, 208

Santa Monica, Calif., 113
"Sarah," 1
Savings. See also Savings accounts
 budget for, 190
Savings accounts,
 advice on, 191–92
 interest on, 190
 loans, 195
Scheele, Adele M., 258
Schoenholz, Dawne, 113, 115, 169
 and fathers' buying of children's affection, 136
 and women's sense of freedom, 117–18
Scholarships at University of California, age and, 11
School bus driving, 220
Schools. See Colleges and universities; Education; Teaching
Seal, Karen L., 173–74, 176–77, 258
Secretarial jobs, 216, 232–33
 New York City placement agency and, 244
Security, 8, 47–48, 62, 160–61ff. See also Depression; Independence; Jobs and careers; Money and finances
 houses as, 52–53
"Segregation, occupational," 216
Self, 255
Self-confidence, 100. See also Security; Self-esteem
Self-criticism. See Depression; Self-esteem
Self-dependence. See Independence
Self-esteem, 25, 49–71. See also Growth; Independence
 children's, and visitation, 131–32
 and job hunting. See Jobs and careers
 and loneliness. See Loneliness
 and social life. See Social life
Self-hatred. See Anger; Hatred; Self-esteem; Suicide
Self-interest, 111–12
Selfishness, 111, 160. See also Unselfishness
Separation (leaving spouse), 1, 18, 25, 52ff., 58ff., 122–23. See also Abandonment; Child support
 author's, 6
 and recovery time, 42
 and suicide, 27
Service businesses, 204
Sewing, 203
 and sales work, 213
Sex, 54, 163. See also Infidelity; Men
 discrimination. See Credit; Jobs and careers
 with former husband, 168
 roles. See Roles and role models
Shapiro, Lee, 133–34
Sharing, 10
 homes, 23

Shaver, Philip, 258
Sheehy, Gail, 258
"Sheila," 124
Shelter, 54. *See also* Houses; Housing
Shields, Laurie, 4
Shock, 42–43
Silences (Olsen), 258
Singles bars, 8
Singles clubs, 86
Singles courses, 98–99
Singles events, 97, 98
Skills. *See also* Jobs and careers; Self-esteem
 listing achievements, 219–21
Skin ailments,
 anger and, 37
 depression and, 28
Sleep. *See also* Bed; Dreams
 disturbances, depression and, 28
Smeal, Eleanor, 258
Smith, Milo, 2, 4, 9, 49–50, 70, 251
 and checking out job availability, 223–24
 and disbelief reaction, 23–24
 and job training, 217
 and tranquilizers, 34
 and volunteer contract, 234–35, 236
 on women relating to women, 83
Smoking, 103
 anger and tobacco addiction, 41
Social life, 73–102. *See also* Men
 and children, 141ff.
 "Rosie's," dominated by husband, 108
Social Policy, 257
Social Problems, 255
Social Security, 2, 187
 Milo Smith and, 11
Social work. *See also* Counseling; Jobs and careers
 Milo Smith and, 11ff.
Sommers, Tish, 4, 12, 172–73
Southern California, University of, Entrepreneur and Venture Management Program, 226
 singles courses, 99
Spirit of Houston, The, 255
Statisticians, jobs as, 220
Status, 23
Stenographers, jobs as, 216
Stepfathers, 129
"Steve" (son of "Tina"), 150–51
Stock dividends, 190
Stomach pains,
 anger and, 37
 depression and, 28
Stores. *See* Department stores; specific types of retail stores
Submissiveness. *See also* Depression; Femininity; Self-esteem
 corporate wives and, 56
Success! (Korda), 257

Success, fear of, 114–15
Suicide (suicide attempts), 4, 8, 18, 19–20, 21, 27, 29, 49, 137
 husband's, 30
 thoughts of, and depression, 28
Summer vacations, 132, 134
Supermarkets, selling to, 207, 213
Support groups, 33, 69–70. *See also* Displaced homemakers centers; specific groups
 and anger, 37–38
 and goal setting, 65
Supreme Court, and pensions, 197
"Susan," 38–39, 42

Taxicabs, driving, 215, 220, 221, 223
Teaching, 6, 25, 181, 182, 215ff., 220, 225, 226
 age and, 223–24
Teen-agers. *See* Adolescence
Temples, to meet new men, 97
Temporary work agencies, 245
Terkel, Studs, 258
Texas, 44, 195
Textiles, selling, 213
Theater company, work with, 238
Therapy (psychological help), 31ff., 151. *See also* specific groups, therapists
 for children of divorce, 137–38, 139, 152, 153
 corporate wives and, 56
Time, recovery, 41–43
Time magazine, 255, 257, 258, 259
"Tina," 150–51
Tobacco (smoking), 103
 anger and addiction, 41
"Todd," "Nina" and, 93–95
"Tom," "Lucille" and, 29–30
"Tony" (husband of "Rosie"), 107–9
Total Woman, The, 257
Trade sales, 207
Tranquilizers. 33–34. *See also* Drugs
Transportation, budgeting for, 190
Travel, 116
 cruises, 23
 and jobs, 211, 222
Truck driving, 215, 217, 220, 223
"Trudy," 109
Truth. *See also* Fantasizing; Reality
 children and, 153
Typewriter repair, as work, 216
Typists, job as, 216

Undercapitalization, 226
Underwear, new, 97
Uniform Reciprocal Support Enforcement Act, 188
Unions, 10–11
Universities. *See* Colleges and universities
Unselfishness, corporate wives and, 56

Index

Valium, 34, 103
Value(s), 3, 10, 27, 109–11, 159, 163–64, 252. *See also* Growth; Self-esteem
children's values, 138
and jobs, 221–23
Vandervelde, Maryanne, 56
Verbal abuse, 51
Verbal skills, and sales work, 214
Vermont, no licensing of placement agencies in, 244n.
Veterans Administration, Milo Smith and, 11
Videotapes, and job interview training, 242
Virginity, 163
Visitation, 175–76. *See also* Children
Volunteer work, 202, 214, 221, 234–40, 251. *See also* Displaced homemakers centers
contract, 234–36, 237, 251
and resumés, 246

Waitresses, jobs as, 216
Walking, 35
Wallerstein, Judith, 131–32
War Between the Tates, The, 257
Wardrobe, 23–24
improving, 241–42
Washington state, 56
Washington University School of Medicine, 35
Wealthy men, and child support, 175, 176
Welfare (public relief), 3, 18, 109, 186
and child support, 175, 187–88, 189
Western Personnel Associates, 233
Who Remembers Mama?, 257
Widow (Caine), 36, 255
Widowhood, 1–2, 6, 111, 112, 142ff.,
182–84, 186
and anger, 36, 184
average age for, 7
and in-laws, 166
and living alone, 35
Milo Smith's, 10
and shock, 42, 43
and social life, friends, 77
and Social Security, 187
Wills, exclusion from, 172
Winston, Marian P., 175, 259
Wisconsin, and child support, 174–75
Woman of Independent Means, A, 256
Woman's Day, 256, 258
Women and Madness, 255
Women, Money, and Power, 256
Women's Equity Action League, 259
Women's Room, The, 255
Women with Low Incomes, 258
Women, Wives, Mothers, 255
Working (Terkel), 258
Working class. *See also* Blue-collar workers
women and disbelief reaction, 23
Working Couples, 258
Worthlessness, feelings of. *See* Depression; Self-esteem
Writing,
author and, 5, 58, 67, 78
sales and written skills, 214

Young, Nancy, 257
Young Women's Christian Association (YWCA), 245
"Yvonne," 81–82, 157–58, 224–25

Zitelli, Barbara, 206–7
and improving appearance, 241–42
and resumés, 246